DIRECTING

BEHIND
THE SILVER
SCREEN

BEHIND THE SILVER SCREEN

When we take a larger view of a film's "life" from development through exhibition, we find a variety of artists, technicians, and craftspeople in front of and behind the camera. Writers write. Actors, who are costumed and made-up, speak the words and perform the actions described in the script. Art directors and set designers develop the look of the film. The cinematographer decides upon a lighting scheme. Dialogue, sound effects, and music are recorded, mixed, and edited by sound engineers. The images, final sound mix, and special visual effects are assembled by editors to form a final cut. Moviemaking is the product of the efforts of these men and women, yet few film histories focus much on their labor.

Behind the Silver Screen calls attention to the work of filmmaking. When complete, the series will comprise ten volumes, one each on ten significant tasks in front of or behind the camera, on the set or in the postproduction studio. The goal is to examine closely the various collaborative aspects of film production, one at a time and one per volume, and then to offer a chronology that allows the editors and contributors to explore the changes in each of these endeavors during six eras in film history: the silent screen (1895–1927), classical Hollywood (1928–1946), postwar Hollywood (1947–1967), the Auteur Renaissance (1968–1980), the New Hollywood (1981–1999), and the Modern Entertainment

Marketplace (2000–present). *Behind the Silver Screen* promises a look at who does what in the making of a movie; it promises a history of filmmaking, not just a history of films.

Jon Lewis, Series Editor

DIRECTING

Edited by Virginia Wright Wexman

RUTGERS
UNIVERSITY PRESS
New Brunswick, Camden, and Newark, New Jersey

Library of Congress Cataloging-in-Publication Data
Names: Wexman, Virginia Wright editor.
Title: Directing / edited by Virginia Wright Wexman.
Description: New Brunswick : Rutgers University Press, 2017. | Series: Behind
the silver screen ; 5 | Includes bibliographical references and index.
Identifiers: LCCN 2016053286| ISBN 9780813564302 (hardcover : alk. paper) |
ISBN 9780813564296 (pbk. : alk. paper) | ISBN 9780813564319 (e-book (web
pdf)) | ISBN 9780813573083 (e-book (epub))
Subjects: LCSH: Motion pictures—Production and direction—United
States—History—20th century.
Classification: LCC PN1995.9.P7 D533 2017 | DDC 791.4302/32—dc23
LC record available at https://lccn.loc.gov/2016053286

A British Cataloging-in-Publication record for this book is available from the British Library.

www.rutgersuniversitypress.org
Manufactured in the United States of America

CONTENTS

ACKNOWLEDGMENTS

Like Hollywood movies, this book represents the product of many hands. I would like to thank all the contributors for their patience and cooperation during the volume's long gestation process. Jon Lewis, general editor of the series, provided prompt, helpful feedback at various points along the way. Special thanks are due to Rutgers Press Editor-in-Chief Leslie Mitchner, whose support and guidance throughout the process went far and above what one expects from someone in her position. Finally, my husband John Huntington, as always, provided wise advice and encouragement at every stage. I am profoundly grateful to all.

DIRECTING

INTRODUCTION Virginia Wright Wexman

Of all the artisans who work in the American film industry, directors have enjoyed the lion's share of attention. Yet the ways in which directors have accommodated themselves to the constraints and opportunities posed by a complex production process and a commercial industry have often been relegated to the margins. The text-centered reading strategies employed by most film critics, which have been adapted from literary and art history models, are ill suited to the task of capturing the distinctive qualities of works created by Hollywood artists who partner with others and operate within a technologically complex commercial industry. Further, the widely accepted notion of a classical Hollywood style that remained relatively homogenous over a long period has discouraged many scholars from examining the changing historical specifics that have shaped the movies directors have been able to make. A common sobriquet used to refer to directors in trade publications, "helmers," likens their role to that of the captain of a ship who must steer a hulking vessel through inclement weather and mechanical breakdowns while managing a large crew. Unlike poets and painters, directors must navigate their professional lives within a vast industrial framework that requires them to cooperate with others and to cope with intricate financial, legal, and organizational parameters. The present volume, which looks in depth at the way in which directors have worked

1

within the Hollywood system, has been informed by this understanding of their achievements. Each of the book's chapters examines a particular period in Hollywood history, and, though each author adopts a unique focus and perspective, all address the ways in which directors have functioned within the sprawling enterprise that is the American film industry.

This introduction contextualizes the case studies taken up in the chapters that follow, placing them within a broad framework that sketches out some of the major issues those studying directors in Hollywood must confront. It begins with a historical overview of the path that has led directors to their present position of eminence, then traces the varied routes individual directors have taken to enter the profession. It looks at directors' daily routines and goes on to describe the nature of the artistry that lies at the heart of their claim to be thought of as authors in the high art tradition. A survey of the issues raised by the collaborative process in which virtually all Hollywood directors must participate follows. The introduction concludes with a brief analysis of the ethnic and gender privilege that has long been associated with being a director in Hollywood. In all of these areas directors have functioned as active agents, both individually and through their institutional base, the Directors Guild of America (DGA).

Favored by History: Hollywood Directors over Time

Historically, directors have not always enjoyed the privileged position they find themselves in today. Recalling his career at Biograph studios, Billy Bitzer stated, "Before [D. W. Griffith's] arrival, I, as cameraman, was responsible for everything except the immediate hiring and handling of the actor. Soon it was his say whether the light was bright enough, or if the make-up was right."[1] Film historian Tom Gunning attributes this shift in power to the growing ascendency of narrative. A director, Gunning argues, could integrate elements of a production around a unifying center, "creating a filmic discourse which expressed dramatic situations."[2] In other words, directors acted as de facto narrators, staging scenes in a way that helped audiences understand the story being told.

From 1909 to 1914 the studios operated under a system that gave directors authority over individual productions. Following the model of the theater stock company, directors like Griffith functioned as producers as well as directors, writing or selecting stories, choosing locations and settings, supervising production personnel, and overseeing editing. Beginning in 1912, however, this practice was gradually replaced by a system that gave directors control over principal photography while preproduction and postproduction became group efforts with producers in charge. By 1913 a scenario editor at Lubin could state, "Now the director does not see the scenario until it is handed him for production,

complete in every detail."[3] As films got longer, production became more complex, as Charlie Keil describes in the first chapter of this volume. New positions were created: art directors, lighting specialists, cutters, and the like. Moreover, continuity scripts became indispensable because they enabled filmmakers to group together episodes set in similar locations and thus shoot scenes out of sequence. In this environment producers began to exercise supervisory powers over the shooting phase of a picture as well as over its preparation and postproduction. In this period, the system itself had many permutations, and the role of director varied considerably. Griffith added close-ups as pick-up shots after a scene had been filmed, while Cecil B. DeMille customarily used multiple cameras. Frank Borzage, Charlie Chaplin, and others worked from rough story outlines rather than finished continuity scripts.

In 1917 Jesse Lasky announced that his studio would return to a director-centered system with writers closely involved with every phase of the process. "Each director in our four studios will be absolutely independent to produce to the best of his [sic] efficiency and ability," Lasky stated. "With the discontinuance of a central scenario bureau each director will have his own writing staff and the author will continue active work on every production until its conclusion, staying by the side of the director even when the film is cut and assembled."[4] But Lasky's initiative bucked larger trends, and directors continued to be positioned as participants in an increasingly corporate industry.

By the 1920s what is now called the classical studio system was firmly in place, and most directors, along with other Hollywood artisans, worked under long-term studio contracts. Even though they were nominally employees, name directors occupied a position of privilege that they sometimes abused. For example, Erich von Stroheim's exacting creative agenda led to extravagant expenditures on sets and costumes and endless retakes. As a result, his films consistently exceeded their budgets. His cut of *Greed* in 1925 clocked in at over five hours, prompting MGM production head Irving Thalberg to take the material away from his perfectionistic employee so that it could be cut down to a length more in line with prevailing theatrical standards.

The 1930s saw major changes in the film industry that curbed directors' authority and control. As William Luhr explains in the second chapter of this book, Hollywood's conversion to sound in the late 1920s involved adding unwieldy equipment that made location shooting next to impossible. Moreover, the economic depression that struck the country shortly thereafter forced the studios to accept bank oversight of their operations, leading to a new emphasis on efficiency. Confined to studio sets where their work was closely monitored by executives, directors were not as free as before to impose their own styles on their films. During this period strong producers like Irving Thalberg and Darryl Zanuck had the most right to claim authorship of the films they oversaw. In 1936 John Ford grumbled,

As it is now, the director arrives at nine in the morning. He has not only never been consulted about the script to see whether he liked it or feels fit to handle it, but he may not even know what the full story is about. They hand him two pages of straight dialogue or finely calculated action. Within an hour or less he is expected to go to work and complete the assignment the same day, all the participants and equipment being prepared for him without any say or choice on his part. When he leaves at night he has literally no idea what the next day's work will be.[5]

Some directors were boxed in even further, for an assembly-line model was taking hold in which specialist directors could be assigned to supervise selected scenes in a given production, thereby functioning as pieceworkers. Busby Berkeley's oversight of dance sequences followed this pattern, as did Raoul Walsh's position as the Warner Bros. "tank man" whose job it was to direct all scenes shot in the studio's water tank. Unhappy and unfulfilled as a result of being saddled with such conditions, directors had strong reasons for making creative rights an issue when they decided to form a union, the Screen Directors Guild (later renamed the Directors Guild of America), in 1936.

As the 1930s drew to a close, the status of top directors improved markedly. Preston Sturges, who was then employed in Hollywood as a writer, labeled A-list directors of the day as "princes of the blood." "The bungalows they lived in on the lot had open fireplaces and big soft couches," he recalled. "Nobody ever assigned them pictures they didn't like; they were timidly *offered* pictures. Sometimes they graciously condescended to direct them but if they said no, a story was a piece of cheese."[6] During this period, important directors like Howard Hawks began to flex their muscles by taking on the role of producers, a development that studio executives did not necessarily view kindly. For example, in 1937 when Hawks was working on *Bringing Up Baby*, RKO executive Lou Lusty sent a memo to his boss Sam Briskin about the director. "Hawks is determined in his own quiet, reserved, soft-spoken manner to have his way about the making of this picture," Lusty complained. "All the directors in Hollywood are developing producer-director complexes and Hawks is going to be particularly difficult."[7]

While studio executives increasingly kowtowed to star directors like Hawks, they continued to clamp down on the rank and file well into the 1940s. John Huston described the situation in his autobiography *An Open Book*. "After a picture commences, your work was monitored—usually by the heads of the studio along with your producer—before you had an opportunity to see them," he wrote. "If they thought you were shooting an inordinate number of takes, there would be an inquiry. If a picture fell behind schedule, they would want to know exactly why. If anything untoward happened on the set, it was reported to the front office."[8]

After 1948 the advocacy role taken up by the Directors Guild worked in concert with trends within the industry and the society at large to give directors ever

greater dominance over the filmmaking process. After the US Supreme Court ruled in 1948 that Hollywood's business model violated antitrust statutes, the major studios were forced to give up their theater chains and thus their secure pipeline to exhibition venues. At the same time, television and suburban lifestyles drew audiences away from movie theaters. By the end of the decade the classical Hollywood system in which the studios functioned as film factories was crumbling. Like other Hollywood workers, directors, who had formerly been employees of the studios, now became freelancers. Some cast their lot with the burgeoning ranks of independent production companies, as Sarah Kozloff documents in the third chapter of this volume. For the fortunate ones who were able to make the transition successfully, the gains in creative autonomy made up for what they had lost in job security.

Kozloff's chapter also describes the way in which the House Un-American Activities Committee (HUAC) targeted Hollywood left-wingers during the 1950s, branding some as communist traitors. Of the Hollywood Ten, who were imprisoned for contempt of Congress because of their refusal to cooperate with the committee's agenda, two were directors: Edward Dmytryk and Herbert Biberman. Many more directors were denied work well into the 1960s as a result of the studios' pledge to blacklist those who were suspected of communist sympathies. Some, like Elia Kazan and Robert Rossen, saved their careers by informing on their colleagues; others, like Joseph Losey and Jules Dassin, found work abroad. Still others had their lives and careers shattered beyond repair by the witch-hunt.

One of the first witnesses to testify before HUAC was director Sam Wood, who charged in 1947 that the Directors Guild had been infiltrated by communists. The DGA issued a firm protest at the time, but the pressure continued. In 1950 Cecil B. DeMille, a powerful force in the Guild and a fervent anticommunist, forced a confrontation with the organization's liberal faction over his proposal to have every member sign an oath of loyalty to the U.S. government. After a seven-hour meeting at the Beverly Hills Hotel in October of 1950, Guild president Joseph Mankiewicz, who found himself in the eye of the storm, issued a call to all members to sign such an oath. Mankiewicz's action was motivated by a desire to save face for DeMille, who, along with the other DGA board members, had been recalled during the tumultuous meeting. Losing DeMille meant putting the Guild itself in jeopardy. "If Mr. DeMille is recalled," John Ford declared on the fateful evening, "your Guild is busted up."[9] The DGA oath, the first one in Hollywood, remained in effect until 1966, when the courts declared it unconstitutional.

During the 1960s and 1970s a number of factors conspired to aid directors in their quest for greater authority. Cinema sophisticates of the day turned toward foreign fare in which the names of writer-directors like Federico Fellini and Ingmar Bergman appeared front and center, inspired in part by the French-spawned

auteur theory that put Hollywood directors on a par with international ones. The theory took hold on American college campuses, nurturing a film generation of young cinephiles who went to movies looking for signs of directorial style. In response, as Daniel Langford notes in the fourth chapter of this volume, Hollywood turned to a new breed of independent-minded directors with an art cinema aura, a group that included Arthur Penn, Robert Altman, Francis Ford Coppola, and Martin Scorsese. Desperate studio executives looking to connect with this new audience gave these and other maverick talents unprecedented control over their productions. This era of extreme directorial freedom came to an abrupt end following the 1980 release of Michael Cimino's *Heaven's Gate*, a grandiose auteur-driven project that proved to be a commercial and critical disaster. The following generation of Hollywood auteurs, including Steven Spielberg, George Lucas, Ridley Scott, and James Cameron, were less iconoclastic and more adept at exploiting the commercial potential of the movies they directed. They were backed by studios that were increasingly positioned as flashy outposts of giant multinational conglomerates.

It would be a mistake to assume that the takeover of the Hollywood studios by multinational corporations in the 1970s and 1980s led Hollywood executives to view filmmaking through a lens focused solely on the bottom line. Prestige and an image of quality remained at the forefront, not only because these factors can define a given studio as a quality brand in the eyes of the public but also because they exert a potent emotional appeal to stockholders, management, and the Hollywood elite. Moreover, with the end of long-term studio contracts and the subsequent practice of crafting one-time deals, personal relationships have taken on new importance, and a desire to accrue cultural capital in the close-knit Hollywood community operates as a catalytic force. Under this system, directors have often benefited from the relationships they have managed to create with bankable actors, who frequently request a trusted director as a condition of their participation in a given production. Building on a strategy pioneered by super-agent Lew Wasserman in the 1950s, powerful agents often package projects to present to studios, teaming directors with writers and stars (canonical films like *Some Like It Hot* [1959] and *Psycho* [1960] were produced in this manner). Where directors were once hired by studio moguls, they now became their own bosses, hiring and firing the agents who brokered deals for them. In the fifth chapter of this volume, Thomas Schatz uses three case studies from Hollywood's 1989 production slate to document the wide range of moviemaking practices during this period and the ways in which directors fit into them.

By the turn of the twenty-first century, the digitalization of the industry presented directors with unprecedented filming options, as J. D. Connor chronicles in the last chapter of this book. By this point many directors had assumed a position at the top of the Hollywood hierarchy. In 1996 Paul

Schrader commented, "[Some] directors have complete control—Spike Lee, John Sayles, Woody Allen, Spielberg. It's an extraordinary power that even Darryl Zanuck never had at the height of the studio system."[10] And directors as a group now have assumed unprecedented stature and influence not just within the industry but in the culture at large. Their newly elevated position is due in part to the ongoing efforts of the Directors Guild, which has won numerous privileges for its members including ever-increasing authority over all phases of the production process as well as control over directorial credits. All Guild members now have the contractual right to be consulted about scripts and also to prepare a cut of their films (called a director's cut) prior to any further editing by producers.

Origins: Where Do Directors Come From?

Unlike medicine or law, for a career as a director no special training or credentialing is required. Historically, most have moved into the profession from adjacent fields: acting (Edward James Olmos, Clint Eastwood, Ossie Davis), writing (Lois Weber, John Huston, Oliver Stone), producing (Stanley Kramer, Alan Pakula,), editing (Dorothy Arzner, Edward Dmytryk, Robert Wise), production design (William Cameron Menzies), cinematography (George Stevens, Haskell Wexler), or choreography (Busby Berkeley, Stanley Donen, Bob Fosse). Many, such as Ernst Lubitsch, Alfred Hitchcock, and John Woo, learned the trade abroad. Television has nurtured other directorial talents, producing an especially rich crop in the 1960s when figures like Sidney Lumet, Arthur Penn, and Elliot Silverstein, who had cut their teeth on live TV shows in New York, migrated to Hollywood. Still others, like Richard Lester and Ridley Scott, got their training directing commercials, while yet another group, including Peter Bogdanovich and Paul Schrader, began as critics.

Increasingly, Hollywood recruits talent from film schools, especially the University of Southern California (USC), UCLA, the American Film Institute (AFI), Columbia University, and New York University (NYU). Each of these major pipelines tends to produce graduates with a distinctive style: from the smooth commercial savvy that marks USC grads like George Lucas, Ron Howard, and Judd Apatow to the edgy urban aesthetic of directors like Spike Lee, Martin Scorsese, and Amy Heckerling, who attended NYU. AFI grads like Terrence Malick and David Lynch veer toward the cerebral and experimental. Columbia has produced a preponderance of Hollywood's most successful women directors, including Kathryn Bigelow, Lisa Cholodenko, Nicole Holofcener, and Kimberly Pierce; while UCLA educated a notable crop of African American directors in the 1970s and 1980s, including Charles Burnett, Haile Gerima, and Julie Dash, a group that has come to be known as the L.A. Rebellion.

"A Job of Work": Directors' Daily Routines

In his landmark 1962 study, *The American Cinema*, critic Andrew Sarris ranked directors in relation to the stylistic brio they brought to their productions. Most of the subsequent writing on directors has followed Sarris's lead, emphasizing the ways in which directors have marked their films with distinctive stylistic signatures that express what Sarris termed "inner meaning." Some favor characteristic camera techniques like crane shots (Max Ophuls) or tracking shots (Vincente Minnelli). Others are associated with particular lighting techniques (Terrence Malick's "magic hour" illumination, Joseph von Sternberg's shadows). The films of still other notable auteurs feature resonant motifs such as mirror shots (Douglas Sirk) or staircases (Alfred Hitchcock). In a later phase of auteurism, critics like Peter Wollen described structural oppositions that could be identified with canonical directors like Howard Hawks (male/female) and John Ford (civilization/wilderness). But recognizing stylistic signatures is not the only way in which one can study the work of directors. Directing is a job as well as an art: directors *direct* or supervise motion picture productions, each such endeavor involving a host of human, technical, commercial, and industrial components. As John Ford once said, it is "a job of work."[11]

During the heyday of the classical studio system, from the 1920s through the 1950s, directors were rarely consulted on scripts, which were customarily given to them shortly before shooting began. Nor did they ordinarily participate in the postproduction phase, which was the province of the editor, overseen by the producer. The job of the director was to guide principal photography. Table I.1 charts the way in which directors typically functioned within the system during this period. The system put in place by Thomas Ince in the early 1910s has always been subject to an infinite number of refinements and variations, but it provided a basic template that most productions followed in one form or another until the breakup of the studio system in the 1960s. Even today, Ince's model functions as a skeleton onto which variations are grafted to meet the unique demands of each moviemaking venture. The scheme was devised to emphasize the creative dimension of a production by prioritizing "above the line" elements (directors, writers, and actors) over "below the line" technicians (the crew).

To play their part in this byzantine process, directors call upon a wide range of skills. Veteran director Allan Dwan once described the director's role by recalling, "They taught me three words. First, they told me to say, 'Camera.' And the next thing I'd say was, 'Action.' And the next thing, 'Cut.' You get those three words and remember them and you're a director."[12] But the job of staging a scene is obviously far more difficult than Dwan cared to admit. Several directors have written how-to manuals about their profession, but these books are, for the most part, vague and chatty.[13] The best source of information about directors'

Table I.1: Production Hierarchies in the Classical Hollywood Studio System

STUDIO HEAD/ PRODUCTION CHIEF	Hires Personnel; Determines Company Policy and Company Style
PRODUCER	Acquires Property; Prepares Budget Estimate; Hires Above-the-Line Personnel (Talent)
Unit Production Manager	Hires and Manages Below-the-Line Personnel (Crew); Manages Above-the-Line Personnel; Drafts Detailed Budget; Prepares Production and Postproduction Schedule; Oversees Day-to-Day Budgeting and Logistics
PREPRODUCTION	
WRITER	Prepares the Script Treatment and Shooting Script
LOCATION SCOUT	
CASTING DIRECTOR	Hires Actors
GRAPHIC ARTIST	Prepares Storyboards
PRODUCTION DESIGNER	Locates/Designs Settings
ART DIRECTOR	Oversees Set Construction
Set Decorator	
PRODUCTION	
DIRECTOR	Oversees Shooting
SCRIPT SUPERVISOR	Monitors Continuity
FIRST ASSISTANT DIRECTOR	Plans and Monitors Daily Schedule; Sets Up Shots; Works with Background/Extras
SECOND ASSISTANT DIRECTOR	Prepares Daily Call Sheets; Prepares Daily Production Reports
SECOND UNIT DIRECTOR	Films Stunts, Location Footage
CAST	Stars (and Acting Coaches), Supporting Players, Extras

Costumers, Make-Up Artists, Hairdressers	
CINEMATOGRAPHER	Supervises Photography
Camera Person	
Lighting Director	
POSTPRODUCTION	
VISUAL EFFECTS TECHNICIANS	
EDITOR	Prepares Daily Rushes, Rough Cut, Final Cut
SOUND EDITOR	Oversees Looping
FOLEY ARTIST	Creates Sounds
SOUND MIXER	Records Sound
COMPOSER	Adds Musical Score

day-to-day activities can be found in Alain Silver and Elizabeth Ward's *The Film Director's Team*, from which the following summary is derived.[14]

In accordance with Ince's regimen, a director's work usually begins with a production meeting of all major personnel held a few days or weeks before filming commences. The aim of such meetings is to troubleshoot potential problems and complications in advance. Once filming is underway, directors oversee a vast army of workers. The director's team includes an assistant director who handles day-to-day scheduling, preparing a daily call sheet that specifies all personnel and equipment needed for the following day's shoot. The assistant director also oversees extras and background details. A unit production manager keeps track of hours worked and budgetary matters in a daily film log, and is responsible to the producer.

Each day's filming proceeds more or less as follows:

- All personnel, equipment, and props involved in the day's shooting arrive on the set as specified in the daily call sheet.

- The director stages the scene, deciding on camera placement and lighting for the first shot in consultation with the cinematographer. He or she then organizes a run-through with the actors, choreographing their movements (a process known as blocking) and rehearsing the dialogue, giving the actors feedback (called notes) when needed.

- The director leaves the set, perhaps to work with the actors or prepare for the next set-up, while the first assistant director sets the stage for the shot to be executed. He or she calls in stand-ins to take the place of the actors so that the cinematographer can set up the necessary lighting and other details that will enable the filming to go smoothly.

- The director returns to the set and films the scene. He or she begins it by calling "Camera!" which starts the camera rolling, then "Action!" which brings the actors to life. The take ends when the director calls, "Cut!"

- The director determines whether the take is acceptable or needs to be reshot. If it seems worth preserving, he or she says "Print!" Even if the take is sent to be printed, the director may determine that an additional take is necessary.

- The routine is repeated for each camera set-up throughout the day with the director in charge and the first assistant director monitoring progress for the front office.

- At the end of the day the first assistant director calls "wrap" and the second assistant supervises the clean-up and distributes the call sheet specifying who and what is needed for the following day.

- In the evening, the director, along with the producer and other crew members, views the rushes of the film shot that day to see whether retakes may be necessary.

- Once all the scenes are filmed, the director's job is finished, and the editors, supervised by the producer, take over.

To keep to such a routine for weeks or months at a time requires a rare combination of qualities: a supreme sense of self-confidence in one's ability to make quick, expensive decisions; unflagging physical and emotional stamina; and the charisma and leadership ability necessary to keep the confidence of the troops. Directors must also be ready to cope with a mind-boggling array of potential roadblocks, including unpredictable environmental conditions, perilous action

sequences, budgetary limitations, the unexpected death or incapacitation of a key team member, and censorship problems. To deal with such eventualities, directors must be flexible, quick-witted, and ready to compromise if need be. If they are able to turn such situations to their advantage, so much the better. George Stevens exhibited many of these qualities on the set of the 1965 film *The Greatest Story Ever Told*, when, after many days of shooting, unexpected snow in the Nevada location threatened to shut down the production. "[Stevens] summoned the entire production," actor Max Von Sydow later recalled. "Everybody. And he asked them to excavate Jerusalem out of the snow. So, I think it was Sunday. Everybody went up with shovels and blowtorches and brooms and all kinds of things. And we managed to at least clear some of the area and shoot at least some close shots."[15]

Directorial Artistry

As we know, directors are not just supervisors; they are also stylists. As such, they occupy a special place in the Hollywood hierarchy. In an ethnographic study of the movie industry carried out in 1950, an anthropologist, Hortense Powdermaker, observed that directors were unique in that they were "primarily motivated by the desire to produce an excellent film, and more concerned about their craft than with profits."[16] The complicated dynamics involved in mounting a scene are designed with aesthetic ends in mind: the director is charged with carrying out each shot in a way that best serves the needs of the story.[17] At the end of the day, it is this talent, along with the ability to get the best out of actors, that separates good directors from bad ones.

Film scholar David Bordwell has described one version of this skill as "ensemble staging." To illustrate, Bordwell describes in detail the way in which director Elia Kazan filmed two brief scenes in the 1950 production *Panic in the Streets*. The film chronicles the efforts of a medical officer (played by Richard Widmark) to contain a potential outbreak of pneumonic plague in New Orleans. The scenes Bordwell discusses involve numerous characters, some of whom are ignorant of the health threat while others know of it but must not tell. Each scene is handled in just two shots, and in each shot the camera moves inconspicuously. Without using a single close-up, Kazan's staging strategy highlights complex emotional and intellectual interactions that occur among many characters, each one of whom has a particular stake in what is going on. Dramatic irony is maximized as our attention is subtly drawn to one or another of the characters though a significant play of light and shadow and a shifting depth of focus. Kazan's dynamic blocking complements these techniques by moving the actors around the set in a way that focuses and refocuses our attention on one character after another, each with a different level of knowledge and a different stake in the outcome, as they

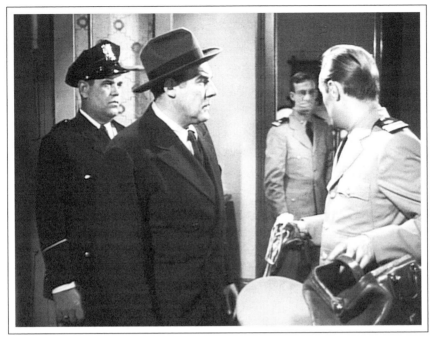

FIGURE 1: *Panic in the Streets* (Elia Kazan, 1950): Dr. Reed (Richard Widmark) orders Lieutenant Paul (background, right) to burn all the bed linen used by the plague victim as Paul closes the door to the sickroom.

FIGURE 2: In this shot from *Panic in the Streets*, a photographer's flashbulb goes off just as a police officer in the background is about to sneeze and wipe his nose, causing Dr. Reed to look up from his microscope.

discuss what must be done. The mise-en-scène, too, comes into play in the first scene as the door to the sickroom is opened and closed at salient moments. In an especially ominous touch at the conclusion of the latter scene, Kazan positions a policeman standing in the background wiping his nose just as a news photographer's flashbulb catches him in a spasm of light, thereby foreshadowing the possibility of an epidemic.[18]

Singularity: The Myth of the Lone Director

Especially since the Romantic era, Western civilization has conceptualized art as the creation of a unique consciousness. Though Hollywood movies, which are manifestly created by large groups, fit uneasily into this mold, a number of factors may give rise to the impression that directors are singular artists in the high art tradition. The auteur theory has posed the idea of directors whose artistry may rise above the noise created by underlings, collaborators, and conditions. In addition, as Sarah Kozloff explains in the third chapter of this book, the possessory credit often appended at the beginning of the front credit roll (the credit that endows movies with labels like "Alfred Hitchcock's *Psycho*") positions the film that follows as the property of its director. Such formulations and signs downplay the complex hierarchies and teamwork that bring Hollywood productions to life. Even the director's chair itself may be occupied by more than one person; though the director of record is normally placed front and center, in the background are replacement directors, second unit directors, assistant directors, and stunt directors.

One of the most significant groups promoting the idea that Hollywood films owe their existence to a single creator has been the Directors Guild of America. When the Guild first took shape in the late 1930s, the concept of the solo director took center stage. Frank Capra, who guided Guild policy during its formative years, had crafted the catchphrase "one man, one film" during the 1920s, and he molded the Guild's agenda to promote this notion. "Any art creation should be the product of one mind," he wrote in the *New York Times* soon after he was elected to the Guild presidency. "With that mind there should be no interference."[19] Thus, through the years the Guild has expanded the areas over which directors have control and has added restrictions to limit the conditions under which directors can be replaced.

In cases where real control falls short, the Guild has ensured that the perception of control can take its place. One of the DGA's first orders of business was to get jurisdiction over the allocation of directorial credits, and only in very rare occasions does it allow more than one director to get onscreen recognition for a film—even when more than one has worked on a given production. The trade publication *Variety* once listed 176 films made between 1970

and 1986 that were overseen by more than one director, but only in a very few cases did the directorial credit reflect this team effort.[20] Famous instances in which more than one director put in significant work on a film but only one got credit include *Gone with the Wind* (1939; Victor Fleming [credited] and George Cukor) and *Laura* (1944; Otto Preminger [credited] and Rouben Mamoulian). An extreme case is 1963's *The Terror*. As Roger Corman, the director of record, later described the filming:

> I shot two days of it on some standing sets from *The Raven* with only part of the script written.... And I had various people directing. Francis Coppola directed part of it. Monte Hellman directed part of it. Jack Hill did part of it. And the last day of shooting there was nobody available, and so Jack [Nicholson, who was acting in the film] said, "Roger, every idiot in town has directed part of this film; lemme direct the last day." So I said, "Fine, Jack, go ahead."[21]

Even when a single director is in charge of a production, he or she is typically supported by subordinates who may wield considerable authority. Second unit directors often film extended sequences in locations far removed from the watchful eye of the alpha-dog director. Directors with specialized skills may be in charge of stunts, montages, or dance numbers. Famed stunt director Yakima Canutt carried so much weight that scripts at Republic Pictures, where he worked on westerns during the 1930s, simply noted, "See Yakima Canutt for your action sequences."[22] In addition, while the director of record is charged with wrangling the featured players, assistant directors manage extras and background action. Robert Altman was almost fired from the production of *M*A*S*H* (1970) because he behaved more like an assistant director than a director by working closely with the background players rather than devoting his attention to the stars; his unorthodox approach was vindicated, however, when the picture became a major hit and garnered critical praise for its rich tapestry of background activity.

Directors and Their Collaborators

The best directors guide their productions with a strong hand and mark their films with distinctive stylistic signatures. But in order to bring their visions to fruition, they must collaborate with many artisan-specialists. This is the arena where directors' jobs as supervisors intersect with their aspirations as creative artists. There are, to be sure, figures like D. W. Griffith, Charlie Chaplin, Spike Lee, and Woody Allen, who dominate every phase of their productions and hire personnel who can support them in achieving their particular visions. A few

other directors have managed to avoid at least some of the complications of collaboration by taking on tasks ordinarily parceled out to specialists. Some, like Joseph L. Mankiewicz and Mel Brooks, write their own scripts. Clint Eastwood has composed music for several of his productions and Steven Soderbergh often serves as his own cinematographer and editor. But in the overwhelming majority of cases, directors rely on the talents of others to complement their own. The most important of these specialized helpmates are producers, writers, actors, cinematographers, production designers, visual effects technicians, editors, sound designers, and composers. One of the aims of the present volume is to shine a light on the complicated interactions between directors and these often-marginalized creative partners.

Directors' collaborations with specialist colleagues operate differently in every case. Uneven power positions and states of knowledge come into play along with temperamental compatibility issues and communication glitches. In many instances the director and his or her team get on well; at other times, discord prevails. The outcome does not necessarily reflect the nature of the collaborative process; movie classics may emerge from sworn antagonists uneasily yoked together, while happy campers can produce flops.[23] Each category of specialist comes with its own particular baggage. What follows are some examples that illustrate the special relationships that may exist between directors and their key specialist helpmates.

Producers: Boosting the Business

As the representatives of the financial interests that ultimately rule Hollywood, producers are typically more interested in commerce than art. They are usually the ones who hire directors, and they do so with commercial considerations in mind, aiming for an efficient production process and a marketable end product. In the studio era, producers like David O. Selznick and Arthur Freed wielded enormous power, and directors' most effective method of opposition was passive resistance. William Luhr describes John Ford's relationship with Twentieth Century–Fox studio chief Darryl Zanuck in these terms. Alfred Hitchcock employed a similar strategy of passive resistance in dealing with Selznick. Selznick brought the director to Hollywood from England in 1940 to make *Rebecca*, but he and Hitchcock did not always see eye-to-eye. Selznick wanted a women's picture closely modeled on Daphne Du Maurier's popular novel—a presold property— while Hitchcock wanted to turn *Rebecca* into another Hitchcock thriller. The director kept a stiff upper lip as Selznick tinkered incessantly with the script and editing of the film to maximize what he saw as its commercial potential. When all was said and done, Hitchcock felt that *Rebecca* was not really his own. "Well, it's not a Hitchcock picture," he told François Truffaut. "It has stood up quite well over the years; I don't quite know why."[24]

One case in which a producer's commercial interests complemented rather than clashed with a director's artistry is *Casablanca*, produced by Hal Wallis and directed by Michael Curtiz. By 1942, when this now-classic film was being made, Wallis was as experienced and knowledgeable about all the aspects of moviemaking as anyone in Hollywood. Irene Lee, the Warner Bros. story editor who discovered the unproduced Broadway play that was to become *Casablanca*, judged Wallis this way. "Hal knew every aspect of pictures and, when he was at Warner Bros., he okayed every single thing—every costume, every script, every set."[25] Curtiz, for his part, brought energy and verve to the project, drawing on his feeling for drama to invest a stagy, meandering story with a sense of action and high emotion. Wallis understood his director's strengths and weaknesses well and knew how to keep them in check. During production of *The Adventures of Robin Hood*, which the duo had worked on a few years before, Wallis warned his associate producer Henry Blanke about Curtiz's style. "In his enthusiasm to make great shots and composition and utilize the great production values in this picture, he is of course, more likely to go overboard than anyone else."[26] Yet while he was aware of Curtiz's excesses, Wallis consistently stood by his director and defended him when crew members complained.

Writers: Weighing the Words

Writers and directors have a long history of tensions. As William Luhr notes in the second chapter of this volume, directors like John Ford have always been inclined to cut out dialogue when a given point can be made visually. And, as J. D. Connor notes in the sixth chapter, directors like Adam McKay rely heavily on improvisation, discarding the script when inspiration strikes. To minimize any conflicts that may arise during filming as a result of such directorial interventions, the standard Directors Guild contract bars writers from the sets of movies they have scripted. Preston Sturges, who was both a writer and a director, was in a position to view the conflict from both sides, but came to appreciate the prerogatives granted to directors when he became one himself. "If anyone knows how a scene should be played it is the fellow who wrote it," Sturges wrote in his autobiography. "Or so I once thought. I agreed with very few directors when I was merely writing. They argued tremendously, and sometimes they lost out. I look upon them now as brave fellows who went down with their colors flying. I don't, as a director, film a scene exactly as the writer—who was myself—wrote it."[27]

The collaboration between screenwriter Joan Tewkesbury and director Robert Altman during the development and production of *Nashville* in 1975 is an instance of a truly interactive writer-director collaboration. Altman's only preliminary directives to the screenwriter were that the film was to be set in Nashville and the climax was to feature an assassination. Tewkesbury initially prepared a draft that featured eighteen characters bouncing off one another during three days

preceding a star-studded benefit performance for a fictional presidential candidate. Altman then added six more characters and specified that the assassination victim should be an entertainer rather than a politician. He also cut much of the exposition and character motivation Tewkesbury had spelled out in her drafts. Once filming began, Altman encouraged his actors to write their own lines, but he and Tewkesbury kept a tight rein on the proceedings. "When actors would write things themselves, it didn't mean you just spontaneously did it," explained Henry Gibson, who played one of *Nashville*'s central characters. "You did it with the approval of Joan, because Joan had created this fantastic structure."[28]

Actors: Crafting the Characters

One of the most important jobs directors are charged with is to get the best out of their actors, but there is no single strategy for achieving this goal. Every director has his or her own method. Some follow the script to the letter; others like to create space for the actors to improvise. Some demand lengthy rehearsals and hone a performance through multiple takes; others prefer the spontaneity a first take can offer. Some, like Ernst Lubitsch and Preston Sturges, offer specific line readings; others, like Alfred Hitchcock and Ridley Scott, leave actors largely to their own devices. Some engage actors in lengthy discussions about their characters' background and motivations; others simply function as an appreciative audience. Still others may suggest tricks by which specific effects can be achieved, as Allan Dwan did when he coached silent superstar Douglas Fairbanks in the art of smiling by telling him to say "piss" for a subtle smile and "shit" for a wide grin. At times directors may resort to outright deception to coax a credible performance from a child. In order to wring heartrending sobs from seven-year-old Margaret O'Brien for a crucial scene in the 1944 *Meet Me in St. Louis*, for instance, Vincente Minnelli told her that her pet dog was about to be brutally murdered.[29]

Because performers' backgrounds and expectations vary so widely, directors must be flexible enough to adapt to unforeseeable situations as they develop. Peter Weir describes the contrasting approaches he took to directing Robin Williams in 1989's *Dead Poets Society* and Jim Carrey in 1998's *The Truman Show*. Of directing Williams, Weir says, "[Our mutual] background of sketch comedy gave us a wonderful way of talking together because I could play the straight man with him and just drop back into those early days when I was writing and performing."[30] Dealing with Jim Carrey on the set of *The Truman Show* was more difficult. Weir later recalled the experience as follows:

> I think he'd always directed himself really prior to working with me, and I found that difficult the first couple of weeks because we'd do a take and he would come round and want to watch it and come up with new ideas. And I would say that we had what I needed. So I had a talk with him

about it and said that he had to trust me to say we've got the shot. And he found that difficult. . . . So I said he shouldn't look at the monitor again. He was coming to watch dailies anyway, so he knew what I was printing. After a couple of weeks, he just let me do my job.[31]

Cinematographers: Painting the Pictures

Much of the ever-evolving knowledge of lenses and lighting techniques involved in cinematography is limited to those in the field, yet productive director-cinematographer partnerships have resulted in a multitude of memorable screen images over the years. Although a few directors know photography inside and out, most content themselves with supplying the vision that can awaken the inventive powers of their cinematographer-partners. In the early days, especially, such partnerships established the conventions that came to define the classical Hollywood style. At the behest of Lillian Gish, D. W. Griffith was persuaded to hire photographer Hendrik Sartov to shoot the soft-focus close-ups that subsequently became a staple of Hollywood glamour photography.[32] In the 1920s Lois Weber worked with cameraman Del Clausen to develop strategies of double exposure and matting to show characters' inner visions.[33]

Directors need not rely on technical know-how to come up with promising ideas that their cinematographers can give shape to. Alfred Hitchcock's creation of the dolly zoom shot, which he used for the first time on his 1958 film *Vertigo*, is a famous example of such a collaboration. The technique was devised to enable the audience to share the dizzy sensation the hero experiences when he looks down from a great height. Hitchcock later described the incident that had inspired what is now sometimes called "the Hitchcock zoom": "I always remember one night at the Chelsea Arts Ball at the Albert Hall in London when I got terribly drunk and had the sensation that everything was going far away from me," he recalled.[34] To replicate this effect, Hitchcock worked with his second unit cameraman Irmin Roberts to adapt a technique first devised by Romanian cinematographer Sergiu Huzman in which the camera dollies in and zooms out simultaneously. This celebrated shot was later used to good effect by Steven Spielberg in *Jaws* (1975) and Brian DePalma in *Body Double* (1984).

John Ford is one of the few directors who had a thorough knowledge of cinematography. William Clothier, who frequently served as Ford's director of photography (DP), once said of the director, "He knew more about photography than any other man who ever worked in the movies."[35] Perhaps because of this deep understanding of their craft, Ford treated his DPs as valued colleagues. The great Mexican cinematographer Gabriel Figueroa, who worked with Ford on *The Fugitive* in 1947, described their relationship with admiration. On the day before shooting was to begin, Ford instructed Figueroa to find the best set-up for a long shot. Given the necessary authority, the cinematographer was able to set up the

appropriate lighting before Ford arrived on the set the next morning. Figueroa described what happened next:

> I asked [Ford] if he would like to check the set-up through the camera and after a puff on his pipe, [he] simply answered, "I am just the director, you are the photographer. But tell me: which lens are we using?"
> "28mm," I said.
> "Okay. So you are cutting here and there," and he began to indicate the imaginary limits of the space covered by the camera lens. It took Ford years of experience to be able to do this, and it made my staff and me aware of the kind of person we were going to work with.[36]

Production Designers: Setting the Scene

Production designers and their art director assistants are in charge of what is in front of the camera to be photographed, and they, too, bring resources to a production that can enrich a director's initial conception. At times, however, the director's superior grasp of the way individual scenes fit into the larger arc of a film's story overrides the production designer's more limited purview. In other words, production designers are focused on space (the fictional world) while the director's perspective also encompasses time (the progression of the narrative).

The 1997 release *L.A. Confidential*, which Curtis Hanson directed and co-wrote, is a good example of the specialized virtues production designers bring to the table. Hanson has called the film "my most personal movie."[37] He wanted to sustain the picture's period feel by setting the final scene in a motel from the 1940s, and he instructed production designer Jeannine Oppewall to find an appropriate location. But after searching the city for such a place, Oppewall got another idea. "I ended up going back to my first images of L.A. when I got off the plane and drove by the oil fields," she later said. She convinced Hanson to let her build a motel set amid a group of oil derricks, and she lobbied for a building designed in an older style from the one he had initially envisioned. "I wanted a motel that spoke about the first days of motels, the 1920s," she explained.[38] Hanson signed on to Oppewall's idea, and she can take much of the credit for *L.A. Confidential*'s spectacular climax, which features a shoot-out in front of a ramshackle motel set in the shadow of towering oil derricks.

Though *L.A. Confidential* profited from the input of a production designer, in many cases a director's superior understanding of how a film's story will play to audiences can override the integrity of the production designer's decor. Lee Katz, who worked with Michael Curtiz during the 1930s, described an occasion when Curtiz drew on his sense of storytelling technique to override the spatial logic of a production designer's set. "The master shot had a grand piano prominently in the foreground," Katz told journalist Aljean Harmetz. "And when Mike moved

FIGURE 3: The motel set used for the climactic shootout sequence in *L.A. Confidential* (Curtis Hanson, 1997).

into a reverse shot, he said. 'Take out the piano.' And I said, 'Mike, isn't somebody going to say, "Where's the piano?"' And he said, 'Believe me, if anybody asks, Where's the piano? they're not watching the picture.'"[39]

CGI Technicians: Integrating into the Industry

Since the turn of the millennium, visual effects artists have become essential partners for directors of splashy action fare, their work fueled by the wizardry enabled by computer-generated imagery (CGI). As a new entity in Hollywood, however, CGI houses have not yet been comfortably integrated into the industry's labor force; and directors, however well intentioned, may find themselves in the middle of fractious labor disputes. An especially cautionary example of such a situation is Ang Lee's 2012 *Life of Pi*, a production in which team spirit frayed under industry pressures. After months of tough negotiations with Twentieth Century–Fox over the high cost of the 3D visual effects needed to realize this intimate fantasy, Lee hired Rhythm and Hues Studios to create the necessary CGI. In the beginning, all was rosy. R&H visual effects supervisor Bill Westenhofer declared that Lee had initiated the partnership on a positive note by saying, "I look forward to making art with you."[40] But after the film was released, the relationship between Lee and his effects team soured. The CGI industry was, at the time, being squeezed by cutthroat competition over costs, and its workers were saddled with low pay and brutal working hours with no union protection. These conditions forced many companies, including Rhythm and Hues, into bankruptcy. Lee was drawn into the fray when he was quoted as complaining that visual effects for *Pi* were too expensive. Many CGI workers reacted to the situation by staging a protest at the Academy Awards ceremony where the film was to be honored. Lee's reputation among effects artists sank further when he neglected to thank Rhythm and Hues in his Oscar acceptance speech.

Editors: Shaping the Story

From their position at the end of the production process, editors, along with directors, have the best vantage point from which to view a film as a whole and hone the clarity and drama of its storytelling. As William Luhr points out in the second chapter of this book, experienced directors like John Ford and Alfred Hitchcock were able to shoot their films in such a way that editors were left with little flexibility; their pictures were more or less edited in the camera. Others, like Martin Scorsese and Robert Altman, emerge from the shooting stage with massive amounts of film that editors must then wrestle into some sort of coherent shape. On *Nashville*, for example, Altman shot over seventy hours of film for a movie that runs just over two and a half hours.

To make the case that gifted editors can make significant contributions to a film's dramatic impact, one need only look at the career of Francis Ford Coppola. Editor Peter Zinner claims to have come up with the idea for the bravura montage that caps the original *Godfather* film in 1972, a sequence featuring cheat cuts between a christening and a series of gangland hits that creates a breathtaking conclusion to the story.[41] And the director's long-time editor-colleague Walter Murch takes credit for the climactic moment in 1974's *The Conversation*, often considered one of the director's most personal statements. Murch relooped the crucial line, "He'd *kill* us if he got the chance," from the taped conversation that gives the film its name. When the story's protagonist Harry Caul replays his tape after unwittingly enabling a murder, the line's emphasis changes to become "*He'd* kill *us* if he got the chance," suggesting a murder plot in which the speakers are not the victims but the perpetrators. (The audience presumably remains unaware of Murch's cheat; we assume that we, like Harry, have simply misunderstood the original playback.) The shocking impact of this moment gives the story its dramatic center, and the editor created it.[42]

Musicians: Manufacturing the Mood

Virtually all Hollywood films rely heavily on music to provide emotional depth, yet few directors know much about the musician's art. Though most of them know what they like when they hear it and can make constructive suggestions, at times they require schooling. Some directors have become associated with particular musical motifs: John Ford's folksy hymns and traditional country favorites are some of the most recognizable examples, along with the percussive, Wagnerian scores by Bernard Herrmann that animate many Hitchcock thrillers. Steven Spielberg has worked with composer John Williams throughout his career, a collaboration Williams described by saying, "His films are very rhythmical, and it makes it easier for me." Though not a musician himself, Spielberg has a feel for the way the composer's music will work in his films. He sensed, for example, that Williams's uplifting theme in the 1982 release *E.T.* should have a longer melodic

line, which could create a fuller emotional crescendo when the winsome alien ascends to the sky. At other times, however, Williams has been way ahead of his director-partner. For example, when he first played the shark motif in 1975's *Jaws*, which famously relies on the alternation of just two notes, Spielberg said, "You're kidding!" Williams responded, "You've made a very primal movie and you need primal music."[43] Spielberg, a quick study, got the point.

A Privileged Few: Directors and Diversity

Directing in Hollywood has long been a bastion of white male privilege. Despite the strides made by the civil rights and feminist movements on other fronts, the percentage of studio films overseen by female or minority directors has remained stalled in the single digits.[44] One kind of explanation for this imbalance looks to the nature of the business, with its high stakes and high risks, factors that encourage clubbiness and insularity.

A 1987 study by sociologists Robert R. Faulkner and Andy B. Anderson investigated the way in which the movie trade works by analyzing 2,430 films released by major studios between 1965 and 1980. They describe Hollywood as a uniquely high-risk industry: "The distinctiveness of this business seems to be in the completeness with which each film production is a separate and distinct commodity moving out into an uncertain market."[45] In the modern era of blockbusters the stakes have only increased. As a result, the hiring process relies on the tried and true. "The film community . . . is dominated by an active elite," Faulkner and Anderson observe.[46] They point to "a sharp separation between the elite (or 'winners') and the great mass of 'non-winners' on the periphery."[47] The short list of *who* is hired is a function of *how* they are hired. An Equal Employment Opportunity Commission investigation of Hollywood during the 1960s found "an overdependence on word-of-mouth recruitment."[48] And word-of-mouth favors the in-group made up of people like those who are already in power and others like them. For example, Stephen Spielberg claimed he chose Colin Trevorrow to direct *Jurassic World* because the younger man made him think of himself as he was years before.[49]

And it is not just the industry as a whole that bears responsibility; specific institutions within it have perpetuated the problem. After several decades of ineffectual initiatives consisting of diversity mixers, reports, and training programs, the Directors Guild stepped up to the plate itself in the twenty-first century by honoring diversity within its own ranks. Though the DGA had awarded prizes to female and minority directors of commercials and TV shows since 1984 and had presented a special award to Oscar Micheaux on the occasion of its fiftieth anniversary celebration in 1986, it was not until 2000 that the organization fully embraced diversity by awarding a Best Feature Film Director accolade

to a minority member (Ang Lee for *Crouching Tiger, Hidden Dragon*). In 2010 directorial honors in the feature film category went for the first time to a woman (Kathryn Bigelow for *The Hurt Locker*), and in 2013 Alfonzo Cuarón, the director of *Gravity*, was the first Latino to win the top prize. In 2002 the group elected its first female president, Martha Coolidge; and in 2013 the openly gay African American TV director Paris Barklay became the Guild's first minority president.

A close look at the evidence suggests that the daunting odds facing women and minority candidates attempting to break through Hollywood's glass ceiling for directors can be bucked. As Daniel Langford documents in the fourth chapter of this volume, in the 1970s Hollywood beat the bushes to find African American directors who could make pictures that spoke to audiences in inner-city neighborhoods throughout the nation who had been energized by the civil rights movement of the previous decade. And in the twenty-first century three Mexican directors, Alejandro Gonzales Iñárritu, Alfonzo Cuarón, and Guillermo del Toro, broke into Hollywood's A-list. They formed their own club, known as "The Three Amigos," to support and encourage one another.

Chapter Organization and Focus

Each of the following chapters features a different focus and approach, but all use primary research to cast new perspectives on the place and practice of Hollywood directors during various historical periods. Conditions within the industry and the culture at large form the background against which the achievements of selected directors are analyzed. In the book's first chapter Charlie Keil examines the key part Cecil B. DeMille played in defining the directorial role in early Hollywood. William Luhr contrasts two major figures of classical Hollywood—John Ford and Orson Welles—in the second chapter, showing that even in an era when the movie business was at its most stable, two very different directorial talents could exist, each with a distinctive relationship with the industry that supported him. In the third chapter Sarah Kozloff looks at the trend toward independent production, which gained steam after the Second World War, analyzing the effect it had on two Hollywood directors of the day, Nicholas Ray and Ida Lupino. Next, Daniel Langford's chapter on the auteur renaissance of the 1970s describes the ways in which the industry briefly encouraged personal films mounted by director-driven production companies and opened its doors to black directors, but then quickly abandoned these experiments. In the fifth chapter Thomas Schatz documents the range of practices in the New Hollywood by tracing the progress of three very different productions, Tim Burton's *Batman*, Steven Soderbergh's *sex, lies, and videotape*, and Spike Lee's *Do the Right Thing*, all released in the summer of 1989. Finally, J. D. Connor examines the effects of digital moviemaking and modern marketing on Hollywood directors in the new millennium.

As the volume as a whole documents, the concept of movie directors as singular creators outside of history, institutions, and culture oversimplifies the realities of Hollywood filmmaking. Directors are more than a series of stylistic tropes or libidinous signatures; they are also active agents. Their creative goals are affected by the industry they work in and the guild that represents them, and they pursue these goals in concert with a diverse array of colleagues. The book argues for greater attention to the details of production and the complicated, fraught process Hollywood moviemaking typically involves. Together with other volumes in the Behind the Silver Screen series, it brings forward the way in which our film heritage has been enriched by the partnerships into which directors have entered with members of their creative teams. Theories about the collaborative process and of the nature of institutional cultures can provide models that can frame such approaches with illuminating conceptual frameworks. What follows offers groundwork for scholars developing theories of this type. We will understand the achievements of Hollywood directors better as a result.

1

THE SILENT SCREEN, 1895–1927

Cecil B. DeMille Shapes the Director's Role Charlie Keil

When Cecil B. DeMille directed his first film, *The Squaw Man*, in 1913, the American film industry was at a turning point, marked by the convergence of a number of significant developments, among them the advent of the feature film, the shift to West Coast production, and attendant changes to the organizational processes governing how movies were made. Nineteen thirteen was also the year that D. W. Griffith ran an advertisement in the *New York Dramatic Mirror*, trumpeting his indelible contributions to cinema by declaring himself responsible for "revolutionizing Motion Picture drama and founding the modern technique of the art."[1] Griffith made a case for his status as the preeminent film artist in the United States by staking out the terrain of cinematic style and laying claim to every device imaginable, from the close-up to crosscutting. Moreover, Griffith asserted his singular achievements by arguing that all of the innovations that he had introduced were "now generally followed by the most advanced producers."[2]

I dwell on Griffith's self-promotional advertisement not to make a case for his uncontestable mastery of the medium by 1913, nor even to suggest that the

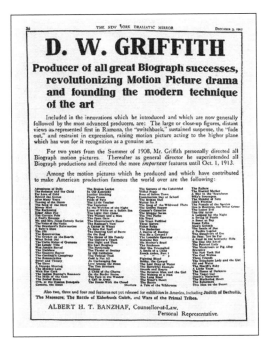

THE NEW YORK DRAMATIC MIRROR DECEMBER 3, 1913

D. W. GRIFFITH

Producer of all great Biograph successes, revolutionizing Motion Picture drama and founding the modern technique of the art

Included in the innovations which he introduced and which are now generally followed by the most advanced producers, are: The large or close-up figures, distant views as represented first in Ramona, the "switchback," sustained suspense, the "fade out," and restraint in expression, raising motion picture acting to the higher plane which has won for it recognition as a genuine art.

For two years from the Summer of 1908, Mr. Griffith personally directed all Biograph motion pictures. Thereafter as general director he superintended all Biograph productions and directed the more *important* features until Oct. 1, 1913.

Among the motion pictures which he produced and which have contributed to make American production famous the world over are the following:

Also two, three and four reel features not yet released for exhibition in America, including Judith of Bethulia, The Massacre, The Battle of Elderbush Gulch, and Wars of the Primal Tribes.

ALBERT H. T. BANZHAF, Counsellor-at-Law,
Personal Representative.

FIGURE 4: The 1913 *New York Dramatic Mirror* advertisement that publicly established D. W. Griffith's credentials as a director of motion pictures.

ad helped cement his status as the most famous filmmaker at work in the American film industry, though he may well have been so. Instead, I enlist this document to reinforce the idea that 1913 was a pivotal time for both the institutionalization of cinema and, consequently, the successful marketing of the idea of the director function. In other words, Griffith's attempt to define himself as a film artist would scarcely have had any traction had that effort not possessed some value within the burgeoning industry at this time. (To verify this conclusion, one need only point out that up to this moment Griffith had remained unidentified by his former employer, Biograph, and that the ad operated as a way for Griffith to set his market value when selling his talent to the next company interested in hiring him.)

In 1913, then, Griffith was not only attempting to secure his authorial legend, he was also helping to define the terms by which the still rather nebulous position of film director might be understood. (One should note, for example, that the ad tends to use the verbs "directing" and "producing" almost interchangeably.) For its maximal utility, the potential of the position had to be registered by both the film industry and moviegoing public alike, so the Griffith ad operates as a form of tutelage, no matter how self-serving. Soon enough, the industry itself would also influence how the public might perceive the director function, at the same time that it would set more firmly the parameters for the roles that directors would perform within developing studio practices. Coincident with the move to the West Coast and the wide-scale manufacturing of features, the industry progressively embraced a production model dependent on the rationalization of labor; concurrently, individual companies gained increased power and public recognition through enhanced levels of publicity and promotion, of both film texts and contracted personnel.

If Griffith established a particular template for defining the director in his *Mirror* advertisement, one predicated on innovation and influence, it proved less

of a signpost for the industry as a whole than its singularity at the moment of 1913 might suggest. The molding of the director function occurred as it was put into practice by the budding studio system, and that process did not rest within the control of a maverick like Griffith. The director function operated as part of a more expansive corporate strategy, in much the same way that the director as worker had to operate within the broader machinations of the nascent studios. No individual director of the 1910s could possess sufficient power to shape how studios came to define the role.

But here is where Cecil B. DeMille, the figure whose directorial debut served as the starting point of this chapter, reenters the narrative. For a variety of reasons, DeMille, who quickly established himself as both an artistic *and* commercial success by the mid-teens, crafted a career that serves as a more likely model for the usefulness of the director function to the industry. Most obviously, DeMille's facility in wedding melodramatic narrative formulae to a self-consciously inventive approach to lighting, staging, and editing seemingly demonstrated how a director could be an artistic benefit to a studio without the concomitant burden of becoming an economic liability. By emerging as a stylistically distinctive but profitable director, DeMille helped demonstrate the salability of the director function for an industry embracing new methods of production and distribution during the 1910s. As Gaylyn Studlar has observed, DeMille was gathering steam just as studios were "economically motivated to look for means [beyond stars] of securing the loyalty of motion-picture audiences . . . and audience expectations of a predictably enjoyable moviegoing experience depended upon [a] director establishing a solid record of favorably received films."[3]

DeMille's status as a crucial figure in our understanding of the film industry's moves to define the director function during the 1910s extends beyond his mere marketability. Even more important may be his role as a studio executive during this period. Heading the Hollywood branch of Famous Players–Lasky for the first half-dozen years of his career, DeMille had to balance running a fledgling studio with the effort to define himself as an identifiable director in the public's mind. Arguably, this experience helped to clarify for DeMille what the role of a director could be at the very time that the parameters of this vital creative position were still in formation. The years prior to 1913 represent a period where the director slowly gained prominence within the production process; DeMille's seminal experiences as a hyphenate studio-executive/director in the mid- to late 1910s demonstrate how the studios embraced the director function as part of a broader strategy of industrial expansion. Moreover, DeMille himself came to recognize how he might exploit the role for his *own* career advancement. Cecil B. DeMille proved integral to the hierarchical conception of the director function that was devised during the 1910s, a conception that became as stratified as the star system that emerged at the same time.

Early American Cinema and the Shifting Role of the Director

Changing conceptions of the director function are directly tied to evolving modes of production within the early American film industry. During the years that I have labeled the transitional period (from 1907 to 1913), effective story-telling became the primary goal of film producers; ultimately, the focus on intelligible stories, conveyed in a manner that would keep an audience involved in the narrative, put additional onus on the screenplay and the role of the director in translating that script to screen.[4] Prior to 1907, an emphasis on the camera operator's centrality to the production process had meant that the role of the director (such as it existed) received significantly less attention. Accordingly, the director function was often subsumed within the responsibilities of the camera operator. Whether one subscribes to the "cameraman system" model of production described by Janet Staiger or the "collaborative system" preferred by Charles Musser,[5] one comes to the conclusion that directors did not consistently perform a clearly demarcated role within producing practices used for fiction filmmaking in the pre-1907 period. Typically the camera operator assumed primacy in the filming situation, not only controlling all the technological aspects (including lens choice and camera positioning), but also staging and coaching the actors. If, within the collaborative system, duties were not simply shared but split, one of the collaborators might well assume the responsibilities commonly associated with a theatrical director, leaving other, more technical tasks for his counterpart; this arrangement, according to Musser, typified the films made at Edison by George S. Fleming (an actor and scenic designer) and Edwin S. Porter (a cameraman).[6] Tellingly, Porter is the figure now identified as the "director" of the films that the pair made for the company, indicating that the cameraman remained the dominant creative figure for films produced before 1907.

Staiger and Musser also differ in their respective preferred typologies for production systems employed after 1907, with Staiger opting for "the director system" to name the method adopted in 1907–1909, and then "the director-unit system" for that prevalent until 1914.[7] Musser, on the other hand, argues that a "central producer system"—which Staiger says did not become dominant until 1914— came into use as early as 1907.[8] Staiger's choice of the term "director system" is telling, as it signals the ascendancy of the director in the production hierarchy, though she concedes that "the terms 'producer' and 'director' were even used synonymously."[9] Staiger stresses that the role of the film director was patterned after that of the stage director, a function that had emerged within the context of modern theater in the 1870s. Such a model seemed appropriate for American cinema as it embraced narrative, and, as Staiger points out, many of the film directors who would gain prominence over the next few years, Griffith, Sidney Olcott, and Herbert Brenon among them, came from the stage, though usually their training had been in acting. In the director system, the director oversaw all

stages of a film's production (and even postproduction), with most distinct tasks (such as cinematography, set construction, and scenario writing) undertaken by designated craftspeople under the explicit supervision of the director.

What both Staiger and Musser identify as the need for more product (demand coming from the rapidly expanding exhibition sector) hastened the introduction of new production systems that accorded the director more authority within an increasingly hierarchical division of labor. And despite their use of different terminology, they concur that, to use Musser's words, "the process of reorganization favored the increased authority of the director . . . [as] areas of directorial responsibility were expanding."[10] As Musser points out, the director function was best positioned to make optimal use of the stock companies of actors that most manufacturers were now establishing to meet the increased production rates. With scenarios gravitating progressively toward character-centered narratives, the contributions of the actor gained more importance. And, as the figure responsible for the actors' performances, the director moved into a position of prominence within the production chain of command.

Directors enjoyed varying degrees of autonomy during this transitional period, as companies vied to make compelling story films that would please audiences and convince exhibitors of the value of a specific company's output. While the production process was becoming increasingly hierarchical, the controlling influence of a central producer varied from studio to studio and from one shooting situation to the next. At Biograph, Griffith functioned as both producer and director, which meant that he could oversee the editing of his films, whereas directors at other companies (such as Edison) ceded that responsibility to a supervising producer. Despite the indisputably important role that the director performed within the production process, few companies afforded the director the near-complete autonomy that Griffith enjoyed (precisely because few directors also functioned as producers for their companies). Instead, the development of a central-producer model meant that directors would perform circumscribed tasks within a broader system of production. Tellingly, they remained anonymous workers for the majority of the transitional period; with most films from these years lacking credits, few clues exist as to the identity of the directors, let alone their respective contributions.

The very anonymity of so many directors during the transitional period raises intriguing questions about how one attributes any associated authorial properties of the director function to seemingly "unauthored texts."[11] Griffith has become a privileged figure within histories of stylistic development during this period in large part because we know which films he directed. (Beyond that, nearly all of his films from the era have been preserved.) What Tom Gunning has defined as the "narrator system"—a type of visual discourse devised to maximize the effective representation of the dramatic situations at the core of this period's scenarios—can certainly be linked to Griffith's distinctive achievements in editing,

framing, cultivating strong performances, and other aspects of film style. But Gunning also allows that the narrator system is a byproduct of the newfound and expanded powers of the director during the transitional period: "With Griffith, and most likely other film directors around the same time, the director was no longer an independent expert working with actors and then relying on the cameraman's expertise for visualization."[12] Arguably, then, any director at this time could have taken the opportunity to capitalize on the changing production circumstances to develop his or her own version of a narrator system. Conversely, a strong central producer could curb any such tendencies toward eccentricity or overly self-conscious deployment of style, or point directors toward a deployment of stylistic means similar to that already established at the production company in order to create a definable house style.

The transitional years operate as a fascinating and turbulent period in the emergence of the director function: on the one hand, the director had assumed the preeminent role during the production process, and took on this position of creative importance precisely at the moment that storytelling norms were changing at a rapid rate; on the other, companies exercised significant control over the final product, and the conditions of filming imposed short shooting schedules and substandard scenarios on directors who often had little training. While the trade press encouraged production companies to be innovative and build their own brand by devising "new and original tricks,"[13] many directors found it difficult to integrate all of the skills necessary to translate a script into a compelling exercise in storytelling. Imitation was often the order of the day, as Allan Dwan confessed when recalling his early career at the American Film Manufacturing Company: "I had to learn from the screen. I had no other model. We picked up and manufactured what technique we could, watched the other fellow."[14] The results could be underwhelming, particularly at fledgling companies whose directors lacked experience. When Mary Pickford was sued by the Independent Moving Picture Company (IMP) for trying to defect to rival Majestic in 1911, she defended her decision to breach her contract with IMP by claiming that its stable of directors was substandard:

> Repeatedly during the term of my employment, I spoke to Mr. Laemmle, the President of the plaintiff company, with reference to the poor quality and directorship of the pictures in which I appeared. I called his attention to the fact that Mr. Clifford, Mr. Ince, Mr. Grandon and others who directed pictures in which I appeared had never directed moving pictures before, and that the result was that pictures of a poor quality were produced. Mr. Laemmle agreed with me that the pictures were not up to the highest standard and that the directorship should be improved, but nothing was done except to supplant one director with another, and no competent director was ever placed in charge.[15]

As the feature era loomed, some of the central struggles concerning the direc-
tor function came into sharper relief. The quality of the direction was paramount
insofar as it would translate into the effective visualization of story ideas. Qual-
ified and experienced directors were preferred over neophytes, but only if the
trained director could offer a strong command of storytelling. Motion picture
production companies continued to exert control over the filmmaking process,
using departmentalized labor organized according to the efficiency principles
of Taylorism, and assigning projects, budgets, stars, and running time limits to
directors in advance. Artistic ambition was valued, but only insofar as it aligned
itself with the financial prerogatives of the company. It is within this industrial
context that Cecil B. DeMille emerged as probably the most successful cultivator
of the director function that the American film industry had yet witnessed.

Cecil B. DeMille, the "Director General" of Famous Players–Lasky

Cecil B. DeMille, like many early silent film directors, began his career in the
theater. He encountered Jesse Lasky when Lasky was pursuing his own stage
endeavors, and the two formed an alliance. Cecil was born into a family that
fully embraced the theater: his father, Henry, had become a playwright after
abandoning his career as a schoolteacher, and both Henry and his wife, Beatrice,
embarked on summer tours as actors when their children were young.[16] In 1886,
Henry's second produced play, *The Main Line*, was directed by David Belasco,
whose career was gaining momentum at this point. Belasco's command of stage
mechanics emphasized the spectacular dimensions of Henry de Mille's[17] text, and
the relative success of *The Main Line* led to an ongoing collaboration between the
two men. Belasco would remain an important figure for the de Mille family, even
after Henry's sudden death from typhoid in 1893. Despite their father's express
wish to the contrary, and with their mother's assistance, both Cecil and his older
brother William began to work in the theater early in adulthood. Cecil started
picking up acting jobs in 1900, at the age of eighteen, while William's immersion
in playwriting around the same time resulted in his first produced full-length
work, *Strongheart*, five years later. The brothers occasionally collaborated on
writing plays, but William first experienced significant success on his own, par-
ticularly with the Belasco-directed *The Warrens of Virginia*, which debuted in
1907. Cecil was cast as the female protagonist's brother, sharing the stage with
a young Mary Pickford. His sustained involvement with Belasco would prove
influential on his subsequent efforts as a film director.

In his autobiography, Cecil recounted a subsequent experience with Belasco,
when the showman commissioned a play from the budding writer in 1910, only
to take the credit for its creation himself once he had reworked it extensively in
rehearsals. Though chastened by the betrayal, and angered to the point that he

FIGURE 5: A publicity photograph, circa 1916, of executives from the Famous Players–Lasky Corporation. From left: Jesse Lasky, Adolph Zukor, Samuel Goldwyn, Cecil B. DeMille, and Al Kaufman. Note that even at this early date, DeMille had adopted his director costume of open-necked white shirt and jodhpurs.

leaked the story to the newspapers, Cecil refrained from taking legal action; in fact, as he pointed out, "I never worked with Belasco again, but when he was ready to sell the motion picture rights to his plays, it was to our company that he entrusted them."[18] Retreating to the position of general manager of his mother's production company, Cecil found himself commissioned to write the book for a one-act comic operetta that Jesse Lasky, a vaudeville impresario, was preparing for production. The success of that work, entitled *California*, led the men to work together on two more similar confections.[19] In 1912, Lasky proposed that Cecil join him and Lasky's brother-in-law, Samuel Goldfish (later Goldwyn), a glove salesman, in a moviemaking venture. Together with Arthur Friend, the four formed the Jesse L. Lasky Feature Play Company, a business arrangement that initiated DeMille's career in motion pictures.

The Jesse L. Lasky Feature Play Company, which originated in New York, was an early American attempt to cultivate the growing audience interest in feature films; DeMille got in at the ground level, making his directorial debut with a feature, *The Squaw Man*, at a time when one-reelers were still dominant, and filming in Hollywood when the East Coast was still the center of production. In fact, the Lasky Company established its secondary base of operations in Southern California with the shooting of *The Squaw Man* in Hollywood. Within a few years, the Lasky Company would be enfolded as a prestige brand

within Famous Players, a larger concern headed by the enterprising Adolph Zukor.[20] By the time of the merger, the Lasky Company had expanded its physical plant in California several times over and DeMille was ensconced as the head of West Coast production. With the formation of Famous Players–Lasky in 1916, DeMille formalized his role within the new organization via a contract that allowed him an annual salary of $52,000 and the option to produce one big picture per year.[21]

DeMille's title proves of particular interest—he was designated director general. Unlike the more prosaic labels for the positions held by other high-ranking executives, such as president Adolph Zukor and vice president Jesse Lasky, DeMille's implies a managerial role while also acknowledging his status as a film director. DeMille's insistence that he be allowed to make one special (i.e., big-budgeted) film per year underscores the fact that he remained attached to his status as a director *and* that public recognition of his name would derive from the high-profile films he helmed. But within the Famous Players–Lasky corporation, DeMille's influence was tied primarily to the managerial clout he exercised in running the West Coast studios.

As executives who functioned as high-level production managers, Lasky and DeMille were heavily involved in the creative processes central to studio filmmaking and often commented on the role of directors. From their correspondence, we can detect three principal ways in which the director function was conceived: as a measurement of resource allocation; as a role in the production process distinct from the writing function; and as an asset in itself when it came to matters of staging or some other demonstration of artistic distinctiveness. I take up each of these factors in turn, indicating how each conveys a sense of the way in which the director function might contribute to the proper operations of the studio.

If we keep in mind the chief concerns of Famous Players–Lasky during the 1916–1919 period—ensuring a steady supply of feature-length films that would garner the good will of exhibitors—we can see that the company aimed to achieve its goals through timely delivery of product that met a certain standard of quality. Meeting these goals was dependent on the director function assuming its requisite role within the production process. As Zukor succinctly put it in a telegram from 1917: "Assure DeMille and others if pictures made at coast will be good [in] story as well as production our proposition will loom up even beyond our wildest expectation."[22]

As Famous Players–Lasky ramped up production, the company became more mindful of efficiency, both to ensure that delivery schedules were met, and to fully realize the return made on the investment in stars. Lost time translated into squandered salaries, as Lasky pointed out in 1916 when he told DeMille that a director's inability to stay on schedule damaged the company's profit margin, "with Pickford costing us $1666.66 for each week day."[23] An unsigned letter

written around this time to M. E. Hoffman, the general manager of the West Coast studio, elaborated on how proper deployment of the director function could maximize the yield from a star: "You will see by her contract that Fannie Ward is guaranteed 47 weeks, therefore it is our intention to work her as hard as possible. In other words we will try to get well ahead in her scenarios so that the director who shoots her pictures can go right from one to the other with as little delay as possible."[24]

At this point the Hollywood studio employed five directors in addition to DeMille. DeMille himself was to be "occupied principally with special productions."[25] Just three months later, Lasky advised DeMille that the studio would need to "work 7 and sometimes 8 directors, not including yourself, all winter at the Hollywood studios. I asked Arthur [Friend, the company's treasurer] to explain this to you before he left for the west and he tells me that you will have to enlarge the studio generally to accommodate this number of directors."[26] Production was tied to directors, who set the pace as a measurement of time to be spent and funds allocated. As Goldwyn's wife, Blanche Lasky, who was charged with overseeing screenwriting on the East Coast, cautioned, "We all must realize that a scenario that takes six weeks to write is too expensive, under present conditions, and would require a tremendous department if we are to keep up with the directors."[27]

Though Famous Players–Lasky wasn't employing a unit production model per se, it was conceiving of its productivity in terms of measurable director activity. Observing how the recently acquired Bosworth plant operated, Lasky remarked that Bosworth had "a system for working two directors alternately on a star, [allowing] a director 18 days to shoot a picture and 18 days lay-off to cut and prepare for his next picture. The second director starts immediately after the first director finishes shooting and works during the time that the first director is laying off."[28] Not only were directors responsible for containing costs through maintaining schedules; they were also meant to manage the postproduction process so that films didn't exceed a set running time. Observing these limits was necessary to prevent exhibitors from having to handle unwieldy and overly long programs. But, as Lasky pointed out, the cost of film stock was also an issue. "[Once] the directors have pledged themselves not to deliver pictures for a final OK until they are down to the required length," he wrote, "[the company] will save between $200,000 and $300,000 per year on positive stock alone."[29]

As much as the director function served as a mechanism for tracking the rate of production, and, by extension, rationalizing the allocation of company resources, it was also meant to designate a stage in the production process that logically followed the preparation of the scenario. Supplying a reliable number of story synopses that would then be translated into workable continuities was Famous Players–Lasky's single biggest challenge during the late 1910s, if the volume of

correspondence devoted to the topic is any indication. Lasky concedes that the director can have input into the process, but only at the final stage: "When the scenario is completed, the continuity writer will read it with the director and take the director's ideas. Whenever he can get good material out of the director's ideas he will incorporate them into the scenario and in a word get the best possible out of the story through the co-operation of the Continuity writer and the director."[30]

The clearly delineated functions of director and continuity writer had to be kept separate to ensure the unimpeded channeling of material from scenario to finished film. DeMille and Lasky exchanged several letters concerning this topic when Cecil's brother William attempted to subvert the system by serving as a writer while also directing. Lasky expresses his dissatisfaction by pointing out that "we would have preferred that Billy fit into the studio the same as our other directors."[31] Cecil, for his part, indicates the limitations that the director function could impose on someone with writerly aspirations when he says of William: "So long as we are paying for his brains, let us use them to get as much out of them as possible, and not simply because he is a director, refuse to utilize his highest quality, which is that of an author."[32] Whether to be the author of a film was to be its director or its writer, DeMille does not say, but he is clear that the stylistic contributions of a talented director can elevate a weak scenario. In response to a memo from the New York office criticizing the West Coast production of a film entitled *The American Consul*, DeMille reminds Jesse Lasky that "you stated that when a director complained about their scenarios, you made them shoot them anyway, so I gave instructions to take this scenario and shoot it, getting me a picture of some kind. The result, under the circumstances, was much better than I had even expected, although not, of course, a good picture."[33]

What, then, did a director do and what made one worthy of retaining, while another should be let go? DeMille, who dismissed two directors in early 1917, says this of one of them: "He has no imagination at all, and to my mind, all his work lacks that most important quality."[34] "That most important quality" is almost never defined, but directors are occasionally singled out as not possessing "it": Blanche Lasky says that a new director, "Mr. Hopper," "is not a good enough director for us, I think the way he handled his mobs and the fights showed him to be not of our class."[35] Jesse Lasky identifies the director of *Each to His Kind*, Edward Le Saint, as one "who did not begin to take advantage of the opportunities which the story afforded";[36] another memo states that the director of *The American Consul*, Rollin Sturgeon, "may have been a bad director—and probably is."[37]

Conversely, the directors who have "it," such as Jack Noble from Metro and Donald Crisp (of whom Lasky simply writes "Don't lose him"),[38] can command a premium price: in October 1916, Lasky says with frustration that he has interviewed over fifteen directors, trying to supply the West Coast studio with directors to replace those who have been let go because of deficiencies or who

jumped to another company due to a better offer. Lasky notes that even some of the interviewees that he passed on "were asking as high as $650 and more a week."[39] Apparently DeMille had raised concerns about the wisdom of giving a new director a contract in excess of $400 a week within the first year, as that would mean having to raise the salary of all directors under the studio's employ. But Lasky insists that the company "must, at any cost within reason secure the best stars and best directors," indicating with that statement that these two groups of employees are the most prized within the studio's labor pool.[40] Certainly Famous Players–Lasky's salary records from March 1918 confirm as much: the highest-priced star, Wallace Reid, commands $400 per week, a rate on par with the average paid to a director.[41] But Lasky rationalizes the inflated pay scale by telling DeMille that "you can see the importance of our having the best directors in the business, because you and I both know that good stories can be ruined by poor directors and that on the other hand—poor stories can be greatly helped by real [sic] good directors."[42]

During the period of unbridled growth that Famous Players–Lasky underwent during the 1910s, the studio faced an ongoing challenge in its efforts to balance the three aspects of the director function: efficiency, coordination of the production process, and demonstration of evident artistry. As much as the company relied on directors to maintain shooting schedules and thus contribute to a process of cost containment, it also paid the best of them at a premium and allowed them special shooting conditions. DeMille, for his part, often went considerably over budget and submitted films that exceeded the prescribed length that exhibitors preferred for features. By 1917, exhibitors were pressuring Famous Players–Lasky to keep the length of features at 4,500 feet. Griffith, now releasing features through Artcraft, a Famous Players-Lasky subsidiary, was allowed to go up to 6,500 feet, a measure of his status as a marquee name that announced artistic quality. But DeMille was encouraged to keep his at 5,100.[43]

The battle between art and commerce was often waged explicitly when the payment of directors was the subject of debate. Depending on his outlook, Lasky might opt for talent over savings ("When you wire me to engage a director, I can feel that the main thing to consider is his ability first and his salary second")[44] or, conversely, declare the need for economizing over all else ("While you may not agree with me, my slogan is 'Dividends first and art second'").[45] Ultimately, Famous Players–Lasky valued talent because it helped to differentiate their productions from those of their rivals; even so, the cost of product differentiation had to be kept within company bounds: "Now while we must maintain the standard of Lasky pictures and absolutely must bring the Famous pictures up to the high Lasky standard, the productions from both studios will somehow have to be produced within a given cost and a given time or the dividends which we expect to pay will not be forthcoming and we will have a big reputation but not be a financial success."[46]

The DeMille Method: Collaborators and Conceits

DeMille exercised control over the defining of the director function while learning how to become adept at the craft of directing himself. His earliest features helped him gain facility with the novel techniques of filmmaking. Arguably, he didn't fully establish himself as a distinctive director until his seventeenth feature, *The Cheat*, released at the end of 1915.[47] But his prodigious rate of production during the two-year period leading up to *The Cheat* explains how he became such an assured director so quickly: most of these early features were shot within two or three weeks, typically at a cost of under $20,000.[48]

During these years, DeMille built up longstanding working relationships with collaborators who would help define his visual style and devise his favored narrative formulae. Cinematographer Alvyn Wyckoff and art director Wilfred Buckland were with DeMille very early on, Wyckoff shooting DeMille's second feature and Buckland coming in on his third. Both would be instrumental in helping create the distinctive form of lighting for which DeMille became famous. Jeanie Macpherson, who would prove to be DeMille's most dependable screenwriter during the silent era, began collaborating on scripts with his tenth feature, *The Captive*, in early 1915, while Anne Bauchens, who began her career as William's secretary, started editing Cecil's productions with *We Can't Have Everything* in 1918, and worked on every silent film thereafter. Though some of these partnerships derived partly from the collaborators being contracted to Famous Players–Lasky, for the most part their connection to DeMille remained strong throughout their careers. While Buckland and Wyckoff ceased working regularly with the director by the mid-1920s, Macpherson and Bauchens both maintained their professional alliances into the sound period. Bauchens, for example, continued to be DeMille's chief editor for nearly forty years, working with him until his death.

Biographers have pointed to DeMille's close circle of female coworkers, which included not only Macpherson and Bauchens, but also his personal assistant, Gladys Rosson, and Julia Faye, an actress who appeared in a great number of DeMille's films from 1918 onward. Some, like Scott Eyman, refer to this group as DeMille's "harem," a term that discounts their contributions to the collaborative process of filmmaking by emphasizing the director's hold over them, and the sexual relationships he was assumed to have had with each woman, save Bauchens.[49] Such loaded terms only work to reinforce the mythology of DeMille as a monomaniacal and controlling auteur, rather than a figure whose career was shaped and facilitated by strong women, his mother chief among them, from the outset. DeMille's powerful position within the industry ensured that he could have his choice of coworker, so we needn't assume that just because he was having a long-term affair with Macpherson, for example, that he did not recognize the importance of her input into the many screenplays that she supplied for his films.

Recent feminist scholarship has worked to carve out recognition for Macpherson's estimable achievements, and give proper attention to the woman who "was an authentic source of inspiration, and a protagonist in DeMille's rise from a mere promise in a fledgling industry to a widely acclaimed cultural phenomenon."[50]

DeMille's collaborators brought with them their own training and skills; when enlisted in the service of the director's features, the collective craft expertise helped distinguish DeMille's output from those of his competitors. Tellingly, DeMille claimed in his autobiography to have been influenced by David Belasco's "method of work," which depended upon working in close collaboration with others: "Belasco had surrounded himself with a permanent staff, as loyal as they were efficient. He depended upon them more, probably, than he knew."[51] One key member of the Belasco team was his set designer Wilfred Buckland, who had known DeMille from their days together in the American Academy of Dramatic Arts. According to DeMille's autobiography, the director's mother advised him to bring Buckland to Hollywood, a move trumpeted in the pages of *Moving Picture World* in 1914.[52] Buckland's facility with light placement, in combination with Alvin Wyckoff's openness to experimentation, resulted in a series of films that received critical approval for their development of "Lasky lighting," also known as "Rembrandt lighting" because of its sensitivity to the play of light and shadow.

Though filmmakers had been developing innovative lighting effects for many years before the advent of Lasky lighting, its appearance in a series of early DeMille features garnered particular critical attention, through a combination of Lasky's promotional acumen, the artistic aspirations of the Lasky-DeMille productions, and the prestige that came with the Belasco pedigree. Even so, as Lea Jacobs has pointed out, the actual creation of the lighting effects in DeMille's features owes little to Belasco's techniques, despite the presence of Buckland. The technology required to produce such effects on stage could not be replicated in a filming situation. In studying DeMille's approach, Jacobs concludes that he "used both spotlights and standing floodlights. . . . It is perhaps best to define Lasky lighting not in terms of the source employed but rather its visual effects—confined and shallow areas of illumination, sharp-edged shadows, and a palpable sense of the directionality of light."[53] Certainly, reviewers of the day took notice and pushed the association with the technique of the Old Masters, as did Stephen Bush when he extolled the virtues of Lasky lighting with regard to *The Golden Chance*: "Never before have lighting effects, i.e. the skillful play with light and shade, been used to such marvelous advantage. . . . If paintings in a Rembrandt gallery or a set of Titians and Tintorettos were to come to life suddenly and were then mysteriously transferred to the moving picture screen the effect could not have been more startling than it was."[54]

The high-art associations conferred upon Lasky lighting were part of a broader campaign to establish the Lasky company, and DeMille in particular, as aspiring to create accessible film artistry. As Sumiko Higashi has astutely

shown, Cecil B. DeMille's background in theater, and his past relationship with David Belasco, were essential components of the Lasky company's initial claims to cultural legitimacy. If DeMille was part of a broader push to render the cinema culturally acceptable by borrowing personnel from middlebrow theater, such a strategy was merely a first move toward the long-range goal of proving film could be an art form on its own terms. According to Higashi, DeMille was a "beneficiary of the cultural legacy established by his father and brother as well-known playwrights [and he] quickly attempted to validate his authorship in a related new medium."[55] That process of validation developed in part through the Lasky publicity machine, but one can also attribute its success to the films DeMille made in the first decade of his career.[56]

From Artist to Entertainer

We can gain some insight into the aesthetic dimension of the director function if we trace DeMille's evolution from celebrated innovator to more predictable commercial entertainer by looking more closely at two important films he made during the 1910s. *The Cheat* (1915), one of DeMille's best-known silent features, was arguably the film that did the most to establish his early reputation as a director of artistic ambition. The film was a sensation in Europe and, according to Lenny Borger, impressed and influenced figures from the French avant-garde, including Louis Delluc and Marcel L'Herbier.[57] *The Cheat* represented DeMille's most successful fusion to date of atmospheric lighting effects, large-scale crowd scenes, and a mise-en-scène devoted to the trappings of the monied set. The latter aspect would soon become a hallmark of DeMille's work and earn him the implicitly dismissive titles of the Great Showman and the Master of Spectacle.[58] But at the time of *The Cheat*, the cost of spectacle had not yet become excessive: the film's budget is on par with most of DeMille's films from this period, and significantly less than the two made with opera singer Geraldine Farrar earlier the same year. (*Joan the Woman*, another Farrar vehicle produced the following year, would cost over ten times as much as *The Cheat*, and represented DeMille's first big-budgeted epic.) With *The Cheat*, DeMille certainly tapped into viewer fascination with desirable luxury items, compellingly displayed, but he offset the lure of such commodities by enfolding them in a narrative expressing ambivalence about consumerism; this ambivalence would largely be abandoned as the budgets of his films ballooned.

The Cheat is significant as much for its formal achievements as for its odious gender and racial politics. Much like another landmark film of 1915, *The Birth of a Nation*, *The Cheat* puts its deft deployment of lighting and editing at the service of a rabid racism, becoming in the process a film that evinces an ugly effectiveness. Nowhere is this more apparent than in the celebrated scene where

the Japanese businessman Hishuru Tori (Sessue Hayakawa) brands the married socialite Edith Hardy (Fanny Ward) as punishment for her indebtedness to him. Many commentators have read the branding scene as a symbolic rape, and the sinister and sexualized dimensions of the act are intensified by DeMille's use of shadow and tinting to highlight its exoticized violence. Moreover, as Lee Grieveson has pointed out, Tori himself becomes an object of fascination by virtue of the film's style, which renders him on par with the numerous collectibles from the Orient that populate his "Shoji Room."[59] Ultimately, the film will reject Tori and his Eastern (and, by association, uncivilized) values. In the climactic courtroom scene, when Tori's violation of Edith is revealed—and further defined as the appropriation of a white man's property—the assembled public erupts in an outpouring of xenophobic rage. What had already been a complicated and splintered depiction of an oversized space—Scott Higgins counts a total of eighty-four shots from thirty-eight different camera positions[60]—becomes a nearly incoherent profusion of shots filled with propulsive body movement and pronounced directionality that intimates a desire for lynching as surely as the earlier scene of branding bespoke rape.

Ultimately, *The Cheat* both chastises and shackles its protagonists, each of whom has overstepped his/her social bounds. Tori has dared to act on his desire for white flesh while Edith has allowed her unbridled consumerism to outstrip her devotion to husband and home. The film's conclusion returns Edith to the control of her husband while firmly placing Tori within the confines of the law. Earlier, the film had aligned these two characters by marking them both with identically situated wounds, Edith's inflicted by Tori's brand and Tori's by Edith's retaliatory gunshot. In so equating them, *The Cheat* suggests that the excesses of the modern housewife and immigrants with "foreign" values represent equivalent threats to the social order. As Sumiko Higashi concludes: "Without minimizing DeMille's superb achievement, the enormous success of *The Cheat* must be understood within the context of an era of rapid urban change that provoked discourse on the 'new woman' and the new immigration as ideologically charged subjects."[61]

While DeMille would step away from the fraught issue of race relations in his subsequent films, the subject of marriage remained prevalent in many of his most successful productions from the late 1910s. Beginning with *Old Wives for New*, DeMille directed a series of thematically linked films that represented a renewed engagement with contemporary subjects, where he "set postwar trends by showcasing the new woman."[62] Lasky's sense that the public had tired of period pictures and wanted "modern stuff with plenty of clothes, rich sets, and action" convinced DeMille that he should take on *Old Wives*, a property that Famous Players had paid $6,500 to acquire.[63] *Old Wives*, shot in the spring of 1918, quickly beget *Don't Change Your Husband*, filmed in the fall of that same year; 1919's *Male and Female* went into production just prior to *Why Change Your Wife?*, filmed that fall. Unlike the other three films, *Male and Female* is not a

social comedy focused on married couples; instead, it is a relatively faithful adaptation of J. M. Barrie's *The Admirable Crichton*, demonstrating particular fidelity to the play's analysis of class hierarchies. As Ben Singer has pointed out, the film's message—"that purely hereditary structures of privilege and disadvantage are pernicious, since they inaccurately gauge individual merit"—adhered to the type of Progressive ideology Hollywood films of the day largely espoused.[64] Nonetheless, the devotion to spectacle renders the outward trappings of class privilege delectable even as the film questions whether they are deserved.

These later films emphasized consumerism over style. One finds in *Male and Female* an apt example of DeMille's increased reliance on the ability of well-appointed sets, props, and costumes rather than striking visual effects to entice an audience drawn to visual splendor. Even now, the elements of Lady Mary's toilette are striking in their opulence, while the film's attention to their detailing stops the narrative dead in its tracks. This tendency reaches its apogee in the rather improbable insertion of a flashback to Babylonian times, where the positions of servant Crichton and the noble Mary are reversed, as he becomes a ruthless king and she a resistant Christian slave. For all its visual excess and seeming incompatibility with the narrative's main thrust, this set piece finds diegetic motivation in a poem that both Crichton and Mary have read intently, William Ernest Henley's "Or Ever the Knightly Years." And its climactic image, depicting the slave lying dead under the paw of a triumphant lion, is a direct visual reference to a nineteenth-century painting, *The Lion's Bride*, by Gabriel von Max.[65] The artistic pretensions of such sources don't disguise the fact that the flashback ultimately owes its existence to commercial demands. As William deMille would later write: "It was . . . during the production of *Male and Female* that [Cecil] started his series of 'fade-backs' to ancient times. . . . The public liked this so well that for a time C.B. made it a part of his formula . . . [so that] he could indulge his taste and that of his audience for spectacle and still tie it into his story by analogy."[66] While his films would still receive guarded praise from the trade press after this point, by the end of the decade DeMille was in the process of ceding his reputation as an artistically minded filmmaker to directors who had actual art school training, such as Rex Ingram.[67]

"The Master of Screencraft": Marketing DeMille as an Exceptional Director

Insofar as DeMille was the director of many of the Lasky Film Company's most acclaimed early features, he came to occupy a privileged position in the promotional campaigns devised for the films he made after the merger. This deliberate campaign to position DeMille as an exceptional figure, whose artistry would confer prestige on the Famous Players–Lasky brand, was one that DeMille

had considerable personal investment in seeing executed properly. As Sumiko Higashi has established, Lasky already saw the value of promoting DeMille's status as a celebrated director as early as 1915. In a letter that Lasky wrote to Samuel Goldfish in July of that year, Lasky equates DeMille's worth to the company as comparable to that of a star performer:

> I think it is a very good business move for us to build up [Cecil's] name as we are trying to build up Blanche Sweet's name. You know the public go to see a Griffith production, not because it may have a star in the cast, but because Griffith's name on it stands for so much. It seems to me that the time has come for us to do the same with Cecil's name. If we can accomplish this, we could let Cecil stage the plays that have no stars and his name in large type on the paper, advertising, etc. would undoubtedly in time take the place of a star's. In a word, he is the biggest asset we have; let's use it for all it is worth.[68]

DeMille appears to have participated fully in the subsequent attempts to market him as valuable artistic asset on par with the company's stars. In fact, as Lasky's letter attests, DeMille could substitute for a star when a film that he was directing lacked sufficiently high-powered acting talent. Accordingly, when a DeMille film features top-line stars such as Mary Pickford or Geraldine Farrar, publicity plays up their presence; otherwise, DeMille stands as his production's chief attribute. Lasky confirms the value of DeMille as a "name" director when writing to him about the promotional campaign for *The Whispering Chorus* in 1917: "I have just had a conference with Bob Davis and he showed me a sketch which they are going to use on the front page of the *All Story Magazine* advertising 'The Whispering Chorus.' I persuaded him to put your name on the front page of the magazine also, as the director the picture."[69] Lasky was even moved to apologize to DeMille when the director noticed that the Lasky name was given priority (or even parity) in promotional literature:

> No single piece of publicity has gone out of this office since I got back from the Coast, without carrying your name in a dignified and worthwhile way, and no piece of publicity has gone out at any time, as far as I can learn, which has carried the Lasky name. This was done not out of any assurances that I gave you, but for exactly the same reason as prompted me in giving you the assurance: you are being given full credit because the credit is yours and everybody in this institute recognizes you and is happy because it is so.[70]

Examination of the ads devised for a series of DeMille features released in 1917–1919 through Artcraft affirms that the director—and the qualities of artistic

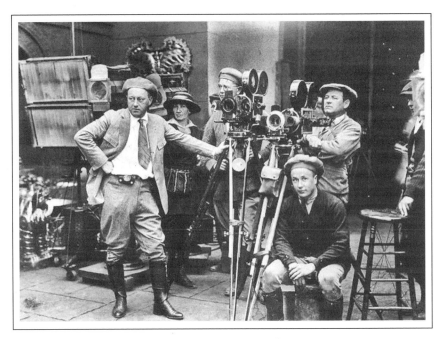

FIGURE 6: DeMille on set, striking a suitably commanding pose, once again in jodhpurs.

achievement associated with the DeMille name—serves as the chief selling point for most of his films. An ad announcing an upcoming slate of four DeMille films proclaims the director a "master mind, genius, artist, the personification of directorship, and founder of the Lasky School of Motion Picture art."[71] Though Farrar's name appears larger than DeMille's in an ad for *Joan the Woman*, he is still identified as "genius of shadows."[72] In the tag lines from the trade press accompanying an ad for *Joan*, entitled "Critics Sing Joan's Praises," *Variety*'s "Jolo" is quoted as saying, "No other than DeMille could have done as much," while Peter Milne of *Motion Picture News* says, "A triumph for Geraldine Farrar, but equally a triumph for Cecil B. DeMille," thereby equating DeMille's importance to the film's overall effect with the contribution of his star.[73] Other ads suggest that DeMille's ability to create successful films derives from his artistry: "His productions will be of unusual appeal—each big in money power as well as artistic value."[74]

Many of the ads are dominated by large photos of DeMille, often occupying as much as one-half of the total ad space. DeMille seems to have cultivated a particular image, fortified by identifiable sartorial iconography, from the outset of his career as a film director. Early publicity photos show him dressed in what would become the standard DeMille costume: white shirt, jodhpurs, calf-high boots, and, on occasion, a riding crop. The outfit suggests a combination of bohemian eclecticism and a hyper-masculine adventurousness (further amplified by DeMille's interest in dangerous activities, such as aviation; he became a pilot in

FIGURE 7: An ad for Paramount from 1921 depicts a generic director figure who bears a striking resemblance to DeMille, demonstrating how he had become iconically synonymous with the director function.

FIGURE 8: An ad for *The Whispering Chorus* (1918) describes DeMille as a "directing genius"; the ad's photo gives him the full director-as-star treatment.

1917).[75] The archetype of the dominant director who exercises total control can be traced to DeMille's carefully crafted persona; certainly, when Paramount wished to represent "the director" generically in an advertisement from 1921, it depicted what Gaylyn Studlar has described as a "DeMille look-alike."[76]

For their part, the Artcraft ads usually feature DeMille in his trademark open-collared white shirt, his steady gaze directed toward the photographer's camera. The poses bespeak a man of confidence and gravity, and the same kind of care is bestowed on the photographs as would be lavished on a star portrait. In one ad for *The Whispering Chorus*, DeMille's name appears in larger type than the film's title, while the copy identifies him as "the directing genius who aided Jesse L. Lasky in establishing the Lasky Productions as motion pictures of supreme merit. . . . No one knows better than Cecil B. De Mille how to tell a story dramatically in pictures."[77] DeMille's name looms even larger for ads for the remake of *The Squaw Man*, and the exploitation of that name becomes the central focus of the film's promotion: "You believe in names. . . . The name of Cecil B. DeMille means a production of distinctive merit. . . . From Cecil B. DeMille down, a list of guarantors of exceptional entertainment as dependable as the list of directors of the National City Bank."[78]

FIGURE 9: By 1919, DeMille's name supersedes all other marketable elements in the promotion of *For Better, For Worse*.

Again, DeMille's fame derives equally from artistic merit and box office success, so much so that the two are inextricably connected.

By the time of *For Better, For Worse*, the ads have advanced to providing a level of specificity regarding what DeMille supplies as a director: "The Value of a Name . . . Cecil B. De Mille's name has real box office value. . . . The public has come to expect greatness from Cecil B. DeMille. His name stands for sumptuous setting, wonderful acting, absorbing plot, wealth of detail and—Money in the box office!"[79] Another ad for this film claims that "with all the wealth of detail and splendor of luxury that go with the name of DeMille, and this great director at his greatest and best—"[80] The line is left unfinished, but the implication is clear: when the great DeMille is at his best, significant box office success is assured. This sentiment is affirmed in one other ad for the same film:

> With every succeeding production the name of Cecil B. DeMille becomes of increasing box-office money value to the exhibitor. Today he is the giant of his profession, the leader of them all, the record breaker of box-office statements. . . . This is the one director of them all, whose name is synonymous with success—not only artistic success but real cold cash, box-office success. . . . [The story] is surrounded with all the luxury and wealth of investiture that characterize every Cecil B. DeMille production.[81]

In the campaign for *Don't Change Your Husband*, what were previously directorial attributes have become conventions, elements of a "DeMille" film that the public has come to expect ("Gorgeous Gowns / Beautiful Women / And a Startling Story of Married Life").[82] Here, the director function reaches its apogee, because now the mere mention of DeMille's name signifies a winning combination of components, operating much like a genre label.

DeMille's increased value to Paramount (as the Famous Players–Lasky Corporation was now being called) was scarcely lost on the director. As director general

of the West Coast branch of the Famous Players-Lasky Corporation, DeMille had come to appreciate the value of the director function exceedingly well, so much so that when he negotiated the terms for the relationship between Cecil B. DeMille Productions and Famous Players–Lasky in 1920, his lawyer advised him that

> you should be authorized to purchase any stories which you desire to produce. . . . The entire picture should be produced in accordance with your own ideas and without any interference from anyone whatsoever, without any right in anyone whatsoever to interfere with the production or making any suggestions or changes, except such as you undoubtedly will be willing to receive; that the continuity should be entirely in your own charge and the title of the production selected by you and the production cut by you and under your direction and that the picture should be released as it is cut by you and with the title selected by you without any changes whatsoever.[83]

The lawyer goes on to discuss the monetary terms of the arrangement, which would entail DeMille receiving a percentage of his films' gross revenue. Handwritten at the top is what appears to be an addendum, from DeMille himself: "Would you rather have all of my prestige and half of my profits or none of my prestige and none of my profits?"[84]

Having been part of a corporation whose practices helped define the director function while dictating how that function could be incorporated into the departmentalized production processes of the studio system, DeMille ultimately positioned himself outside of that system to the degree that his own established reputation allowed. And, having made sure that Famous Players–Lasky consistently promoted his name as an indication of its own commitment to quality, and having secured a rate of payment far in excess of any other director at the studio, DeMille recognized that the paucity of top-flight directors gave him leverage when he set up his own company. His unique status as the executive of a corporation who doubled as a director served as a gateway for a career spanning the next thirty-five years. During that career he would remain attached to Paramount, a studio whose corporate identity was tied, as Jerome Christensen has argued, to the privileged status of its directors and stars.[85] Cecil B. DeMille's fundamental understanding—and exploitation—of how the director function could assume such hierarchical dimensions still stands as his most enduring legacy as a filmmaker.

2

CLASSICAL HOLLYWOOD, 1928-1946

The Company Man and the Boy Genius William Luhr

The period from 1928 to 1946 has come to be known as the age of classical Hollywood, and directors who were active during this time functioned in a studio system at the height of its power. Epochal moments bracket this era. At its beginning in 1928 the industry switched almost entirely from silent to more costly sound filmmaking. The end of the era, 1946, marked the start of movies' most successful period, with an estimated 90 million theater admissions per week between 1946 and 1948.[1] The intervening years were marked by developments that influenced the status and working conditions of all directors in the industry—not least of which was the Great Depression, which crippled the economy until World War II brought it to an end in the early 1940s. The major studios were engaged in an ongoing project of consolidating power at the top, limiting directors' control, and, at times, positioning them as cogs in an assembly line model of filmmaking. During these decades only a fortunate few directors were able to follow in the footsteps of legendary figures from the silent era like D. W. Griffith, who dominated the production process from script preparation to editing. Most directors remained trapped in the industry machinery, functioning as

pieceworkers within the Hollywood film factory. Eventually, the directors fought back against their worsening situation by mobilizing as a group to define and defend their status and authority.

The enormous capital outlay that the conversion to sound in 1927 required had a major impact on working conditions for directors. The new equipment was cumbersome and restricted camera mobility. Actors had to be tutored in the art of delivering dialogue. Not least of the difficulties was the cost. By some accounts, between January 1928 and February 1929 the studios spent $24 million to install sound equipment and $300 million to wire theaters for sound.[2] The need for such capital led to the consolidation of the industry into a handful of dominant studio players. In addition, the eastern financial institutions to which the studios had turned for funding imposed tight controls as a condition for their cooperation. At the start of 1929, more than forty banks and electrical companies had members on the boards of the ten largest studios. These developments accelerated a restructuring of filmmaking practices that was aimed at producing a steady stream of marketable product on a reliable, cost-effective schedule. To adapt to these new protocols the top brass adopted a more business-oriented model in which executives and producers carefully monitored the entire moviemaking process—including the work of directors.

The process of shifting authority from directors to producers and executives had begun in the early 1910s. As films evolved from loosely organized storefront entertainments to big business, studios had sought to maximize profits by making production practices more efficient. In this volume's first chapter Charlie Keil describes the way in which Cecil B. DeMille managed this situation during the 1910s and 1920s in a way that vested more power and control in the hands of directors. By the 1930s, however, studio executives had taken the reins. This process dovetailed with the long-term agenda of the studios to control directors by supervising their work and limiting their participation in the production process. These strategies, coupled with the difficulty of transporting the heavy new sound equipment to distant places, tended to centralize production activity within the studio walls. Location shooting soon became the exception rather than the norm, and directors increasingly found themselves working on studio sets where executives could keep watchful eyes on them.[3]

To streamline the moviemaking process, the studios compartmentalized much of the labor with producers acting as business managers coordinating the various units responsible for different tasks, such as direction, script development, casting, technical services, wardrobe, set design and construction, and editing. As the chart of the production process in this book's introduction shows, the prevailing model called for a director to come in only when shooting was to begin, with the script, cast, personnel, sets, and even distribution schedule already in place. After the designated shooting time, the director turned the film over to the postproduction team and moved on to another project. In some cases,

different directors were assigned to a single film and expected to shoot segments of it without an overall sense of the whole project. The 1920s and 1930s also saw a trend in which each studio sought to create its own distinctive style: glossy and polished at MGM, gritty and hard-edged at Warner Bros. Directors were expected to conform to these studio styles; in so doing they made themselves more or less interchangeable.

The new system hobbled directors in other ways as well. Powerful producers sometimes thrust them into the middle of messy situations. Independent producer David O. Selznick, in particular, was notorious throughout the industry for his compulsion to control every aspect of his films. He wanted to hire directors who could also write and produce, but then was unable to leave them alone. For example, in 1939 he brought Englishman Alfred Hitchcock to the United States. Hitchcock had made successful films under the British system in which he functioned not only as a director but sometimes as a writer and producer as well. Through much of the 1940s, he endured a stressful relationship with Selznick, who repeatedly attempted to micromanage the productions of his prized English import.[4] One of the ways in which the canny director resisted such producer interference was by cutting with the camera, or shooting in such a way as to leave little extra footage for editors to use if instructed to restructure the film. This strategy often involved deviating from the standard practice of shooting master shots, which show the entire scene playing out in long shot as well as "coverage" footage showing individual scenes from different angles. The conventional pattern enabled editors to cut closer shots and coverage footage into the master shots in ways different from what the director intended. Hitchcock's method implicitly denied this power to editors.

The producers and executives who ran the studios did not always cast themselves as adversaries of directors. Most recognized the value of prestige and in practice allowed greater creative leeway to moviemakers who had proven they could bring in quality films. A few directors managed to stake a claim for greater control by establishing themselves as geniuses whose films could be seen as expressions of their unique sensibilities. The premiere example of such a genius director was Charlie Chaplin, who, beginning in the 1910s, performed multiple roles in his movies, including that of director, star actor, producer, writer, editor, and even composer before being forced out of the industry—and the country—in the 1950s as a result of his communist sympathies. Because of his unrivaled popularity and the fact that he eventually controlled much of the financing of his own productions, Chaplin largely remained a separate entity in Hollywood, outside the system. In direct opposition to the business strategies at other studios, he would work at his own pace, often taking years to complete a film, and only place it into distribution when he was satisfied with it.

Chaplin extended his reach into areas where the studios had previously ruled supreme. He was one of the founders of United Artists, a company organized in

1919 as a distribution hub for independently produced films; as such, it was the most visible of numerous attempts to establish independent filmmaking structures outside of major studio control. Over twenty years later, in 1941, Chaplin was one of the founding members of the Society of Independent Motion Picture Producers (SIMPP), which also included Orson Welles, Walt Disney, Mary Pickford, Walter Wanger, Alexander Korda, Samuel Goldwyn, and David O. Selznick. Like United Artists, SIMPP opposed the controlling power of the big studios. In 1942 it was behind the filing of an antitrust suit concerning Paramount's United Detroit Theater, one of the events leading up to the influential 1948 Paramount decision forcing the studios to divest themselves of their exhibition outlets.[5]

At the next level down from the geniuses were the name directors, who were able to develop ongoing relationships with studios and/or producers that allowed them considerable freedom. Frank Capra with Harry Cohn at Columbia, Victor Fleming and King Vidor at MGM, Cecil B. DeMille at Paramount, and Michael Curtiz at Warner Bros. were members of this elite club, as was John Ford at Fox. Other name moviemakers like Howard Hawks resisted long-term studio affiliations altogether. But even this group represented only a small fraction of the corps of Hollywood directors; the vast majority had little say over the work they did. Ford spoke for many of his colleagues when, in 1936, he excoriated studios for regarding directors as people "who just tell actors where to stand."[6]

The directors did not suffer such treatment in silence; they organized, spurred on by political developments of the day that favored unionization. During the 1930s President Franklin D. Roosevelt's New Deal policies encompassed an ambitious wave of laws that energized programs for social change, including supports for labor to engage in collective bargaining. Many Hollywood craft workers seized upon this new opportunity to advance their interests by forming unions. The Directors Guild of America (DGA) was founded in 1936 as the Screen Directors Guild, two years after the actors and writers had organized. In contrast to these other talent guilds, which focused primarily on issues of compensation and job security, the directors banded together as part of a long-term and still evolving push for securing directorial prerogatives with reference to issues such as authority on the set, enhanced working relationships with colleagues and underlings, and, most significantly, the principle of one director on a film.

John Ford: The Company Man

John Ford was a director who grasped the import of these changes in the industry and capitalized on them. By the 1930s he was not only a commercially successful moviemaker but also one with critical prestige. In addition to being honored by the Motion Picture Academy in 1941 for *How Green Was My Valley*,

he had won Oscars in 1935 for *The Informer* and in 1940 for *The Grapes of Wrath*. A decade later in 1951 he would win again for *The Quiet Man*, making him the most honored director in Academy history. Ford's growing stature in the industry and the commercial success of many of his productions in the 1920s and 1930s enabled him to exercise considerable control over many of his films as well as to negotiate non-exclusive studio contracts, giving him the security of a studio affiliation while also allowing him to work elsewhere. He seldom engaged in public battles over screen credit and modestly described directing as "a job of work." He often followed his highly successful films with low-profile productions, avoiding the frequent Hollywood practice of using previous successes to promote grander projects, which often ended catastrophically. Although he made numerous prestige films, he took pride in his westerns. He was fond of bragging about his industry beginnings as a stuntman during the silent era and often presented himself as a gruff, slovenly iconoclast. Yet throughout his career he cultivated relationships with studios, producers, and coworkers that enabled him to thrive professionally.

Despite having to function in changing and unpredictable circumstances, Ford managed to create a body of work identifiably his own. His signature style was made possible in part through productive associations with valued creative associates. Though wary of producers and executives, Ford was indebted to actors, screenwriters, and cinematographers with whom he enjoyed long, profitable collaborations that persisted amid a diverse array of studio contexts. His favorite performers included stars like John Wayne, Henry Fonda, Harry Carey, Victor McLaglen, and Maureen O'Hara. He also relied on skilled character actors like Ward Bond, John Carradine, Mae Marsh, and John Qualen, who formed what came to be known as the Ford stock company. Ford's long partnerships with screenwriters like Dudley Nichols, Nunnally Johnson, and Frank S. Nugent were equally important to him, as were longstanding collaborations with master cinematographers like George Schneiderman (twenty-one films with Ford between 1921 and 1935) and Joseph H. August (fourteen films with Ford between 1925 and 1945). Teamwork was important to him. "They've got to turn over picture-making into the hands that know it: that's the ideal," he told an interviewer in 1936. "Like Dudley Nichols and me."[7]

Early on, Ford also took lessons from the work of director colleagues. In the late 1920s, for example, he came under the influence of German Expressionism through the director F. W. Murnau, who shot one of his most celebrated films, *Sunrise*, on the Fox lot in 1927 while Ford was working at the studio. After observing the striking effects Murnau achieved, Ford varied his own visual style to make some moody, poetic films, such as *Four Sons* (1928).

Though Ford benefited from such affiliations and influences, he was also capable of persevering despite the lack of reliable helpmates. During his long career, he was partnered with a legion of different production personnel of widely

varying skills and competence, but he invariably managed to include signature stylistic tropes in his films nonetheless. Widely admired Fordian motifs, such as resplendent skies and scenes of communities gathered together for performances of traditional folk music, reappear in his productions again and again despite the heterogeneous array of cinematographers and musicians he worked with over the years. He was also repeatedly drawn to projects about Ireland and American history and made films on such topics throughout his career.

Ford's earliest and most important creative associate was his older brother Francis, who first got him a foothold in the industry. An actor-director, Francis was a Hollywood pioneer who had found success directing and acting in serials during the early 1910s. When John arrived in Hollywood in 1914, Francis got him work at Universal. Though John claimed that he learned much of what he knew about directing from his brother, some of this knowledge was by negative example. After growing success in the 1910s, largely with popular serials like *The Broken Coin* (1915), Francis formed his own independent company, Fordart Films Inc., in 1917. Eventually it failed, as did other attempts at independent production, largely because of the elder Ford's lack of business expertise as well as his continued adherence to the serial format, which was losing popularity in an industry that increasingly focused on feature filmmaking. By the 1930s, as John's career was rising, Francis had abandoned his directorial ambitions and was reduced primarily to acting in small roles.

John Ford was more attuned to changes in the structure of the film industry than his brother had been, understanding that what worked in 1915 would not work in the 1930s. Until 1920 he directed only westerns, most of which were shorts. But by the 1930s, too much money was involved in filmmaking for the freewheeling ways of the silent era to persist. Responding to this shift, Ford made mostly features after 1920 and began to diversify his output with comedies and dramas. In 1920 he made his first film for Fox, which became his home studio from the 1920s into the late 1940s. In 1924, he made *The Iron Horse* there with what was for the time a large budget of $280,000. The film made over $2 million and put Ford on the map as an important director.[8]

Of the fifty-two films Ford made at Fox, twelve were produced under then-studio head Darryl F. Zanuck, including lauded titles like *Young Mr. Lincoln* (1939), *The Grapes of Wrath*, and *How Green Was My Valley*. All featured members of Ford's stock company, and although each was written, lensed, and scored by different studio hands, Fordian motifs are common to all. But Zanuck was always in charge. "He was the quintessential studio boss in the great age of studio bosses," screenwriter Philip Dunne wrote in his autobiography. "No foot of film ever left the studio without his imprimatur."[9] Though Ford favored westerns and male-centered dramas, when Zanuck asked him to direct a Shirley Temple vehicle, *Wee Willie Winkie*, in 1936, Ford complied, knowing that it would give him leverage to propose future projects more to his liking.

In 1936 during the production of *The Prisoner of Shark Island*, the first of the Ford-Zanuck collaborations, the pecking order between the powerful producer and the headstrong director was firmly established when Zanuck came onto the set to complain about the performance Ford was getting from actor Warner Baxter. "If you're not satisfied with the way I'm directing this," Ford declared, "you can get somebody else." Zanuck was quick to take offense. "Are you threatening to walk off this set?" he demanded. "Don't ever threaten me. I throw fellas off the set. They don't quit on me." The two almost came to blows, but Ford ultimately backed down.[10] From then on the easily aggravated director took out his hostility on underlings, especially the associate producers who occasionally visited his sets to check on his work. The most famous confrontation of this sort occurred during the production of *Wee Willie Winkie* when a low-level executive came onto Ford's set to accuse the director of being behind schedule. Ford's response was to open the script and rip out four pages. "We're back on schedule," he stated. "Now beat it."[11]

The production history of *How Green Was My Valley* illustrates the way in which Ford worked with Zanuck and others at Fox to make films that were both industry products and personal statements. Zanuck initially intended *Valley* to be a lavish, four-hour Technicolor production that would rival Selznick's recent and extravagantly successful *Gone with the Wind* (1939). The ambitious Fox chieftain loaned William Wyler from Samuel Goldwyn to direct the film, which was based on a best-selling novel, and Wyler spent months preparing it for production. For complex reasons related in part to the outbreak of World War II in Europe, the project was interrupted, its narrative scope cut by half and its script rewritten. At a certain point Wyler left the project.[12] And yet, although Ford joined *How Green Was My Valley* when the script, personnel, sets, and schedule were largely in place, he found the material deeply compelling and came to consider it his most autobiographical film.[13]

Zanuck, who had begun his career as a scriptwriter, was always closely involved with the development of Fox screenplays, and he regarded a finished script as sacrosanct. Directors could request script changes, but Zanuck had to OK them. "You did not write scripts for directors, not in Zanuck's studio. You wrote them for Zanuck," Philip Dunne stated. He recalled Zanuck telling him once, "'If I could start with a best-seller, something that's already a proved hit, and assign one of you [screenwriters], I wouldn't care who directed it.' The director was the necessary evil."[14]

Zanuck was also famed for his editing skills, and in this realm he frequently clashed with his star director. The overriding conflict between the two men over editing concerned tempo. Zanuck liked speed; Ford preferred a more leisurely pace. To Zanuck, *Young Mr. Lincoln* seemed "a little draggy." When he made a similar complaint about the rushes he was viewing of Ford's next production, *Drums along the Mohawk*, the director shot back in a letter from

location in Cook County, Pennsylvania. "Both the script and the story call for a placid, simple movement which suddenly breaks into quick, heavy dramatic overtones," he wrote. "All this requires care." Zanuck, for his part, did not appreciate Ford's poetic style, later advising Elia Kazan against making "an art or 'mood' picture. The kind of thing John Ford does when he is stuck and runs out of plot. In these cases, somebody always sings and you cut to an extreme long shot with slanting shadows."[15]

The wily Ford had numerous methods of circumventing Zanuck's editing scissors. Like Hitchcock, he cut in the camera. Part of this strategy involved avoiding close-ups. Once, on the set of *How Green Was My Valley*, he revealed his reasons. In a pivotal scene the heroine Angharad (Maureen O'Hara) leaves the church after marrying a rich man she does not love while the man she does love, the minister Mr. Gruffydd (Walter Pigeon), watches from a distance. After shooting the scene in long shot, Ford looked off at Pigeon. "If I make a close-up," he confided to his cameraman Arthur C. Miller, "somebody will want to use it."[16] In an even more unorthodox move, Ford frequently set up shots that were mismatched in terms of screen direction, a practice that had the potential of disorienting viewers by violating the sense of spatial integrity. The Indian attack in *Stagecoach*, which creates the impression that Indians are coming at the stage from all directions, is the most famous of many examples. As confusing as this technique could be, it had the advantage of preventing Zanuck—or anyone else—from speeding up the pace of a scene by cutting away from any given shot instead of letting it play out to

FIGURE 10: Mr. Gruffydd stands in the far background as he watches Angharad depart with her new husband in *How Green Was My Valley* (John Ford, 1941).

its conclusion. Yet Zanuck remained a thorn in the director's side. Ford was fond of recounting a nightmare he claimed to have had in which he was dead and, as he was entering heaven, noticed a sign above the pearly gates that read "Produced by Darryl F. Zanuck."[17]

Because of his non-exclusive contrast at Fox, Ford was able to take projects to other studios if Fox showed no interest. Some of his most celebrated films, including *The Informer, Stagecoach,* and *The Quiet Man,* were produced in this manner. Regardless of his successes at different points in his career, however, Ford never tried to be a one-man show. Instead, he allied himself with strong producers like Zanuck and Merian C. Cooper and established studios like Universal and Fox. Although Ford became interested in many projects over the years and repeatedly sought financing for some, he would not begin production unless he had sufficient resources to complete the film. He tried for decades, for example, to interest producers in an adaptation of Sir Arthur Conan Doyle's *The White Company,* but, since he could never secure the fiscal support for it, the movie was never made.

When Ford tackled independent projects, he was often willing to work under a tighter production schedule and a lower budget than he would have expected at Fox. But whether he made films with his home studio, another one, or an independent corporation, he generally established production structures very similar to those of the studios, with defined budgets, a detailed script and production schedule, and a distribution plan. When he wanted to make *Stagecoach,* Zanuck, David O. Selznick, and others rejected the project as uncommercial. Ultimately Ford made *Stagecoach* with the independent producer Walter Wanger and served as his own producer. Wanger, however, received the credit "Presented by Walter Wanger" as he did on other movies he produced.[18] Ford worked with Wanger again in 1940 on *The Long Voyage Home* in roughly the same way, although this time he did not serve as his own producer. In the interval, he directed three films with his home studio, Fox, working under Zanuck: *Young Mr. Lincoln, Drums along the Mohawk,* and *The Grapes of Wrath.*

The Informer is fairly typical of Ford's approach to independent work. He attached himself to the property in the early 1930s but had difficulty securing studio support. The project was rejected by Fox, Columbia, MGM, Paramount, and Warner Bros. largely because of its downbeat nature and politically sensitive subject matter. Ford eventually made *The Informer* at RKO, taking with him valued collaborators, including Dudley Nichols, who wrote the screenplay; and Victor McLaglen, who played the title character, Gypo Nolan, an Irish rebel who betrays the cause. The film was given a bare-bones production budget of $242,756 and a mere eighteen-day shooting schedule.[19] After work on *The Informer* began, RKO's faith in the commercial viability of the project diminished and, about halfway through production, the studio moved Ford and his crew across the street from the main lot to a dusty rental facility. Ford later described this move

as advantageous, claiming that the distance from the main RKO lot meant less interference from studio executives.

The budget for *The Informer* did not allow for the construction of elaborate sets, but Ford compensated by creating a distinctive expressionistic look for the Dublin of the early 1920s. He had brought cinematographer Joseph H. August with him from Fox. August's facility with low-key lighting effects enabled him to help Ford create the shadowy, backlit images that could enhance the doom-laden aura the settings and props evoked. Ford also worked with RKO's art director Van Nest Polglase and his assistant Julia Heron to stage scenes using canvas backdrops, fog, and symbolic props. The "WANTED" poster depicting the friend whom Gypo betrays for the posted reward money was one such prop, which took on symbolic significance in the story. Although the guilt-ridden informer rips the poster from a wall and tosses it down the street, a wind blows it relentlessly back to catch on his legs.

As Ford's career progressed, the tasks for which he received formal screen credit diminished markedly. During the silent era, he was frequently credited for work he did not only as a director but also as a writer, actor, and member of the production crew. In the sound era, his screen credits were generally limited to director and, periodically, producer. Although he often involved himself extensively in script preparation during this time, he did not receive screenwriting credit. The reduction in Ford's credits reflects a general trend in the industry, for studios were increasingly unwilling to allocate multiple credits to directors.

FIGURE 11: Gypo examines the poster depicting his friend before tearing it off the wall in *The Informer* (John Ford, 1935).

Ford participated in many of the initiatives of the 1920s and 1930s for directors' rights. At times he was visible and vocal but at others he hedged his bets. In 1927, he had served as president of the Motion Picture Directors Association, a largely fraternal organization founded in 1915 by, among others, his brother Francis.[20] He participated in a boycott of the 1935 Academy Awards ceremonies spearheaded by labor concerns, but a week later he quietly accepted his Oscar.[21] In December 23 of the same year he was one of the twelve directors present in King Vidor's home in a meeting that led to the formation of the Screen Directors Guild.[22]

As treasurer of the Screen Directors Guild during its early years, Ford steadfastly supported the group's efforts to ally directors with other film workers against the studios. In 1936 he articulated his loyalties to the artisans who made the movies rather than the executives who financed them in a speech to his fellow directors in which he stated:

> We want to know why the hell so many directors and assistants are not working. . . . I, for one, would like to cooperate with the other people in the game and find out what's at the bottom of this. I firmly believe that that kind of cooperation is plainly our duty unless we are satisfied to remain an insignificant and exclusive club. Let's try to get back to the old days—when the people on the set looked to the director for leadership. Let's pitch in with our co-workers and try and find a way out of this mess. Let['s] work in the industry, with the industry, and for the industry. Let's not be high-hat—let's help the others. I grant you that the Producers haven't recognized us, but for Christ's sake, and I say that with reverence, let's not get into a position where the workers of the industry don't recognize us.[23]

Ford's political affiliations also shifted during his career from left-wing in the 1930s to Republican by the mid-1960s. Though he certainly had his share of battles and cultivated the image of an industry maverick, more often than not he fit into the corporate industry structure. His career flourished into the 1960s thanks in large part to shrewd management and an ability to mesh his talents with the contributions of others. His films demonstrate his willingness to conform to traditional Hollywood strategies for commercial success. He may have complained in public about many things in Hollywood, but he always spoke as an insider who had an ongoing involvement with the system.

Orson Welles: The Boy Genius

Throughout his career, Orson Welles presented himself and was widely admired as a multifaceted talent who would dominate every film project in which he was

involved. Labeled the "boy genius" early in his career, he marketed himself as a personality with his radio appearances and the starring roles he took on in many of his productions. Even before he made *Citizen Kane*, his first film, in 1941 at age twenty-six, he had rejected a number of Hollywood offers on the grounds that they would interfere with his desired role in filmmaking, "my profession of actor director," which he based upon the theatrical model of actor/manager.[24] For Welles, the individual artist was the sine qua non. He well understood that such an attitude placed him at odds with the Hollywood system. "[A] certain kind of filmmaker . . . really wants to make the film entirely on his own," he once said, "and that sort of fellow is the sworn enemy of the system . . . and the system is at great pains to denigrate such a person."[25] From the beginning he complained about the way in which contemporary studio practices undermined individual creativity. "What I don't like about Hollywood films is the 'gang' movie and I don't mean the Dead End Kids. I mean the assembly line method of manufacturing entertainment developed in the last fifteen years or so, and I share this prejudice with practically everybody whose craft is the actual making of a movie and not just . . . the business of selling it," he stated. "When too many cooks get together they find, usually, the least common denominator of dramatic interest."[26]

Like Chaplin, Welles took multiple credits on his films and cultivated his image as a renaissance man who did it all. He repeatedly engaged in bitter disputes over authorship credit, most famously with Herman Mankiewicz over the screenplay for *Citizen Kane*. Welles had claimed sole screenwriting credit but, after Mankiewicz threatened a lawsuit, agreed to shared credit.[27] Before he ever came to Hollywood, Welles protested an attempt to designate Howard Koch as the author of the 1938 *War of the Worlds* radio broadcast in a published text. He even had a falling-out with Chaplin when he demanded and received screen credit for the story idea for Chaplin's *Monsieur Verdoux* (1947). Although Chaplin said that Welles had merely suggested the idea, Welles claimed that he had contributed substantially more.

Welles had come by his celebrity honestly, having built his reputation on innovative approaches in multiple media with attention-grabbing stage and radio productions. His 1936 "Voodoo" *Macbeth* was staged in Harlem, and his 1937 adaptation of *Julius Caesar*, entitled *Caesar*, was designed to draw parallels between Caesar's Roman dictatorship and Mussolini's contemporary Fascist regime. His infamous 1938 *War of the Worlds* radio program created a national panic when many listeners took it for a news broadcast. In 1941 he followed up his groundbreaking work on *Citizen Kane* with an acclaimed Broadway production of *Native Son*. All these projects contributed to his reputation as a brash visionary.

Welles arrived in Hollywood with a spectacular contract that gave him privileges surpassing that of industry stalwarts. His two-picture deal with RKO, while fairly standard for the time in terms of budget and director's salary, was extremely unusual in two ways: it enabled him to prevent studio executives from

viewing the rushes during production, and it granted him approval of the final cut of each of his films. He was to have his own production unit within the larger studio, to be called Mercury Productions after the name of his theatrical troupe, the Mercury Players. He repeatedly commented that, in negotiating this unusual contract, "I didn't want money, I wanted authority."[28]

The contract came about not only because of Welles's fame as the boy wonder of the theatrical world but also because of the precarious situation at RKO. The studio had been in equity receivership since 1933, a victim of the stock market crash of 1929 and the Great Depression that followed. It reemerged in January 1940 under the leadership of former Paramount executive George Schaefer. When Schaefer took the helm in 1939, he hoped to turn RKO into a new MGM, which had been the most successful studio of the 1930s. Part of his plan to revive RKO's image involved producing some highly publicized prestige films. With that objective in mind, Schaefer courted Welles, among others, in 1939 and on July 22 he signed Welles to a two-picture deal with the famous contract.

Many in Hollywood felt that Welles hadn't "earned" his position, particularly since he had never directed a film.[29] From his highly publicized arrival in July 1939, he was resented as a showboating New York snob who was slumming in Hollywood. On September 26 of that year James R. Wilkerson, editor of the *Hollywood Reporter*, voiced the prevailing sentiment among industry insiders when he condemned Schaefer for allocating a budget of $750,000 to *Citizen Kane* while cutting the pay of others at RKO. As Wilkerson wrote sardonically, "Mr. Schaefer evidently does not think an investment of $750,000 or more with an untried producer, writer, director with a questionable story and a rumored cast of players who, for the most part, have never seen a camera as a necessary cut in these critical times."[30]

Welles's initial attempts to fulfill his RKO contract during 1939 and 1940 came to nothing. The first of these efforts was an adaptation of Joseph Conrad's novella *Heart of Darkness*, which he had previously mounted as a radio show. Welles, who had written the script unaided, envisioned the movie version as a bold experiment in subjective storytelling. His detailed scenario shows the action unfolding as a series of long takes, a strategy that would become a stylistic hallmark of all his subsequent films. Due largely to the number of special effects shots the screenplay called for, the budget ballooned to over a million dollars, and the production was scrapped. Soon afterward, Welles embarked on a more conventional project, a spy thriller entitled *Smiler with a Knife*. To craft this script he sought the help of Herman J. Mankiewicz, the veteran Hollywood screenwriter who was to work with him again on *Citizen Kane*. *Smiler with a Knife* was also abandoned, probably because it did not offer sufficient scope for Welles's artistic aspirations and the studio's desire for a prestige production. Another proposed picture, this one based on Welles's famous radio broadcast of H. G. Wells's *War of the Worlds*, was championed by RKO production chief Harry Edington.

Edington reported to George Schaefer on audience research, which showed keen interest in such a film, but again the project failed to get off the ground because it lacked the artistic heft Welles was seeking. Schaefer was quick to defend the lofty ambitions harbored by his prize catch. "The only way I was able to secure Welles was because of my sympathy with his view point," Schaefer wrote in response to Edington's pleas. "[Welles] was anxious to do something first, before Hollywood typed him. This has been uppermost in his mind, and I know it would be difficult to change."[31]

Ultimately, it was the *Citizen Kane* project that got the greenlight. Made with the full support of RKO, it was promoted as a one-man show, conceived by Welles with him as coauthor, director, and producer.[32] Welles also played the title character, a press baron whose early idealism and optimism give way to pomposity and stagnation as he ages. Yet the flamboyant Hollywood newcomer surely exaggerated in presenting himself as the movie's sole authorial hand. After all, he was working in a large-scale business enterprise that involved a complicated interplay between vast sums of money, sophisticated technology, and cadres of specialized personnel. Success as a director in Hollywood depended on a willingness to exploit these resources, not a determination to rise above them, and Welles understood this reality despite his remarks to the contrary. Especially at this early point in his Hollywood career, he benefited substantially from the contributions of key collaborators. Many of his talented colleagues from the Mercury Theatre worked on the project, including producer John Houseman; composer Bernard Herrmann; and actors Joseph Cotten, Dorothy Comingore, Everett Sloane, and Agnes Moorehead. Mankiewicz was another key partner.

To create the look of *Kane*, Welles hired the innovative cinematographer Gregg Toland, who helped him craft a baroque, noirish visual design for the film. Toland had experimented with deep focus, complicated crane shots, and high-contrast lighting effects throughout the 1930s, but Welles's lack of preconceptions and eagerness to innovate combined with new equipment allowed the daring cinematographer to go much further with these techniques. Toland worked with Perry Ferguson, an affable, inventive art director who had been assigned to the project by RKO. Ferguson made the most of his limited budget in several scenes, especially those set at Kane's estate, Xanadu, by placing a few conspicuous objects at varying distances from the camera and filling in the gaps with light-absorbing black velvet drapes that gave the backgrounds a feeling of mysterious depths. "Very often—as in that much-discussed 'Xanadu' set in *Citizen Kane*," Ferguson later wrote, "we can make a foreground piece, a background piece, and imaginative lighting suggest a great deal more than actually exists on stage."[33] Though these two Hollywood veterans were undoubtedly crucial in creating the dazzling visual style of *Kane*, Welles, who had overseen it all, carried many of the techniques they had devised for him into his subsequent productions and became known for a baroque visual style marked by deep focus compositions

FIGURE 12: Perry Ferguson's set design of Susan's apartment in *Citizen Kane* (Orson Welles, 1940).

featuring multiple planes of action, chiaroscuro lighting, and long takes, which often involved bravura crane and dolly shots.

As a thinly veiled, unflattering portrait of William Randolph Hearst, *Kane* encountered serious resistance from the powerful Hearst press and did poorly at the box office. Welles didn't help his cause when, at the very outset of his RKO contract, during which he was supposed to be preparing his first script, he negotiated permission from the studio to undertake the exhausting schedule of flying back and forth between Los Angeles and New York every week to do *The Campbell Playhouse*, a weekly radio show for which he adapted material, directed, narrated, and acted. Such bi-coastal, dual-media activity, which lasted from September 1939 to the end of March 1940, appeared to signal an almost recklessly cavalier commitment to his Hollywood obligations.

Despite the negative publicity he was getting, this was a spectacularly creative period for Welles. He appeared to be all over the map, juggling multiple projects in different media. In early 1941, soon after he had finished shooting *Citizen Kane* and before it opened, he returned to Broadway to direct *Native Son*. He continued to do radio work as well, and in the summer of 1941 he was preparing his second film, *The Magnificent Ambersons*, the production of which began that October and continued into January 1942. Welles would also soon appear in leading acting roles in studio features directed by others, such as *Journey into Fear* (RKO, 1943) and *Jane Eyre* (Fox, 1943).[34] In 1942, however, as World War

II was escalating, his career started to unravel. Many factors contributed to his decline, including overcommitments to multiple projects, power shifts at RKO, and his absence from Hollywood for much of the year as he pursued other projects and dabbled in politics. The last of these factors was to prove his undoing as the war took hold and he was lured abroad to help the American cause.

Welles's first foreign adventure began at the behest of Nelson Rockefeller. As part of an initiative to counter the Axis powers' aggressive attempts at courting Latin American alliances, President Franklin D. Roosevelt named Rockefeller the coordinator of the Office of Inter-American Affairs and, in late 1941, Rockefeller appointed Welles a Good Will ambassador to South America. Initially it appeared that this post would simply oblige Welles to give a series of lectures, but it gradually developed into a plan to make a multi-segment movie presenting positive views of Latin American culture to North American audiences. The film would be coordinated and financed by the Office of Inter-American Affairs as well as RKO (Rockefeller was an RKO board member).[35] Welles threw himself enthusiastically into the project, as well as into his related duties of visiting numerous Latin American countries as ambassador, where he devoted himself to radio broadcasts, press interviews, and various diplomatic activities. He spent most of his time between January and August 1942 in Brazil and Mexico working on the movie, to be called *It's All True*. It was to be an omnibus film consisting of several parts (although the nature of the segments would change as the project developed). One segment, to be called *Carnaval*, would celebrate the cultural and musical vitality of the annual, pre-Lenten festival in Brazil.

During this hectic time Welles wanted to finish editing *The Magnificent Ambersons* by having RKO fly the raw footage to him in South America. Given that America had by then entered World War II, this plan proved impractical; and, in any event, RKO was uneasy about the length and downbeat ending of Welles's version. Even Schaefer, who was then under fire from the RKO board for his dismal financial record, turned on his protégé. "We have got to get away from 'arty' pictures and get back to earth," he wrote to Welles in South America. "Educating the public is expensive."[36] Eventually, the studio took the film away from its overcommitted director, reshot the last scene, and cut forty minutes.[37] But even if Welles had been able to edit *Ambersons* to his liking, its commercial viability was clouded from the outset. Unlike *Kane*, *Ambersons* did not stand to benefit from Welles's star presence; instead he took an offscreen role as the story's narrator. Moreover, the plot was depressing and the protagonist unlikeable. Not surprisingly, the film received mostly negative reviews and lost half a million dollars.

It's All True fared even worse. Welles shot a great deal of the footage for two of the four proposed segments but was never able to complete the film or to properly edit what he had shot. The shooting conditions he encountered on location in Brazil were daunting to say the least. The expensive Technicolor sequences Welles wanted, which required brilliant light, proved especially troublesome. Unable to

get arc lights from Hollywood, he was forced to use antiaircraft searchlights borrowed from the Brazilian army, a poor substitute. Though he drew support from his loyal production assistant Richard Wilson, the rest of the crew he had brought with him from the States were miserable and rebellious. Production manager Lynn Shores reported back to Schaefer as follows:

> In a vague way, [Welles] has given me to understand that we are to travel over most of South America with Mercury Players, various units of Technicolor and black and white, radio set-ups, good will speeches and general messing around for the next two or three months. It has been a horrible nightmare to me personally. I am carrying not only the working but the personal problems of twenty-seven individuals, each one with an axe to grind and a grievance of some sort at every hour of the day.[38]

Given this situation it is not surprising that RKO gradually lost interest in *It's All True*, dismissing the project as a waste of money. Studio executives also resented what they considered Welles's profligate behavior while in Latin America.[39]

Much about the dynamics of Welles's situation at the time is evident in a look at the unpublished treatment for *Carnaval*, one of the projected segments for *It's All True*. Like most treatments, it is a document intended to sell the project to potential backers and it radiates Welles's enthusiasm. He was selling the originality of his approach, the infectious excitement of the Latin American culture (particularly samba music) that the film would capture, and the ability of the project to improve North American relations with South America. Viewed from another perspective, however, it reveals a profound disconnect between Welles's approach to filmmaking and contemporary studio practice.

"This is a new sort of picture," the treatment begins. "It is neither a play, nor a novel in movie form,—it is a *magazine*."[40] Welles goes on to argue for the unique nature of the project and explains why it was necessary to shoot it in Brazil. "The sheer intensity of Rio's Carnaval is entirely beyond the scope of any Hollywood spectacle," he wrote. "The vivacity and spirit of Carnaval's celebrants are unavailable elsewhere." While acknowledging the logistical difficulties that this approach creates, Welles gives his rationale for the large amount of footage he intended to shoot.

> But here's a paradox. *Carnaval* must necessarily be filmed in its entirety in Rio, but the picture itself cannot be made except in Hollywood. Because of the expense of shipping film, because of the elements of time and distance, it has been naturally impossible for us here to refer to rushes and we have had to work without the critical advantage of nightly sessions in projection and cutting rooms. This is an important reason why it has been necessary to shoot an unusually large quantity of film.

The treatment as a whole radiates ambition, innovation, and enthusiasm; it promises a captivating entertainment employing methods never before attempted to present an untapped subject, a film far beyond the capacity of contemporary Hollywood to achieve. However, when approached from the perspective of a studio producer of the time, particularly one aware of the negative publicity surrounding Welles in Hollywood, the *Carnaval* treatment appears to be a formula for disaster. The lack of a script would make it impossible to budget or schedule the picture. Even if completed on time and under budget, the project offered no stars, it would not be in English, and it would have no narrative line. Each of these three elements would diminish its mainstream box office potential. The fact that it would not be in an established genre would make it even more difficult to market, and there was studio anxiety over the possibility that U.S. audiences would reject the film on the basis of its cast of Brazilian *favellas*: poor, nonwhite amateur performers.

Welles's implicit message to the studio was "Trust me" since, in his plan for production, no one but Welles would have a sense of the cohesion of the overall project. He expected the studio to withhold judgment until the arrival of the finished film, but by then the money would have already been spent. Any competent producer would realize that, given the approach set forth in the treatment, everything would depend on the studio's absolute faith in Welles's ability to shoot marketable material and to assemble the footage that he had shot off the cuff in Brazil after it had been transported to Hollywood. Welles's case was not helped

FIGURE 13: Welles directing a large cast of nonprofessionals for *It's All True*.

by the fact that his earlier attempt to edit *The Magnificent Ambersons* on a different continent from that in which it had been shot had already failed dismally.

George Schaefer had had great faith in Welles's genius, but by the summer of 1942 the RKO studio brass felt that Schaefer's leadership had accomplished little and forced him out. His replacement, Charles Koerner, had no interest in his predecessor's commitment to prestige films and cancelled all unit production deals, including the one with Mercury Productions. He unceremoniously released the remainder of Schaefer's slate and restructured the studio to specialize in unpretentious but generally profitable B-films.[41]

The combination of Welles's overcommitments, his continued absence from Hollywood, and the unfortunate changes in studio leadership hurt the high-flying filmmaker's industry profile badly. By 1943 he had little to show for his time in Hollywood. Although *Citizen Kane* had garnered considerable critical respect, it had gone over budget and been slammed by the Hearst press. Never finding a popular audience, it lost roughly $150,000. *The Magnificent Ambersons*, also over budget, received many negative reviews and lost even more money.[42] *It's All True*, never completed, developed a reputation as evidence of Welles's irresponsible extravagance and ended up as a studio tax write-off. Although Welles would make one more film for RKO, his viability as a director at the studio, particularly after its restructuring, was lost.

Survival in Hollywood

In the late 1940s the old-style studio system began to break down. Soon, as a result of antitrust litigation brought against the Hollywood studios by the Roosevelt administration, the majors would be forced to divest themselves of their exhibition outlets, undermining the reliability of a predictable return on investment. At the same time, television and other newly emerging modes of entertainment competed for consumers' leisure time and money. By 1951, theater admissions had dropped by 50 percent. During World War II the careers of many directors, including Welles and Ford, were disrupted due to their involvement in government service for the war effort.[43] Ford was made an officer in the Navy and charged with the production of wartime documentaries. Two of these received Academy Awards—*The Battle of Midway* (1942, Best Documentary) and *December 7th* (1943, Best Documentary, Short Subjects). Welles's wartime project, *It's All True*, was never completed. The pattern continued into the postwar era. As the studio system continued to shift its shape, Ford recovered and thrived, as did other Hollywood directors such as Frank Capra, George Stevens, and William Wyler. Welles never did.

Ford's response to the conditions facing him after World War II was to follow the pattern set by peers like Frank Capra and William Wyler by striking

out on his own. When his contract with Fox expired, he left the studio that had been his home base for so many years, even though Zanuck offered him the princely annual sum of $600,000 to renew. Never again did he commit himself to a long-term studio affiliation.[44] Instead, he partnered with Merian C. Cooper to revive their independent Argosy Pictures production company. Argosy had been founded in the late 1930s but the company had only sponsored a single film, *The Long Voyage Home*, released in 1940. Made in cooperation with Walter Wanger Productions, it flopped at the box office. Despite this inauspicious beginning, however, Ford and Cooper continued to believe in the advantages of owning a fully operational production company. Between 1940 and 1953 the two friends made ten films under the Argosy banner.[45]

Welles, by contrast, never found his footing in postwar Hollywood. After the war, he made *The Stranger* (1946) to show that he could conform to industry standards and complete a studio film on time and within budget. It was a modest success but came too late to save his reputation. Most of his subsequent projects encountered insurmountable difficulties. Some were shot over many years while he scrambled to gather the funding necessary to complete them. Even Welles's successes were never big money makers. While he dismissed the significance of his work as an actor, much of Welles's Hollywood success came from performing in films directed by others. Long after he had lost viability as a director, he had profitable acting roles in studio films.

Though Welles is justly famous for his innovative practices in filmmaking, such deviations from standard Hollywood practice do not really account for the differences between him and Ford in terms of their career trajectories. Many of Ford's films show comparable stylistic daring, including *Four Sons, The Informer, The Long Voyage Home*, and *The Fugitive* (1947). The issue was not style as much as the difference in the two directors' notions of what the job entailed and in their abilities to adjust to Hollywood's changing culture between 1928 and 1946.

3

POSTWAR HOLLYWOOD, 1947–1967

On Dangerous Ground Sarah Kozloff

Setting the Scene

No period of American film history provides us with a tidy narrative, but contra-
dictory crosscurrents and treacherous riptides particularly mark the postwar years,
between 1947 and 1967. Movie audiences had shrunk: people were flocking to the
suburbs where theaters were few and far between; the Baby Boom sidelined many
potential ticket buyers; and vast numbers took advantage of new leisure activities,
especially television. Moreover, American movies began to face new competition
from imported foreign films as international directors such as Akira Kurosawa,
François Truffaut, Federico Fellini, and Ingmar Bergman, who made daring and
personal works, won great acclaim at postwar film festivals.[1] For all these reasons,
the number of movies Hollywood churned out kept slumping until 1963, at which
point feature distribution slipped to an all-time low of 163 for the year.[2]

Ominous developments within the film industry itself also affected directors'
careers and companies' bottom lines. The 1948 Consent Decrees ended *U.S. v.*

Paramount, a longstanding legal case brought by the federal government to stop studio practices that restrained free trade and disadvantaged independent producers, distributors, and exhibitors. This court decision forced the major studios to spin off their holdings of movie theaters. In addition, the Red Scare of the postwar era, popularly named "McCarthyism," took the form of investigations by the House Un-American Activities Committee (HUAC) into Communist "infiltration" of Hollywood. These investigations started in the fall of 1947. By December the studios had instituted a "blacklist" targeting any employee associated with left-wing causes. Eventually a group of ten screenwriters, directors, and producers who had all at one time belonged to or sympathized with the Communist Party went to jail for up to a year. The Hollywood Ten were only the most conspicuous victims as anticommunists and McCarthyites waged war in the film community throughout the 1950s.

These social and economic factors combined to undermine not only American film directors' employment opportunities but also their artistic freedom. The older generation, men such as John Ford or Alfred Hitchcock who had started in the silent era, could use their autonomy as free agents and the clout of their powerful agents to get work, exert artistic control, and command high salaries. Some of the high-water marks of the postwar era, such as Howard Hawks's *Red River* (1948) and *Gentlemen Prefer Blondes* (1953), William Wyler's *Roman Holiday* (1950), Hitchcock's *Rear Window* (1954) and *Vertigo* (1958), and Ford's *The Searchers* (1956), illustrate masters working at the top of their game. Even these powerful directors, however, faced restrictions. Wyler, for instance, constantly had to fight with his producers for his films' liberal social messages.[3]

But what about younger directors starting out in this postwar era and running up against all these systemic challenges? The older generation's sensibilities became passé by the 1960s; it was the newer generation that would pave the way for Hollywood's reinvention and eventual resurgence in later decades. How did fledgling professionals navigate the choppy waters of blacklisting and censorship? How did Hollywood's economic restructuring, principally the rise of so-called "independent production," provide opportunities or pitfalls for new voices, new aesthetics, and new stories?

Two exemplary figures who launched their careers during this period confronted some of the most fraught and complicated issues facing directors of the day. Nicholas Ray (1911–1979) captured the angst of the postwar period, while Ida Lupino (1918–1995) proved that women had unique stories to tell. The titles of two of their films coincidentally describe the position of younger directors in the postwar era: *Not Wanted* (Lupino, 1947) and *On Dangerous Ground* (Ray, 1952). A close look at the production histories of these two films reveals the ingenuity and resourcefulness with which each of these directors met the challenges they faced.

A Changed Economic Structure: Independent Production

Before and during the war, most directors worked under long-term contracts with major studios where benevolently tyrannical bosses often nurtured their careers. Just as studios manufactured stars, some moguls fostered directing talent by allowing directors to work first in silent serials or in B-films and then graduating them to higher value projects. In the postwar era, many directors stuck with the studios that had served them well in the past, including Cecil B. DeMille at Paramount and George Cukor at MGM. But others were lured into the burgeoning independent production scene by the promise of more freedom and control as well as financial windfalls.

During the silent era and even during the thirties, Hollywood had always included a certain number of independent outfits.[4] Samuel Goldwyn and David O. Selznick headed boutique production units, as did the principal players of United Artists: Mary Pickford, Douglas Fairbanks, D. W. Griffith, and Charlie Chaplin. After World War II independent companies burgeoned. According to the *Motion Picture Herald*, in 1945 some 40 independent production companies were operational; by 1957, this number had grown fourfold to 165.[5] However, the growth did not proceed in a straight line: the number of companies dipped in the late 1940s and rebounded in the middle 1950s.[6] Film historian Janet Staiger estimates that in 1950, 25 percent of the features came from independent companies, while in 1956 the percentage was closer to 53 percent, and by 1959, 70 percent.[7] As the years went on, those numbers continued to fluctuate.

Financial considerations worked both for and against the independents. On one hand, independent production companies (then and now) always entail lower overhead than the major studios: they rent space as needed and hire fewer people.[8] But all independents have to scramble to lay their hands on advance funds to make a product that might or might not return profit some months or years in the future. During the postwar era these production budgets came from a variety of sources. *Variety* mentions bank loans (either from Los Angeles banks or East Coast ones); loans from distribution outfits; loans from other independent companies; or loans from the major studio that would eventually distribute the movie.[9] And no independent film could begin shooting without a deal with a major distribution chain.[10] Because they were so interdependent on conservative banks, distribution companies, and other studios, the question of how "independent" these smaller companies truly were is up for debate.[11]

The precarious economic situation of independent companies meant that few survived for any length of time. Although Republic and Monogram managed to stay afloat for years, smaller production houses bobbed and sank with astonishing frequency. Indeed, some were basically quickie tax dodges, a ruse that President Harry S. Truman called out in a national speech, claiming that

such companies took "unfair advantage of the difference between the tax rates on ordinary income and the lower tax rates on capital gains."[12] The Revenue Act of 1950 narrowed these loopholes, but stars and directors continued to be attracted to independent companies for financial gain.[13]

Independent distribution companies stood on even shakier ground than the independent production studios did; as film industry scholar Tino Balio reminds us, "Film distribution is not an ease of entry business. To operate efficiently a distribution company requires a nationwide or worldwide organization and enough cash to finance and distribute thirty to forty pictures a year."[14] Eagle-Lion Films (1946–1950) and Distributors Corporation of America (1952–1959) folded, though Allied Artists—which subsumed Monogram—buffeted many gales to survive as an integrated production and distribution company.[15]

Financial incentives were only one factor driving independent production and distribution. As the scholar J. A. Aberdeen argues, some of the independents saw themselves as renegades against studio control, romanticizing their fight against the monopoly power of the so-called Big Five (MGM, Paramount, Warner Bros., Twentieth Century–Fox, and RKO, which had all owned large chains of movie theaters) and the Little Three (Columbia, Universal, and United Artists, all without exhibition arms).[16] Some of these renegades were important Hollywood players. William Luhr noted in the previous chapter that Charlie Chaplin, Walt Disney, Samuel Goldwyn, Alexander Korda, Mary Pickford, David O. Selznick, Walter Wanger, and Orson Welles founded the Society of Independent Motion Picture Producers (SIMPP) in 1941. This organization fought against the standard fees that exhibitors gave producers, wanting a percentage of the box office instead. And SIMPP worked in tandem with the Justice Department to bring legal challenges against the majors. One of SIMPP's most vocal proponents, producer Samuel Goldwyn, publicly argued, "Hollywood has long needed the stimulus of outside competition."[17]

Strategies varied among the independents. Some produced expensive, color, widescreen epics, trying to win back the audiences that had fled to their suburban television screens. Others worked on the lower-budget side of the equation with popular genres: seedy detectives, body snatchers, teenage werewolves, and blobs proliferated in the late 1950s. Neither approach guaranteed success, however, because (a) audiences were fickle, and (b) the major studios still held the cards concerning distribution, and without a massive distribution and advertising campaign smaller film companies struggled to gain sufficient attention or profit.

Although some Hollywood directors, such as Preston Sturges, made their best movies within the studio system, supported and held in check by studio executives, almost all of them resented such interference and felt that if they could just be left alone they would create better films. As a result, many directors created or signed with independent production companies in hopes of

finding comparative autonomy. A 1946 article in the *New York Times* penned by one of the old guard, Frank Capra, stresses the advantages of independent production companies.

> Producers and directors working under [the studio head] found that instead of creating as they pleased, letting their own imagination and artistry have full rein, with the public the final judge of the worth and merit of their efforts, they were of necessity obliged to make pictures for the approval of the one man at the top. Thus the creative side of film-making . . . was tailored (consciously or unconsciously) to the tastes of the studio's head man.
>
> Multiply this situation by a half-dozen studios and you have one potent reason for the "typical Hollywood product." A half dozen head men—a half dozen funnels through which the product flowed—deciding what the public should see, and how the product should be fashioned for 100 million weekly patrons to see.[18]

For the younger generation, independent production wasn't just the director's preference; often these companies provided one's only entree into the business. As the accompanying table demonstrates, Ida Lupino and Nicholas Ray owe their careers to independent production companies. Along with intriguing data about Lupino and Ray, the table documents the length of time the production companies lasted: from the very short-lived to those surviving for two decades or more. It also allows us to see the involvement of many familiar figures. Interestingly, apart from Ida Lupino's Filmakers, I cannot find any other independent companies with female owners. Bette Davis or Barbara Stanwyck, who certainly had as much clout as Tyrone Power or Alan Ladd, did not incorporate businesses.

Ida Lupino started in independent production because she was not wanted within the ranks of directing talent. Like so many women directors throughout film history, she was able to break into directing at all only because of the status and power she amassed as an actress. Performing first in her native England and then, after emigrating, mostly for Warner Bros., she played a variety of roles, frequently women from the shady side of the street. She always kept up her acting to bring in income (she plays the female lead in Ray's *On Dangerous Ground*), but when she was thirty-one and tired of the tedious parts she was offered, she co-founded an independent company, Emerald Productions (named after her mother).[19] Emerald dissolved quickly, but Lupino went on to found The Filmakers Inc., which she co-owned with Malvin Wald and her then-husband Collier Young.[20] Lupino and Young even went so far as to publish a full-page ad in *Variety*. The text is worth quoting in full:

Table 3.1: Independent Production Companies Founded between 1931 and 1964

YEAR FOUNDED*	COMPANY NAME	STAR/DIRECTOR OR PRODUCER	YEAR DISBANDED‡	EXAMPLES OF NOTABLE FILMS
1931	Monogram/ Allied Artists	Walter Mirisch	1979	Invasion of the Body Snatchers (Siegel, 1956) Cabaret (Fosse, 1972)
1935	Republic Pictures	Herbert Yates	1959	Johnny Guitar (Ray, 1954)
1940	Argosy Productions	John Ford Merian C. Cooper	1953	3 Godfathers (Ford, 1948) The Quiet Man (Ford, 1952)
1940	Pine-Thomas	William C. Thomas William H. Pine	1957	Run for Cover (Ray, 1955)
1943	Samuel Bronston Productions	Samuel Bronston	1964	King of Kings (Ray, 1961) 55 Days at Peking (Ray, 1963)
1945	Mark Hellinger Productions	Mark Hellinger	1948	The Killers (Siodmak, 1946) The Naked City (Dassin, 1948)
1945	Liberty Films	Frank Capra Samuel J. Briskin	1951	It's a Wonderful Life (Capra, 1946) State of the Union (Capra, 1948)
1947	Robert Rossen Productions	Robert Rossen	1964	All the King's Men (1949)
1947	Santana	Humphrey Bogart	1955	Knock on Any Door (Ray, 1949) In a Lonely Place (Ray, 1950)
1948	Hecht [Hill] Lancaster	Burt Lancaster	1967	Sweet Smell of Success (Mackendrick, 1957)
1948	Horizon [Eagle] Pictures	Sam Spiegel	1985	The African Queen (Huston, 1951) The Bridge on the River Kwai (Lean, 1957)
1949	Emerald/Filmakers	Ida Lupino Collier Young	1954	Not Wanted (1949) Outrage (1950) The Bigamist (1953) The Hitch-Hiker (1953)
1949	Stanley Kramer Productions	Stanley Kramer	1954	High Noon (Zinnemann, 1952)
1950	Michael Todd Productions	Michael Todd	1958	Around the World in Eighty Days (Anderson, 1956)
1950	Wald-Krasna	Norman Krasna Jerry Wald	1952	The Lusty Men (Ray, 1952)

Table 3.1: (continued)

YEAR FOUNDED*	COMPANY NAME	STAR/DIRECTOR OR PRODUCER	YEAR DISBANDED‡	EXAMPLES OF NOTABLE FILMS
1952	Batjac/Wayne Fellows	John Wayne	1974	Big Jim McLain (Ludwig, 1952) The Alamo (Wayne, 1960)
1953	Otto Preminger / Carlyle /Gamma / Sigma Productions	Otto Preminger	1971	The Moon Is Blue (1953) The Man with the Golden Arm (1955) Exodus (1960)
1953	Figaro	Joseph Mankiewicz	1958	The Barefoot Contessa (1954) The Quiet American (1958) The Bridge on the River Kwai (Lean, 1957)
1953	Jaguar Productions	Alan Ladd	1957	Drum Beat (Daves, 1954) A Cry in the Night (Tuttle, 1956)
1954	William Goetz Productions	William Goetz	1961	The Man from Laramie (Mann, 1955)
1954	Magna-Rodgers and Hammerstein	George Skouras, Michael Todd, Joe Schenck, Rodgers, Hammerstein II	1958	Oklahoma! (Zinnemann, 1955) South Pacific (Logan, 1958)
1955	Bryna Productions	Kirk Douglas	1986	Spartacus (Kubrick, 1960)
1955	Alfred J. Hitchcock	Alfred Hitchcock	1965	The Birds (1963)
1955	Associates and Aldrich	Robert Aldrich	1972	The Big Knife (1955)
1956	Sol C. Siegel Productions	Sol Siegel	1967	High Society (Walters, 1956)
1955	Copa Productions	Tyrone Power	1957	Nightfall (Tourneur, 1957) Abandon Ship (Sale, 1957)
1956	Robert Laffont Productions	Robert Laffont	1958	Bitter Victory (Ray, 1957)
1957	Schulberg Productions	Budd Schulberg	1958	Wind across the Everglades (Ray, 1958)
1958	Baroda Productions	Gary Cooper	1961	The Hanging Tree (Daves, 1959) They Came to Condura (Rossen, 1959)
1964	Robert Wise Productions	Robert Wise	1971	The Sound of Music (1965)

Source: from AFI.com.
*Or year first film released.
‡Or year last film released under original ownership.

DECLARATION OF INDEPENDENTS

We are deep in admiration for our fellow independent producers—men like Stanley Kramer, Robert Rossen and Louis de Rochemont. They are bringing a new power and excitement to the screen. We like independence. It's tough sometimes, but it's good for the initiative. The struggle to do something different is healthy in itself. We think it is healthy for our industry as well. That is why we independent producers must continue to explore new themes, try new ideas, discover new creative talents in all departments. When any one of us profits by these methods, there is bounty for us all—major or independent. We trust that our new Filmakers Production, NEVER FEAR, is worthy of the responsibilities, which we have assumed as independent producers.[21]

Filmakers was a highly original undertaking. The company offered a new type of structure for Hollywood: it was radically collaborative, with all of the principals helping out with all of the production tasks. Budgets were tiny, though profits could be large: for example, *Not Wanted* cost $150,000 and earned back a million in revenue within a year. The company distributed its products through Film Classics, Eagle Lion, and finally RKO. Filmakers' productions also broke new aesthetic ground: the company was keen to make low-budget, semi-documentaries about important social topics. For support, Lupino cited the example of the Italian Neorealists (though the New York crime films such as Jules Dassin's 1948 *The Naked City* provide a closer model).[22] Filmakers ultimately would produce twelve movies—five directed by Lupino—before going bankrupt in 1954.[23]

Unlike Lupino, Nicholas Ray's connection with independent production was intermittent. He had a longer, more varied, and higher-profile directing career, extending from 1948 to 1963. Although his lifelong goal was to be his own producer, he was never disciplined enough to obtain this status.[24] He came to Hollywood from the New York theater scene, primarily the Theatre of Action and the Group Theatre. Though his study with the architect Frank Lloyd Wright lasted only a few months, many film critics hold this experience up as a significant influence on Ray's predilection for expressive modernist sets. Following these apprenticeships he spent years in a Federal Theatre Project traveling the South and gathering folk music, which led to directing a radio show. Then in 1945 Elia Kazan invited the nomad to Hollywood to work as his assistant on *A Tree Grows in Brooklyn*. In 1947, at age thirty-six, Ray directed his first film, *They Live by Night*, for RKO.[25] Ultimately he would make six films for RKO, but he also worked for independents like Santana Productions, Wald-Krasna, Pine-Thomas, Samuel Bronston Productions, the Samuel Goldwyn Company, Schulberg Productions, and Laffont Productions, as well as four established studios: MGM, Twentieth Century–Fox, Warner Bros., and Columbia.

Artistic Freedom and Control:
The Screen Directors Guild and Blacklisting

During the postwar era the question of whether a director had creative autonomy rested less in the company's stature and more in whether the corporate owner-ship respected a given individual's creative vision. Was the director merely an important hand in the building of the film in an assembly-line process, or was he or she the person who steered the ship? This period saw a shift toward the lat-ter model, thanks not only to the freedom and control independent production offered but also to the efforts of the Screen Directors Guild (SDG). Paradoxically, at the same time the Guild was advocating for the creative rights of its members, it was also enmeshed in gender and racial discrimination, conservative ideology, and the political strife that characterized the era as a whole. All these issues had a stifling effect on movie content.

Tracing the history of SDG provides useful context. As Virginia Wright Wex-man describes in the introduction to this volume, from its founding in 1936, the Screen Directors Guild worked to enhance its members' artistic freedom.[26] During the height of the studio era, studio supervisors controlled all elements of the production process and might or might not even consult with directors. By 1960, however, the Guild's contract agreement states that all directors "must be consulted about cast, must be able to view the rushes, notified of sneak previews, consulted on editing and music."[27] "Editing" proved to be the ultimate sticking point. In 1947 the Guild could only plead for directors to have some say over the final cut of the film.[28] Even in 1960 the Guild conceded: "The producer's decision as to all cutting and dubbing shall always be final and nothing herein contained shall be so construed as to prohibit the making of such changes as the Producer may deem fit."[29] The right of Guild members to make a "Director's Cut" prior to further tampering by producers wasn't formalized until 1964 as part of "An Artistic Bill of Rights."[30]

But before we consider the SDG as a white knight coming to the rescue of embattled *auteurs* and *artistes*, we need to acknowledge that the Guild itself constricted artistic freedom. First of all, directors had to be admitted to the Guild—which was a closed shop—and pay dues.[31] This necessarily limited Hol-lywood directors to people with the necessary financial wherewithal and "old boy," mainstream connections. Before the SDG was founded, silent-era direc-tors such as Oscar Micheaux (a pioneer of African American cinema) and Lois Weber (a path-breaking female director) were able to tackle daring subject mat-ter, but in this era the industry did not make room for such outsiders. Nicholas Ray joined the Guild without difficulty in 1947 before he started directing *They Live by Night*. Ida Lupino, however, was not permitted to join until 1950—after having directed two features—when she became only the second female director ever admitted into the Guild.[32] Although Lupino took over the direction of *Not*

Wanted three days into shooting because Elmer Clifton, the original director, had a heart attack, she never took credit. Dan Georgakas, the editor of *Cineaste*, a major film journal, claims that this was because Lupino wasn't yet a member of SDG. He further argues that both SDG and Filmakers thought that publicizing the presence of a woman behind the camera (especially with such sexual subject matter) would sink the film's prospects.[33] Thus, when a reporter visited the set Lupino tried to deny what was plain to everyone: "Ida Lupino isn't really directing this picture, you understand," the visitor wrote. "She says so herself. But it's difficult to tell just what she's doing if it isn't directing."[34] As film historian Jeanine Basinger reports, "When Lupino joined the Guild . . . meetings she attended were often opened with the greeting: 'Gentlemen and Madam.'"[35] How many more women might have become directors if they had not faced the hurdle of being admitted to what was then an all-male union?[36]

The overarching sexism Lupino faced in the film industry comes to the fore in a 1965 interview she gave to Louella and Harriet Parsons, renowned gossip columnists. The Parsons comment: "A director's job is mentally, emotionally and physically demanding. Rough on a man, it's well-nigh impossible for a woman. It involves long hours on the set, dealing tactfully but firmly with an assortment of temperaments and giving orders to an all-male crew, often skeptical of a femme [*sic*] boss." Lupino's own statements on the tribulations faced by women in the director's chair reflect the extent to which she had internalized the sexism she had encountered.

> "The chief handicap," she laughs, "is having to get up earlier than a male director, get your hair done and make-up on and look feminine. . . . Keeping a feminine approach is vital. Men hate bossy females. Instead of saying, 'Do this,' I try to make everybody a part of it. I say to the cameraman, 'I've got a wild idea. What do you think of it?' Often I pretend to know less than I do. That way you get more cooperation."[37]

Lupino got cooperation from her crews by playing an unthreatening "mother director" figure. "I hate women who order men around," she once confessed. "I say, 'darlings, mother has a problem. I'd love to do this. Can you do it? It sounds kooky, but I want to do it. Now, can you do it for me?"[38]

The Screen Directors Guild struggled not just with gender issues but also with political ones. Many of its members were deeply conservative. A full-page advertisement in *Variety* paid for by six Hollywood heavyweights including Ronald Reagan and Roy Brewer exemplifies the poisonous atmosphere of the times. The ad proclaims, "Anyone who associates with the Communist Party is *befouled* [my emphasis]."[39] The SDG was in a weak position vis-à-vis producers in this era because of deep internal discord between its liberal and conservative factions. This discord led to a highly charged meeting of 300 Guild members

at the Beverly Hills Hotel on October 22, 1950, where a right-wing group led by Cecil B. DeMille tried to unseat Joseph Mankiewicz, who was then serving as president.[40] Although the left-wing bloc ultimately won over the crowd, the Directors Guild became the first of the film guilds to institute a blacklist of its own members by requiring each to sign a loyalty oath and disavow any ties to communist or socialist groups. Hounded by conservative paranoia, left-leaning directors such as Charlie Chaplin, Orson Welles, Joseph Losey, Jules Dassin, and Abraham Polonsky left the country. Many who stayed, such as Edward Dmytryk and Elia Kazan, publicly reneged on their liberal past and named names. Other left-leaning directors privately groveled to HUAC or its representatives. Although screenwriters could work through "fronts," this was not an option for directors, who had to appear on sets and in production meetings.

Lupino could easily have run into trouble with anticommunist witch-hunters because of her liberal ideology, past political activity, and guilt by association. On *Not Wanted*, she worked with the screenwriter Paul Jarrico, who would soon face blacklisting. Another of her colleagues, Malvin Wald, a liberal screenwriter who helped her co-found Filmakers and cowrote both *Not Wanted* and *The Outrage*, was closely associated with known communists, including Jules Dassin and Albert Maltz (one of the Hollywood Ten). That she was never called to testify and never publicly hounded is something of a mystery.

The case of Nicholas Ray is even more surprising. How did Ray avoid the hounding and humiliation ceremonies that ended so many other careers? Ray had actually joined the Communist Party in the late 1930s and had many friends and lovers who were committed Party members. When the blacklist years began, Ray briefly took a liberal position. He was one of the twenty-six directors who stepped forward to sign the petition demanding that October 1950 emergency meeting of the Directors Guild at the Beverly Hills Hotel. But ultimately he emerged unscathed from all his left-wing associations, subsequently serving two terms on the SDG board and continuing to direct without facing any public challenge. His biographers point to his close friendship with Howard Hughes. Hughes, who owned RKO from 1948 to 1952, exerted great power in right-wing political circles in postwar Hollywood and protected Ray as his protégé. Bernard Eisenschitz speculates that outside of the limelight Ray must also have gone through some kind of clearance process and privately named names.[41]

The anticommunist sentiment that prevailed in Hollywood also affected the movies directors were able to make. Dorothy Jones, a historian who studied movie content for the brave and invaluable publication *Report on Blacklisting*, claims that the HUAC hearings and the blacklist had a chilling effect overall on the release of social problem films.[42] Thus, no matter what company they were working for, filmmakers like Lupino and Ray were not free to make films as critical of society or as hard-hitting as they might have liked.

Lupino often spoke explicitly about wanting to make films about social problems. *Not Wanted* treats unwed motherhood. Lupino addressed this issue when Anna Roosevelt interviewed her on a radio broadcast:

ROOSEVELT: Isn't that [unwed motherhood] a pretty touchy subject for the screen, Ida?

LUPINO: Yes, I suppose it would be considered that. As a matter of fact, several of the studios have turned down this picture because they were afraid of it. However . . . we are now bringing to the screen a film which will show the public the heartbreak of the unwed mother. We even think the picture will help to show what can be done about this social problem.[43]

Lupino's later productions demonstrate equal daring. *Never Fear* (1949) foregrounds polio and paralysis; *The Outrage* (1950) centers on a young woman's trauma after being raped; *Hard, Fast and Beautiful* (1951) focuses on a mother who is unfulfilled in her marriage and tries to use her daughter's career as a tennis star for her own greed and social advancement; *The Bigamist* (1953) is about a man who finds himself married to two women.

Similarly, Ray's *In a Lonely Place* (1950) and *Johnny Guitar* (1954) attack witch-hunting head-on; *They Live by Night* (1948) and *Knock on Any Door* (1949) take the side of society's underdogs; and *Rebel without a Cause* (1955) became the rallying point for a younger generation dissatisfied with their elders' hypocrisies and cowardice. *Bigger Than Life* (1956) critiques middle-class American duplicity. Many of Ray's films reveal the explosive violence inside seemingly peaceful people and the ease with which a group of citizens can turn into a lynch mob.

Comparing the Ray and Lupino films with the popular movies of the fifties throws the audaciousness of their social themes and noir atmosphere into relief.[44] This is the decade when the Freed Unit of MGM scored with *An American in Paris* (1951) and *Singin' in the Rain* (1952); Paramount put its chips on Cecil B. DeMille's *The Greatest Show on Earth* (1952) and *The Ten Commandments* (1955); and Disney entertained families with *Cinderella* (1950), *The Lady and the Tramp* (1955), and *101 Dalmatians* (1961). Certainly other liberal moviemakers chose to create politically challenging films—for instance, screenwriter Carl Foreman, director Fred Zinnemann, and producer Stanley Kramer collaborated on *High Noon* in 1952—but to do so was a courageous act.

One sees just how risky bucking conservative forces could be by looking at the case of *Salt of the Earth* (1954). Three blacklisted professionals, screenwriter Michael Wilson, producer Paul Jarrico, and director Herbert Biberman, collaborated to shoot this film in New Mexico, using a non-union crew and nonprofessional actors, and basing it on the real-life tribulations of zinc miners. Because this film presents a searing discussion of racism, unionization,

dangerous working conditions, official corruption, and gender inequality, powerful forces, led by Howard Hughes, colluded against it, guaranteeing that labs would not process the footage and union projectionists would not run it. The film could not be distributed; it was effectively squashed.

Censorship

From the 1920s through the 1950s, the Hollywood studios supported a quasi-independent organization charged with censoring movies. Its official name was the Production Code of America (PCA), but it was often referred to as the Hays Office after its first head, Will Hays. In 1934, in the wake of several high-profile movie industry scandals, Joseph Breen took over the office and doubled down on its charge. The PCA's purpose was to protect each film and shield the industry as a whole from public outcry.[45] The Catholic Legion of Decency served a similar purpose with a rating system that marked films as objectionable by branding them "C" for "condemned."

By the fifties, the PCA was no longer as powerful as it had been when it fined *Gone with the Wind* for using the word "damn." According to Simon Whitney, one of the side effects of the antitrust litigation was that the PCA quietly dropped its fine of $25,000 for any theater that showed a film without a seal after the 1948 consent decrees between the major studios and the federal government that settled the antitrust case *U.S. v. Paramount*. Thus, as Whitney points out, "In 1953, 7,000 theaters played Otto Preminger's *The Moon Is Blue* without the seal—a show of independence which both the producer, jubilantly, and an officer of the Legion of Decency, regretfully, attributed to the new freedom of theaters since divorcement."[46] An additional factor that undercut the PCA moralists was that imported foreign films were much less prudish about sex, and American filmmakers resented being held to a puritanical standard. Nonetheless, the negotiations waged over Lupino's *Not Wanted* and Ray's *On Dangerous Ground* illustrate the ways in which the PCA repeatedly forced both directors to compromise and pull their punches. Portraying a young woman as pregnant out of wedlock was seen as a threat to the country's morals. Ray's film about a policeman gone rogue and violent could not be allowed to make audiences question the American legal system.

Film scholar Diane Waldman has thoroughly traced the censorship history of *Not Wanted*, from the first treatment by Paul Jarrico and Malvin Wald, entitled *Bad Company*, to the finished film with a script by Jarrico and Lupino.[47] Waldman puts unwed motherhood in the context of the late forties, when the discourse about this issue was in the midst of switching from religious/redemptive models to psychological explanations. Thus, Sally, the film's protagonist, is portrayed more as a naïve young girl than as a fallen woman.

The process of getting PCA approval for the project began on June 11, 1948, when Enterprise Productions submitted a treatment then entitled *Bad Company* to the Breen Office. This version differs from the final film in key respects: the heroine is only sixteen; her seducer is a college boy out for an easy score; and her eventual husband is not an injured veteran. The Breen Office's response read in part, "The theme, as it is treated in this present version, is utterly impossible under the code."[48] Six months later, a different producer came back with the same story. On December 6, 1948, the PCA wrote a memo detailing the following requirements.

1. The youngsters involved should be raised above the high school level . . .

2. The parents should not be depicted as inept nincompoops; this to avoid throwing the sympathy with the sin as well as the sinner.

3. [The producer] should be sure that in the preparation of his screen story, the sin is shown to be *wrong*. We told him that this was the *most important* item of them all.

4. He would have to watch very carefully the *details* of the illicit relationships.

The Breen Office mandated that the seduction occur offscreen and voiced concern about "the questions of labor and childbirth. Not only is this an extremely delicate subject from the point of view of the Code, but also it can prove a seriously embarrassing subject from the point of view of audience reception."[49]

When Emerald took over the property and Lupino helped rewrite the script, she acceded to the Production Code requirements and made every effort to cooperate with and charm the PCA. She fell all over herself in praising the Breen Office's help in getting her controversial films made. For example, she told a reporter: "I found them amazingly helpful. . . . We went over the script with them and they pointed out what it must do. They virtually wrote the story for us."[50]

The finished film follows the PCA guidelines. It continually stresses religion, especially in the scenes in the Haven Hospital for unwed mothers; and the marketing campaign presents the story as a moral lesson. Responding to these cues, *Time* magazine found it an "earnest and unadorned account of a tragic problem."[51] Yet at the same time it condemns the sin, *Not Wanted* clearly sympathizes with Sally, the sinner. Often Lupino frames the action from Sally's point of view. The film makes the viewer understand her sexual desire for Steve, the man who seduces and eventually abandons her, and her reluctance to return to her parents.[52] As Waldman notes, changing the title to *Not Wanted* changes the film's

meaning. The baby is "not wanted"; Sally is "not wanted" by Steve; the unwed mother is "not wanted" by society; and Drew, the injured veteran, is "not wanted" by Sally. While Lupino made every effort to placate the PCA, at the same time she transformed the story so that it became less a moral lesson than a poignant exposé of unreciprocated love, less a glamorous Hollywood melodrama about good and evil than a study of the blighted prospects of the lower classes. As critic Ronnie Scheib eloquently states,

> Lupino's movies are small-scale rite-of-passage films, passage into womanhood, into nightmare, into lack of control. Cast out of a familiar, protective environment, torn by conflicting desires or no desire at all, Lupino's characters do not know how to act. Their "problems"—rape, polio, illegitimate children, bigamy—have put them beyond the pale, beyond the patterned security of their foreseeable futures. The "problem" is not how to reintegrate them back into the mainstream; the "problem" is the shallowness of the mainstream and the void it projects around them—the essential passivity of readymade lives.[53]

Not Wanted fits Scheib's pattern well; viewers can hardly fail to notice the shallowness of a mainstream postwar society that crushes all the characters.

Like *Not Wanted*, Ray's movie departs from clear generic models, in this case blending film noir with expressionist fable. Gerald Butler's novel, on which *On Dangerous Ground* is based, was originally entitled *Mad with Much Heart*. The

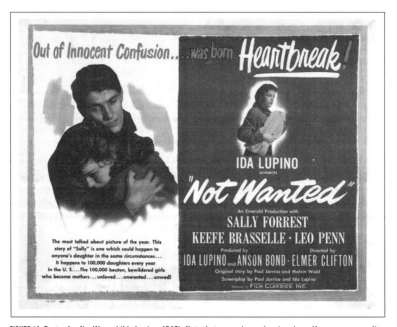

FIGURE 14: Poster for *Not Wanted* (Ida Lupino, 1949). Note that as producer she gives herself possessory credit.

book chronicles the spiritual redemption of big-city police detective Jim Wilson, which takes place while he chases down a child murderer in the country.[54] Ray was taken with the story and worked with screenwriter A. I. Bezzerides to adapt it. The film and novel differ, however, in that the novel starts with the chase in the (English) countryside. The film, by contrast, invents a whole backstory for Wilson about how working in the depths of depravity in the city has hardened him and made him violent. In its treatment of police brutality, *On Dangerous Ground* echoes Sidney Kingsley's play *Detective Story*, which Ray saw in New York while he was working on the script.[55]

The screenwriters were well aware that the screenplay followed an unusual structure. They included a preface when they submitted it to the PCA:

> This story is in three parts, which vary sharply in style:
>
> Part One—Night in the city. The tempo is swift, harsh and relentless: we witness numerous apparently unrelated and anonymous duties on the Special Squad of a big city police force. This is the life that has made Jim the man he is.
>
> Part Two—The open country. With its rolling hills, snow-covered and desolate, this is the scene against which Jim Wilson discovers the meaning of his life. This action, no less violent that the others, has the deep significance of a personal tragedy.
>
> Part Three—Return to the City. In this brutal, garish echo of part one, Jim resolves his destiny.[56]

The script was sent to the PCA on March 9, 1950, and the return letter baldly stated that the censors found it unacceptable.

> The specific reason for this unacceptability lies in the *excessive* and sadistic portrayal of cruelty and brutality in the person of our lead, Jim Wilson. . . . In the actual telling of the story, the portrayal of the brutality goes entirely too far. Not only would this constitute a Code violation, but you will realize, of course, that it would be a serious censor board problem which would unquestionably subject the picture to extensive cutting and possibly even rejection, especially in the many municipalities where censor control is exercised by the police department. . . .
>
> It goes without saying that there is no prohibition in the Code against telling the story of a police officer who has gone sour. However, as a practical matter, it seems to us that there is imminent danger of lessening respect for law and order in telling a vivid story of one policeman who is savagely . . . brutal in his conduct without, at the same time, taking some pains to point out and emphasize that this is only one man in a large force of otherwise decent men.[57]

Although the PCA admits that nothing in the Code prohibits showing the police in a negative light, the office's instinctive desire not to offend authorities comes to the fore. On March 23, 1950, two members of the PCA met with Ray, producer John Houseman, and RKO staffer Harold Melniker.[58] A letter confirming their discussion reads in part: "The first [method of solving the problem of the film's brutality] would have to do with the actual photographing of the violence, which was the problem of the director. You assured us that you could achieve your objectives just as well by *indicating* the violence and suggesting it, rather than by actually photographing it."

Ray envisioned *On Dangerous Ground* as a critique of police authority. He wanted to show how the power of the police to enforce justice could lead to callousness and a sickness in the soul. To this end, he and Bezzerides submitted revision after revision to the PCA. On May 8 Breen worried, "In examining this new material, it seems to us that the danger of excessive violence and brutality, over which we are very fearful in this story, is beginning to creep in a little more extensively than in the previous version." PCA approval was finally granted on April 4, 1951, more than a year after scripts had been submitted and shooting had been completed. The finished film still suggests Wilson's brutality through Robert Ryan's performance and the noir atmosphere of the city scenes, without actually showing much violence on the screen. Partly because of the difficulties in

FIGURE 15: Robert Ryan as Jim Wilson with an informant in *On Dangerous Ground* (Nicholas Ray, 1952). "You make me do it. Why do you make me do it? You know you're gonna talk. I'm gonna make you talk. I always make you punks talk. Why do you do it?"

coming up with an acceptable final cut, *On Dangerous Ground* was not released until February 1952, making it almost two years from script to distribution. Ultimately, the film lost half a million dollars.

New Aesthetics: Location Shooting and Nuanced Acting

When their projects went into production, Lupino and Ray followed similar paths. Both exploited the virtues offered by filming actual locations. Their superior skills in guiding actors came into play at this stage as well. The production phase also offered them further possibilities for tinkering with the scripts, and both directors took advantage of this opportunity to change the endings of their films.

One of the most telling features of both *Not Wanted* and *On Dangerous Ground* is the amount of on-location cinematography they both include. Shooting on location had two great advantages. First, it eliminated paying for studio space. Second, it offered Lupino and Ray the opportunity of working outside the direct gaze of producers and studios, and union rules could be relaxed a touch. Finally, for both directors, natural scenery took on thematic resonance.

Ida Lupino made shooting on location an integral part of her semi-documentary style. Large sections of *Never Fear* were shot at a rehabilitation hospital, while *The Hitchhiker* was shot outside in rural areas of California. *Not Wanted* was filmed in fourteen days in and around Los Angeles. Ronnie Scheib stresses the dichotomy in Lupino's films between this "open-ended 'documentary' autonomy of real location space" and her melodramatic story lines, a dichotomy shared by Rossellini and De Sica's Italian Neorealist films.[59] The final chase sequence in *Not Wanted*, during which Drew pursues Sally to keep her from committing suicide after she has been released from the police station, is a good example of this dichotomy. The scene has occasioned much criticism for its melodramatic excess, but here, as in earlier scenes, any sentimentality is leavened by the prosaic nature of the setting, as Lupino and her cinematographer, Henry Freulich, skillfully depict the seedier side of Los Angeles with moving cameras, angled compositions, and natural light in a way that recalls Neorealist films. Francine Parker calls this "silent long last scene . . . one of the most moving, beautifully shot scenes of any film."[60]

In *On Dangerous Ground*, as well as in his later films, Ray's use of locations was more poetic and psychological than documentary: locations create an atmosphere that comments on the characters and the action. For instance, *Run for Cover* (1955) uses landscapes not to celebrate the beauty of the American West but to suggest the main character's sense of desolation when he discovers that his protégé has betrayed him, or to portray the idyllic comfort of the homestead he establishes with his fiancée. In *Rebel without a Cause*, Ray famously uses the

FIGURE 16: Sally briefly considers jumping during her flight from Drew through real exterior locations in *Not Wanted.*

FIGURE 17: Drew collapses on a jaggedly picturesque bridge in *Not Wanted.*

Griffith Observatory to show the teens' feelings of insignificance as they consider their place in the cosmos.

Though Ray's great talent lay in his ability to compose shots in color and widescreen formats, *On Dangerous Ground* shows his sensitivity to the possibilities of black-and-white cinematography and to composition in the squarish Academy ratio of 4:3. The long tracking shots of the snow-covered countryside, so memorable in the car chase, convey Jim's metaphysical journey from the dark recesses of the city to the cold purity of the country. Bernard Eisenschitz describes the

bleak snow-covered scenes in this film, which Ray and his director of photography George Diskant shot in late March 1950 near Granby, Colorado, as "a quest for lost innocence."[61] The film's evocative power also stems from its score, which producer Houseman commissioned from Bernard Herrmann.[62] This famous score deepens the audience's involvement with Wilson by contrasting two motifs: the "hunting horn" theme, which alludes to the obsessive nature of Jim's pursuit of the killer; and a plaintive leitmotif featuring strings and woodwinds, which is associated with the redemptive power of the love he begins to feel for Mary, the murderer's blind sister.

Both Lupino and Ray had advantages over many other directors of the time period because of their skill with actors. Though many crowd-pleasers of the day such as *How to Marry a Millionaire* (Jean Negulesco, 1953) foregrounded costumes and physical attractiveness, other performances moved away from glamour and sex appeal to prioritize psychology. In his introduction to *Larger Than Life: Movie Stars of the 1950s*, film scholar R. Barton Palmer argues, "If the movies of the 1950s mostly shied away from the more controversial areas of national and international politics, some of the era's most notable releases at least launched the celluloid examination of psychological 'truth,' with more searching dramatizations of the inner life than had previously been brought to the screen."[63] Both *Not Wanted* and *On Dangerous Ground* make the most of this new emphasis on character psychology.

Lupino drew on her extensive acting background to craft the performances in films she directed. She often hired unknowns; in *Not Wanted* both Sally Forrest, who played the lead, and Keefe Brasselle, who played the wounded veteran,

FIGURE 18: The snowy exteriors of *On Dangerous Ground*.

had their first major roles. A visitor to the set shows how gently and specifically Lupino guided these novices by describing ways they could use their bodies to express their characters' inner feelings:

> "Sally, when you come down those steps you're beat. You have no place to go. You have nobody to turn to, but the last person in the world you want to see is Keefe." . . . Sally does it again, only this time she isn't turning her body properly, she isn't feeling the dejection, and Keefe moves toward her too quickly. Miss Lupino says, "Turn your head slowly. Ask yourself where you're going. Then when you see Keefe, turn your whole body toward him quickly, hold it, then turn away from him and run. And, Keefe, when I yell your name, take out after her."[64]

Ray, too, was adept at coaching actors, with many performers doing their best work for him. Ray worked quietly with his casts; his biographers stress both how inarticulate he was and yet how mysteriously magnetic. Ray trusted actors and made them feel safe enough to be able to express deep and complicated emotions. This strategy often led to inspired moments of improvisation, as happens in *On Dangerous Ground* during the final meeting between Jim (Robert Ryan) and Mary (Ida Lupino). A visitor to the set describes the way in which Ray coached Ryan and Lupino before shooting this scene. "Ray, a quiet man, practically whispers directions to his actors. He took Robert Ryan aside and solemnly whispered in his ear. Ryan nodded. Then Ray went to Miss Lupino and whispered to her. She nodded. Ray moved behind the camera, and the scene was shot. They did it again. More whispering. Miss Lupino took more preparation, and it was done."[65]

In both films the endings found in the scripts given to the PCA were changed in the final versions to focus on the transformed psyches of their troubled protagonists, making their futures seem brighter. In *Not Wanted*, Ida Lupino cuts out the moralistic words Drew was supposed to speak about forgiving Sally's sin, making the ending less didactic and patriarchal and shifting the emphasis to Sally's own perception of her new situation.[66] In *On Dangerous Ground*, Ray insisted, over Bezzerides's and John Houseman's objections, that Jim return to Mary at the story's conclusion, making the film much more hopeful about their romance and Jim's potential regeneration.[67]

Shifting Currents: Into the 1960s

During the late 1950s and early 1960s not only young directors but all of Hollywood trod on dangerous ground. Widescreen Technicolor epics ruled the day: each company—whether independent or major—bet the house on a big score. Sometimes they struck gold and sometimes they struck out. One casualty was

RKO. After several years of erratic ownership, during which many of the most experienced talent left the studio, Howard Hughes sold the studio in 1955. In 1957 the original RKO ceased production: one of the original Big Five had folded. Many of the independents suffered similar fates, in some instances curtailing the careers of the creatively ambitious directors who had launched them with such high ideals. Frank Capra's independent production company, which he had hopefully named Liberty Films, quickly slid into financial trouble, and in 1947 he had to sell it to Paramount. In hindsight he believes that founding it proved virtually fatal to his professional career and selling it contributed to Hollywood's postwar downward slide.[68]

In 1954 Filmakers also closed its doors. One reason often cited is that the company tried to move into independent distribution after realizing that Hughes at RKO had maneuvered them a raw deal by charging all advertising costs back to them.[69] But it was also true that the serious-themed, black-and-white, low-budget, Academy-ratio films that Lupino favored also didn't offer enough potential profit.

At the same time that many of the independents were folding, however, others managed not just to survive but also to alter the culture of Hollywood, perhaps because, within their limitations, they were willing to take more risks and shake up the studio system. Bryna Productions (distributing through Universal) and Alpha and Carlyle Productions (distributing through United Artists) both broke the blacklist by hiring Dalton Trumbo—one of the infamous Hollywood Ten—to write *Spartacus* (Stanley Kubrick, 1960) and *Exodus* (Otto Preminger, 1960), respectively.

An independent outfit was also responsible for breaking the power of the Production Code. In 1952 the Supreme Court issued a decision in *Joseph Burstyn v. Wilson*, famous in film history as the "Miracle" Decision, ruling that the First Amendment, the right to free speech, covers motion pictures too. Burstyn was an independent distributor of foreign films in the United States and Wilson the commissioner of education of the State of New York. When New York closed down Burstyn's screenings of Roberto Rossellini's *Il Miracolo* (in which a disturbed woman believes she is the Virgin Mary) because of complaints that the film was sacrilegious, Burstyn sued and eventually won.

Even before the polemics of French New Wave theorists were translated in the 1960s, the status and power of directors in comparison with writers, studios, or producers became a pressing issue in Hollywood. One of the most contentious areas concerned so-called possessory credits, that is, when a director puts his name above the title with an apostrophe. In 1955 the Screenwriters Guild brought suit against Otto Preminger for giving himself possessory credit on *The Man with a Golden Arm*. (Preminger may have stirred headlines, but other directors, such as Hitchcock, Capra, and George Stevens, had long been asserting their ownership and creativity by taking this controversial credit.)[70] The SWG lost this battle, but they did not give up, challenging the Directors Guild on this issue

repeatedly. In 1966, the SWG cut a deal with producers denying directors such bylines, but the next year the Directors Guild filed suit in protest, offering statements by Hitchcock, Capra, Zinnemann, and King Vidor claiming that they were entitled to such billing.[71] In 1968 directors even threatened to strike unless this demand was accepted.[72] The issue of which filmmakers should have the right to call themselves a film's prime author played out on the international stage as well. As early as 1956, *Variety* reported on a meeting held in Paris by the International Association of Film Authors. "Producers Not Creators, So Say Authors at Paris Meet," read the headline. The body of the piece continued: "Directors, screenwriters, and composers are the true creators, not the producers. Films, as an art, need liberty to serve mankind."[73]

How did Lupino and Ray fare during this fraught decade?

With the exception of one late opportunity, Columbia's *The Trouble with Angels* (1966), after Filmakers' demise, Lupino was never again hired by a film company to direct a feature. Thus, we will never know what she could have been capable of had she been allotted ample resources or supported by powerful backers. And despite the feminist scholarship that has shed new light on her accomplished oeuvre, she remains a marginal figure in the history of cinema: several of her films are still not available for viewing outside of archives. Through her Hollywood connections, however, Lupino was able to shift to television, which, because it paid lower salaries, was more open to hiring people of diverse backgrounds (including those shut out of Hollywood for liberal activism). For the rest of her career as an actress and a director she worked steadily in TV, helming episodes of such well-known series as *Have Gun, Will Travel*, *The Twilight Zone*, *Gilligan's Island*, and *Alfred Hitchcock Presents*.

Meanwhile, Nicholas Ray continued directing feature films for many more years, mostly for major studios. *Rebel without a Cause*, produced and distributed by Warner Bros., represented the height of his public success, and Ray soon after found himself lionized as the exemplary auteur by *Cahiers du cinéma*.[74] Following the trend of runaway production, he shot several of his later films abroad. However, Ray's personal demons—insecurity, gambling, drugs, and alcohol—became so intense that he collapsed on the set of *55 Days at Peking* (1963) and was barred from finishing it.

While Lupino's and Ray's Hollywood careers languished, in New York City a younger generation of directors, including Arthur Penn, Sidney Lumet, Martin Ritt, and Sydney Pollack, all of whom had served their apprenticeships in television, came to the fore with new techniques and new perspectives. They were unafraid of social issues—indeed, drawn to left-wing causes—and eager to work on location away from Hollywood. They embraced low budgets and experimented with flashbacks and flash-forwards. In films such as *The Miracle Worker* (1962), *The Pawnbroker* (1964), *Hud* (1963), and *They Shoot Horses Don't They?* (1969), these four directors combined raw vitality, location shooting,

and intense performances by vibrant young actors with the existential angst of Lupino and Ray. A decade later, one can see these same qualities in Claudia Weill's *Girlfriends* (1978). Looked at in this light, both Ida Lupino and Nicholas Ray served as precursors to the edgy cinema of the sixties that lay just beyond the horizon.

4

THE AUTEUR RENAISSANCE, 1968-1980

A Culture of Rebellion Daniel Langford

Perhaps no other time in American film history is more associated with directors than the period of the late 1960s and 1970s, commonly referred to as the auteur renaissance. Popular books such as Peter Biskind's *Easy Riders, Raging Bulls: How the Sex-Drugs-and-Rock 'n' Roll Generation Saved Hollywood* and documentaries such as *A Decade under the Influence* (Ted Demme and Richard LaGravenese, 2003) have chronicled this time period based on tell-all interviews and the filmographies of monumental figures such as Martin Scorsese and Francis Ford Coppola.[1] The auteur renaissance, sometimes called the New Hollywood, is typically viewed as a golden age of filmmaking when passionate directors were given the freedom to forge ahead against the tired conventions of Old Hollywood.[2]

The shift that took place in the film industry during this time has been attributed largely to the French auteur theory, which espoused the idea that a skilled director could function as the primary author of a film and use it as an outlet for personal expression. Young people, especially, were drawn to this newly serious attitude toward film as art form created by director-auteurs. Auteurism took hold among young American directors and film-literate audiences just as

a recession was dogging the industry during the years 1969–1971.[3] Hollywood had responded to the burgeoning youth market a few years earlier with several unconventional films targeted at young audiences, most notably Mike Nichols's *The Graduate* and Arthur Penn's *Bonnie and Clyde*, both of which opened in 1967. The directors of these breakout hits were based in New York, not Hollywood, and each brought with him an innovative sensibility and sense of style that charmed critics as well as audiences. Major film studios took note and began hiring younger directors with unorthodox visions. In many cases these untried talents were given considerable creative control. Film scholar Thomas Elsaesser best describes the American appropriation of the French auteur theory during this time by noting, "What is perhaps elided is the difference between the romantic conception of the artist-auteur (of the New Hollywood) and the classical artist-auteur: where the latter makes his voice heard within the system and its many constraints, the former sets himself off against the system."[4] In other words, the young rebel directors of the 1970s didn't want to create art within the system; they wanted to transform the system itself.

For critically acclaimed auteurs like Scorsese and Coppola, the auteur renaissance has to be seen as a tension between directorial free enterprise and the limitations of a hierarchical and economically motivated film industry. Film historian David Cook has offered the most thorough examination of the canonical 1970s American auteurs, articulating three categories of directors: an older generation born in the 1920s that broke out with several hits in the late 1960s (Stanley Kubrick, Robert Altman, Sam Peckinpah, and Arthur Penn), another group coming from parallel professions and industries (Mike Nichols, Peter Bogdanovich, Alan J. Pakula, Woody Allen, Mel Brooks, and many more), and finally the film school graduate movie brats (Francis Ford Coppola, George Lucas, Steven Spielberg, Martin Scorsese, and Brian De Palma).[5] Although Cook notes that niche talents like Woody Allen and Mel Brooks crafted auteurist careers primarily in one genre, most of these figures moved across popular genres. Some, like Altman or Bogdanovich, survived on several modest hits and a significant degree of cultural capital provided by critical institutions. Others, like Coppola, Lucas, and Spielberg, were able to transition from smaller projects to the growing trend toward blockbuster filmmaking.

Auteurism involved much more than the personal beliefs of certain directors and critics; it was also a discourse of film development and production organization that captured the film industry's attention during a crucial time period. By the late 1960s, poor decisions made by major studio executives had pushed Hollywood into a costly recession.[6] This downturn followed the much longer downward trend in theatrical revenues during the postwar era thanks to suburbanization, the rise of television, and the 1948 Paramount Consent Decree, which forced the sale of the major studios' theater chains, challenging the Hollywood's oligopolistic control of the theatrical market.[7] Nonetheless, despite

several notorious flops, big-budget hit musicals like *Funny Girl* (1968) and *Fiddler on the Roof* (1971) propped up the box office into the early 1970s.[8] But the critical mockery of family-oriented musicals of the time as culturally obsolete reveals a growing feeling of generational disgust for traditional filmmaking practices among young audiences and filmmakers.[9] Taken by itself, however, this antipathy does not explain how the importance of a rebellion against Hollywood became a key component of directorial authorship during the auteur renaissance. Though the French had provided the initial concept and Hollywood's recent excesses the bad object, the 1960s cultural milieu also involved an emphasis on individual creativity championed in youth-oriented gatherings and political movements, as well as in businesses across the country.

Rather than simply repeat or deny the accepted tropes of maverick auteurs fighting corporate conservatism, this chapter contextualizes the film industry's relation to directors during this era, reaching beyond the select roster of successful auteurs who have functioned as the time period's regular spokespersons. Hollywood's embrace of the auteur ideal led to new—albeit short-lived—director-driven studio configurations. Production programs linked to major studios, including Columbia's BBS Productions and Universal's unnamed unit led by Ned Tanen, exemplify the range of allowed experimentation. However, the art-film inclinations of Hollywood's young auteurs were soon reined in by Hollywood's adherence to genre-based filmmaking. The conservative biases of the studios operated especially forcefully in relation to black directors, who were briefly welcomed in Hollywood during this era but quickly shunted aside.

Youth Hits and Rebellious Auteurs: Director-Driven Filmmaking at the Major Studios

The two standard auteur renaissance harbingers, *Bonnie and Clyde* and *The Graduate*, offer insights as to how youth-oriented, director-driven films quickly drew the attention of the Hollywood majors despite their untested content. Both these films and their directors were hailed by critics as representing a significant thematic and formal shift from movies released earlier in the decade. More importantly, as the two films played in theaters through 1968 they became major box office hits. Actor-producer Warren Beatty sold Warner Bros. on *Bonnie and Clyde* as a violent, formally inventive take on the gangster formula that featured alienated young protagonists. The larger hit, however, came when Joseph Levine's independent production and distribution company Embassy Pictures released *The Graduate*. While *Bonnie and Clyde* placed among the top-grossing films during its run between 1967 and 1968, *The Graduate* proved to be a much bigger success and also generated a lucrative sound track album.[10] One could arguably call *The Graduate* an updated romantic comedy, but its emphasis

on contemporary youth and frank sexuality offered content more attractive to exploitation masterminds like Levine than to more cautious studio executives.

Throughout the 1960s and 1970s, independent exploitation distributors such as Avco Embassy and American International Pictures briefly reached the status of mini-majors and challenged the major studios by releasing highly profitable movies that seemed less formulaic and more controversial than the average studio film.[11] During Hollywood's recession in the 1960s these independent distributors took a larger market share than in previous years, but, lacking the distribution muscle of the majors, they were limited in what they could achieve. Studio distribution remained a key component for reaching a mainstream audience, and throughout the 1970s the seven major studio distributors earned 90 percent of theatrical revenues despite releasing only one-third of MPAA-rated films.[12] However, the success of more unusual movies like *The Graduate* spurred the majors to shore up their leading position at the box office by testing the limits of youth-targeted content and authorial freedom.

Only a few years earlier Arthur Penn had been given free rein by a major studio to explore alienation and make an innovative American art film. Like Robert Altman and Stanley Kubrick, Penn was one of the older auteurs of the 1970s, and by then he had had extensive industry experience. Following his successful 1962 film *The Miracle Worker*, Columbia offered Penn a two-film deal to finance and release any movie he wanted to make, giving him creative control over the production process.[13] To offset risk, the films were budgeted at one million dollars. Using this situation to his advantage, Penn released *Mickey One* in 1965. The picture starred Warren Beatty as a nightclub comic in Detroit who, for mysterious reasons, has incited the wrath of the gangster underworld and must assume a new identity in order to escape punishment. Like a European art film, *Mickey One* was steeped in paranoia and emphasized atmosphere over narrative clarity.[14] Not surprisingly, the film struggled to find an audience. Even after this chastening experience, Columbia continued to experiment with director-driven art films, but the obscurity and financial failure of *Mickey One* in comparison to the genre-driven *Bonnie and Clyde* would be an ongoing factor in the studios' management of auteur directors.

One of the most iconic examples of the way in which directorial agency could be both embraced and complicated by industrial reality was the short-lived production house BBS. Though it had only produced eight films before its dissolution in the early years of the decade, BBS has become an iconic character reappearing in many accounts of the auteur renaissance narrative, even garnering its own Blu-ray box set, *America Lost and Found: The BBS Story* (Criterion, 2010). The boutique studio was launched in 1965 when Bert Schneider and Bob Rafelson resigned from Screen Gems, Columbia's TV subsidiary, to form their own independent company, Raybert Productions. In the same year Columbia signed Raybert to an exclusive contract to produce television shows and feature

films.[15] Raybert's first project for Screen Gems was a successful television program, *The Monkees*, built around a rock group modeled after the Beatles, which aired during the years 1966–1968. However, in 1968 the company's first film, *Head*, which also featured the Monkees and was directed by Rafelson, flopped at the box office.[16] Despite this embarrassment, Schneider and Rafelson achieved a massive payday and the attention of Hollywood after financing *Easy Rider*, helmed by first-time director Dennis Hopper, which grossed an estimated $50 million from a $325,000 budget.[17]

Financing independently produced offbeat films like *Easy Rider* with risk-reducing low budgets was not at all a new practice for the major studios, as Sarah Kozloff explains in the third chapter of this volume.[18] A movie with a budget as small as *Easy Rider*'s that managed to capture the elusive youth market inevitably caught the attention of an industry that had always been alert to mining new revenue streams. Thus it was not surprising that, after Rafelson and Schneider partnered with Screen Gems executive Steve Blauner and changed their name to BBS (Bob, Bert, and Steve) Productions, Columbia contracted with the independent outfit to make six more films. BBS would finance the pictures for less than one million dollars each, while Columbia guaranteed to recoup each film's negative cost and distribute it upon receipt of the final print.[19] Some of the director-driven projects BBS sponsored, including *Five Easy Pieces* (Bob Rafelson, 1970) and *The Last Picture Show* (Peter Bogdanovich, 1971), were considered financial and critical successes, while others such as *A Safe Place* (Henry Jaglom, 1971), *Drive, He Said* (Jack Nicholson, 1971), and *The King of Marvin Gardens* (Bob Rafelson, 1972) flopped.[20]

The BBS founders took full advantage of the company's high profile to argue for the right of directors to demand artistic freedom from oversight on their films as the answer to the major studios' sagging box office and outdated product. Schneider not only advocated for directorial authorship, he also articulated the ideal of personal filmmaking as an explicit contrast to traditional studio practices, which he saw as dependent on marketable premises and stars. In the *Five Easy Pieces* press book, he claimed, "We do not care what the story content of a film is, who the stars are, or if there are stars involved. We are concerned only with who is making the film. If his [*sic*] energy and personality project something unique, he is given the freedom and the help to express himself. We'll gamble that films will reflect those personal qualities."[21]

Rafelson, who directed BBS's *Head*, *Five Easy Pieces*, and *The King of Marvin Gardens*, echoed Schneider's arguments in various press interviews: "What this business needs is not better directors, but better producers who are willing to give directors with the ideas a chance to do films their own way, with all the freedom that entails. It's not just final cut, it's final everything. If the studios won't do it, then our company will back young directors and finance their pictures ourselves."[22] In another interview, Rafelson followed this logic

to argue that the decision to finance *Easy Rider* was made entirely on Dennis Hopper's "strong conviction" and "vision" rather than any cultural or countercultural calculation.[23] Holding the dual role of executive producer and director, Rafelson made impassioned arguments that the industry's ultimate failure was its refusal to bankroll passionate young directors (like Hopper and himself) with complete creative control. Trade papers and film critics voiced similar sentiments regularly during this time period, noting BBS's emphasis on personal filmmaking.[24]

Though Schneider's and Rafelson's claims made their way into the press, their message was aimed more at their own industry than at prospective audiences. Neither of the two offered any indication that they were in fact familiar with the auteur theory or had based their development decisions on it. Instead, BBS took their inspiration from a much larger cultural movement that had become suspicious of bourgeois society and corporate management. In social historian Thomas Frank's consideration of the 1960s advertising industry, *The Conquest of Cool*, he argues that since the publication of William Whyte's *The Organization Man* in 1956, a growing unease with social conformity had worked its way into corporate management theory.[25] Frank notes that management books from the 1960s onward advised against over-organization and fostered a creative revolution in the advertising industry, spearheaded at the time by boutique agencies with unorthodox work environments.

In Hollywood, BBS exemplified this shift in its effort to formulate a director-centered organization in place of a hierarchical management style that emphasized repeating tested formulas over individual creativity.[26] BBS also had ties to the counterculture, which Frank argues appealed to hip businessmen and creatives due to its emphasis on individuality and nonconformity. Rafelson's directorial debut *Head* was steeped in drug culture, and Schneider had become increasingly involved in radical politics, directly supporting the Black Panther Party and the antiwar movement.[27] BBS's emphasis on personal filmmaking was also derived from the anticapitalist underground film movement, which *Easy Rider* director Dennis Hopper had dabbled in.[28] Although Schneider and Rafelson were certainly not the only independent producers who had given directors a greater degree of autonomy, with *Easy Rider* they had produced an attention-grabbing hit film at the apotheosis of broader cultural movements that celebrated individual expression.

If BBS was one of the most vocal proponents of the new ideal of directorial authorship, it exemplified the industrial contradictions and tensions underlying such a proclamation as well. Despite Rafelson's argument that directors needed to be given "final cut . . . final everything," at BBS only he and Schneider made the final decisions. When Hopper refused to edit *Easy Rider* down from his original four-hour cut, he was taken off the film and later shown a final cut made without his supervision.[29] Peter Bogdanovich has recounted casting arguments over

The Last Picture Show, and Rafelson himself admits that Schneider almost fired Bogdanovich from the film after viewing his dailies during production.[30] Following the dissolution of BBS, Schneider admitted to some violent disagreements with directors, though he claimed that they usually concluded with him backing their vision.[31] In a 2010 interview only years before his death, Steve Blauner tells a sobering story of his experience dealing with Jim McBride, best known as the director of *David Holzman's Diary* (1967), on an aborted BBS production. Blauner stated that BBS never offered McBride final cut and after the young auteur made too many demands during the preproduction process, Blauner fired him and shut down the film.[32] Thus, in reality, the ideals of personal autonomy often clashed with the risk-averse nature of even low-budget commercial filmmaking. Nonetheless, BBS did offer much more creative control to directors than had been common practice in Hollywood, and perhaps more importantly the company encouraged similar practices by sharing their auteurist goals loudly with their industry.

BBS films did not generally employ the same radical narration and formalism of the 1960s European art film, but they can be viewed as complex American art films that challenged classic Hollywood conventions.[33] In *Easy Rider* Hopper had introduced formal techniques from the avant-garde into a readily decipherable road movie formula, while in *Five Easy Pieces* Rafelson focused on a psychologically complex character, Bobby Dupea, who has little purpose or clear motivation. Many BBS films were pessimistic character dramas that lacked clear-cut Hollywood endings, and some of its biggest flops, like *Head, A Safe Place*, and *Drive, He Said*, were those that placed the greatest emphasis on subjective narration, featuring a disjunctive logic and dreamlike tone, or, in the case of *Drive, He Said*, a level of character ambiguity that ventured into incomprehensibility. With such fare BBS could not remain financially viable. The studio eventually discontinued its program of providing projects for promising new directors, but for a brief moment they were able to support auteur-driven films that pushed beyond the range of innovation customarily allowed in studio filmmaking.

Though BBS fashioned itself as an artistically motivated independent company that stood apart from bureaucratic oversight, their company's business practices translated fairly easily into major studio operations. Bert Schneider preferred not to publicize his place within a family dynasty that headed up Columbia during BBS's brief existence, but the distribution resources and guaranteed financing of a major studio that BBS's contract with Columbia provided were crucial factors in the small company's viability.[34] As might be expected, other major studios saw the limited risk involved in financing films at one-million-dollar budgets that might return the multimillion-dollar grosses of *Easy Rider*, and quickly jumped on the bandwagon. Soon Universal, a subsidiary of MCA and one of Hollywood's most conservative studios, would adopt BBS's methods, but it failed to achieve the same degree of success.

Beneath the surface, Universal's set-up was not that much different from the one at BBS. The productions were to be organized by MCA vice president Ned Tanen, studio mogul Lew Wasserman's right-hand man. Tanen's arrangements became known as an unnamed special division within Universal that financed independent producers with a guaranteed distribution deal for films costing approximately one million dollars.[35] By New Year's Eve of 1969, MCA announced that it was financing Frank Perry's *Diary of a Mad Housewife*, which came out in 1970, along with Dennis Hopper's follow-up to *Easy Rider*, *The Last Movie*, released in 1971. In the press released that proclaimed this initiative, Perry emphasized the "absolute autonomy" provided to him through a production deal that, unlike BBS, actually included final cut. Ensuing press coverage of the Tanen unit emphasized the "free rein" given to directors that favored non-commercial style and personal filmmaking. As time went on, more and more articles began to describe Tanen's unit as representing a new style of creative, youth-targeted, low-budget filmmaking that would leave the studio system behind, creating a "Prototype For Hollywood's New Freedom."[36] Despite his status as a Hollywood insider, Tanen indulged in the same rebellious discourse as the BBS team, arguing, "What's going on is probably the best thing in films since sound. A shake-out!"[37]

Behind the bold language promulgated by its sponsors within the industry, several factors indicated that, though the director-centered revolution represented by these boutique entities had captured the cultural zeitgeist, it had not altered the calculated logic of studio filmmaking. Just as BBS was only one component of Columbia's film production, Tanen's production unit remained a glorified experiment that supplemented Universal's higher-budgeted traditional films. The studio's biggest hits during these years included pictures like the disaster blockbuster *Airport* (George Seaton, 1970) and the historical costume drama *Anne of the Thousand Days* (Charles Jarrott, 1969), the latter film produced by septuagenarian Hal Wallis.[38]

Tanen's version of director-centered filmmaking also reveals the limits that would continue to be imposed on directorial autonomy even in these circumscribed contexts. Final cut may have been a significant step forward for the young auteurs, but the types of personal projects that major studios would distribute began to narrow. Universal guided Tanen's slate to avoid the pitfalls inherent in BBS's artistic experiments, but in doing so it increasingly limited the types of projects that would give directors free rein. Tanen had launched his unit in an experimental mode by giving Dennis Hopper the ability to create a truly radical avant-garde film, *The Last Movie*. Though Hopper's film referenced the western genre's mythology, it confounded most audiences and was a critical and financial disaster.[39] Tanen's next release, *Diary of a Mad Housewife*, bears the closest relation to BBS's films. A collaboration between director Frank Perry and his screenwriter wife, Eleanor Perry, the story satirized the daily horrors of bourgeois

patriarchy through the subjectivity of a Manhattanite homemaker struggling to survive her husband's increasingly absurd demands.

After his experience with these two unconventional pictures, Tanen turned his attention to genre-oriented moviemaking with a personal touch. His 1971 slate included a satirical youth comedy (*Taking Off*, Miloš Forman), an abstruse western (*The Hired Hand*, Peter Fonda), an existential road/racing movie (*Two-Lane Blacktop*, Monte Hellman), a bizarre romantic comedy (*Minnie and Moskowitz*, John Cassavetes), and an ecologically minded science-fiction film (*Silent Running*, Douglas Trumbull [made in 1971, but released in 1972]). Even though some of these films, especially *Minnie and Moskowitz*, may have challenged their generic categories, Universal could view them as financially safer than experimentalist head-scratchers like *The Last Movie*.

Ironically, Universal's marketing campaigns for some of Tanen's projects emphasized genre to the films' detriment. Fonda's *The Hired Hand* centered on the relationship of a cowboy with his estranged wife, adding a refreshing female perspective to Fonda's slow-paced atmospheric work. But Universal ignored the movie's artier revisions of the genre and instead emphasized western clichés with a poster that pictured Fonda pointing his gun in a classic western stance with the slogan, "Peter Fonda is riding again . . . to the woman he lost . . . for the revenge he craves!"[40] Similar problems plagued the limited marketing campaign for *Two-Lane Blacktop*, an existential road movie that drained the adrenalin out of its cross-country race in order to focus on the alienation of its characters. Universal, however, ran the slogan "You can never go fast enough" in its press book, and produced a trailer that concluded with the line, "The far-out world of the high speed scene!"[41] These are among the more egregious examples of several poorly conceived marketing efforts that led Ned Tanen to argue that MCA disliked his films and purposefully mishandled them.[42] Universal's insistence on emphasizing genre was a sign of how the major studios hoped to direct the unconventional sensibilities of unproven directors into familiar territory. For Universal this strategy would not pay off, but by this point studios like Twentieth Century–Fox and Paramount had made lucrative investments in high-budget genre films directed by young auteurs like William Friedkin (*The French Connection*, Twentieth Century–Fox, 1971) and Francis Ford Coppola (*The Godfather*, Paramount, 1972), which had become major hits.

Director-centric models of development and production were attempted by other studios and filmmakers as well. Coppola was the director who proved the most ambitious in this regard. After serving an apprenticeship under exploitation king Roger Corman, Coppola cut a deal with Warner Bros. in 1969 reminiscent of the one BBS had made with Columbia, whereby his production company, American Zoetrope, would create movies for the youth market.[43] After the studio rejected Coppola's projects as uncommercial and demanded its money back, Coppola joined Friedkin and Bogdanovich to form the Director's Company,

FIGURES 19 AND 20: Images from Universal's trailers for *The Hired Hand* (Peter Fonda, 1971) and *Two-Lane Blacktop* (Monte Hellman, 1971) that emphasize genre and action over the films' art house sensibilities.

which contracted for a similar arrangement at Paramount, but again the films usually failed to meet studio expectations. In the early 1980s Coppola's attempt to turn Zoetrope into a small autonomous film studio went aground due to his inability to pay high interest rates on the loans needed for production costs.[44]

As the studios ducked in and out of the auteur business, individual directors who sought work in Hollywood were forced to negotiate their careers amid shifting institutional supports. Dennis Hopper was only the most notorious example of a young auteur who was thrown out of the major studios because of his art-house inclinations. Considering the broadened production slates that brought in young talent during the 1970s, it is surprising how many more of these youthful directors failed to make a second film that received major studio distribution. For every Peter Bogdanovich, Robert Altman, and Martin Scorsese, there are figures like Henry Jaglom, Peter Fonda, Monte Hellman, and Douglas Trumbull, who

either would not return to directing for many years or had to piece together work with limited independent distribution.[45]

New Wave director Brian De Palma has a history so filled with detours and setbacks that it stands as testimony to the difficulties young talent typically encountered in their dealings with the film industry during the 1970s. Before making it to Hollywood, De Palma had directed five films as a New York City independent filmmaker loosely related to the underground film scene.[46] The most successful of these were *Greetings* (1968) and *Hi, Mom!* (1970), two countercultural sex-fueled comedies focusing on draft dodging and revolutionary politics. De Palma shot both films non-union on extremely low budgets and released them through an independent company, Sigma III, known for distributing foreign art films.[47] Though De Palma openly criticized Hollywood filmmaking at this time, he also voiced a desire to work within what was then called "the Establishment." Following this latter path he directed *Get to Know Your Rabbit*, a comedy about dropping out and corporate co-optation featuring Orson Welles and TV star Tom Smothers, for Warner Bros. in 1970.[48] But this arrangement proved to be an unhappy one, and Warners eventually recut and released *Rabbit* in 1973 without De Palma's approval. Momentarily embraced by the studios, De Palma, like many other young filmmakers, was soon scratched from the ranks.

After his expulsion, De Palma turned to a series of independently produced low- or middle-budget horror and thriller films as a way of working back into mainstream filmmaking. With his 1973 production *Sisters*, he began a working relationship with the successful exploitation company American International Pictures and soon managed to secure limited, and arguably mishandled, major studio distribution for several pick-up deals (*Phantom of the Paradise* [Twentieth Century–Fox, 1974] and *Obsession* [Columbia, 1975]). Even after United Artists successfully distributed *Carrie* in 1976, De Palma did not reach any sort of mainstream autonomy and recognition until the mini-major Filmways released *Dressed to Kill* in 1980.[49] De Palma managed to find a more stable position within the mainstream industry after going through three or four different phases of his career within a decade, finally settling on a strategy of genre filmmaking that progressively boosted his budgets and distribution reach. Through it all, he managed to sustain his cachet with young cinephiles by affecting a flamboyant style that borrowed liberally from cult Italian horror films (*giallo*) and featured conspicuous homages referencing auteurist favorites like Michelangelo Antonioni, Sergei Eisenstein, and especially Alfred Hitchcock.

In the end, Hollywood's flirtation with auteur-centered filmmaking was short-lived. A combination of poor marketing, undisciplined filmmaking, and resistant audiences kept BBS, Tanen's unit, and similar undertakings within other major studios from turning a profit large enough to validate the experiment. The profitability of the rebel director that such studio-sponsored experiments had promised came into question after a series of low-budget, auteur-driven

films failed to repeat the windfall profits of *Easy Rider*. Yet the narrative of the auteur renaissance continued beyond 1972 largely because directorial freedom was renegotiated within a more limited range of content that focused on genre filmmaking. Now the impressive production values and the marketing and distribution resources of the major studios were mobilized in the service of directors like Steven Spielberg and George Lucas, who could reliably turn out blockbusters.

The Other Auteurs: Hollywood's First Black Directors

The temptation to divide 1970s film history between critically anointed auteurs and all other filmmaking of the period elides the significance of African American directors who gained unprecedented access to the mainstream film industry during the 1970s, thanks in large part to the Blaxploitation boom. Black-themed films released during Hollywood's auteur renaissance marked the first time in history that African American film directors achieved major studio distribution. Yet while established white auteurs of the day were able to negotiate their freedom by working within traditional genres, few black directors were ever given work outside the critically scorned cycle of Blaxploitation films, and very few sustained extensive filmmaking careers at all.

No African American director was granted a major studio release before 1969. Those who finally found work in Hollywood during the 1970s faced uniquely complex conditions. They had to combat decades of dehumanizing stereotypes of their race and provide an alternative picture of the black experience on screen. Moreover, they faced significantly more limitations on what they were allowed to do than the canonical Renaissance filmmakers did.[50] Although a majority of black-themed films were still white-directed, during the 1969–1976 period black directors released almost sixty commercial features, twenty-seven of them distributed by major studios.[51] However, the welcoming hand Hollywood extended to black directors during this time was shamefully brief. During the four-year period from 1972 to 1976, twenty-eight African American directors released theatrical features, while during the following eleven years from 1977 to 1986, only nine such directors could claim the same accomplishment. Taken as a whole, the experience of African American directors in Hollywood during this period can be broken up into three phases: Blaxploitation precursors from 1969 to 1971, the 1972–1976 Blaxploitation production cycle, and a serious gap that extends to the 1990s, when a new generation of black directors like Spike Lee and John Singleton came to the fore.[52]

Some of the first African American directors in Hollywood arrived just before the Blaxploitation cycle began. Most notably, in 1969 Gordon Parks became the first black director to release a film through a major Hollywood studio.[53] Parks brought with him an impressive resumé. Best known for his extensive career

as a still photographer, he was also a musician, poet, and author of the well-received semi-autobiographical novel *The Learning Tree*. Parks refused to give up the adaptation rights to his book without serving as the movie's director himself and had been pitching the project to the studios since 1964. In 1969 Warner Bros. finally offered him the job.[54] The film Parks created portrayed black lived experience in a straightforward manner, avoiding the stylistic experimentation favored by many of his contemporaries. The story centers on a young boy named Newt growing up in Kansas during the 1920s surrounded by systemic racism. Although *The Learning Tree* is usually framed as a tale of Newt's coming of age, it also offers a second plotline centered on Newt's unruly friend Marcus, whose father is a poor alcoholic. Through Marcus, the film offers a damning critique of a segregated and racist society, as Newt watches his friend turn to crime and violence in response to his disadvantaged position in life. Eschewing assimilationist narratives and a rhetoric of personal responsibility, *The Learning Tree* places the blame for black suffering and self-destructive revolt on the entrenched racism of white power structures. Though the film's social critique is mitigated by its location in the past and by the many positive white characters who appear intermittently, it is hard to ignore the story's somber conclusion as Newt turns his back on the sheriff who has just casually murdered the fleeing Marcus.

In 1970, following Parks's success with *The Learning Tree*, Bill Gunn, Melvin Van Peebles, and Ossie Davis were able to release major studio films, and their career paths exemplify the limited way that Hollywood would continue to use black directors. Since Blaxploitation had not yet been popularized, these directors, like Parks himself, can be seen as part of the general late-1960s push by the studios to bring in new directors to create unconventional films. Gunn, like Parks, boasted multiple talents. He was a playwright and novelist, and he was the primary screenplay writer for *The Landlord* (Hal Ashby, 1970) and *The Angel Levine* (Jan Kadar, 1970). His 1970 directorial debut *Stop!* (a.k.a. *Stop*) portrayed the crumbling marriage of a privileged white couple who inherit a mansion in Puerto Rico after the husband's late brother ends his own marriage and life in a murder-suicide. The four characters engage in sexual exploration involving homosexuality and partner swapping, while also indulging in marijuana and mescaline.[55] Warner Bros. clearly had high aspirations for Gunn and the film, as their press kit boasts that the director's "screen directorial debut came about as a result of Warner Bros.' policy of finding and developing new talent. . . . He has been able to make a rare debut as a writer-director." Despite this promise and despite subject matter that spoke to white audiences, *Stop!* went essentially unreleased by Warner Bros., appearing at a Texas drive-in for only one week before the studio shelved it.[56]

Melvin Van Peebles's career followed a different path, but he, too, failed to establish a secure footing in Hollywood. After moving to France and directing his first film, *The Story of a Three-Day Pass* (1968), Van Peebles completed one

FIGURES 21 AND 22: Gordon Parks often juxtaposes sequences comparing Marcus's hardships with Newt's more privileged circumstances, emphasizing how racism can stimulate class stratification, in *The Learning Tree* (Gordon Parks, 1969).

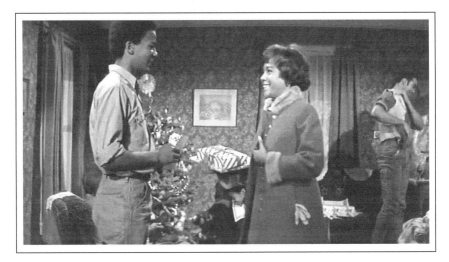

major studio feature, *The Watermelon Man*, in 1970 before settling for a career as an independent. Due to its intriguing subject, *The Watermelon Man* appealed to Columbia's ambitions to create an accessible movie relevant to new audiences. The film tells the satiric tale of Jeff Gerber, a casually racist white father living in the suburbs who one day wakes up to find that he has turned into a black man. Godfrey Cambridge plays Gerber in whiteface at the story's outset, and much of the film's humor is derived at Gerber's expense as his new racial identity reveals the extent of his white privilege. The film's conclusion takes a more somber turn as Gerber's family leaves him and his neighbors pressure him to move out. Gerber eventually accepts his new position as a black man in a racist society, and in the film's final images he appears to have joined a black militant group and is seen

practicing various fighting positions. While this surprising conclusion implies a unique level of control on Van Peebles's part, the young director had to fight to retain many of the project's most radical elements, for Columbia had much more interest in using Van Peebles's black authorship as a sign of cultural relevancy that in allowing him to express a personal vision. Most significantly, Van Peebles refused to use a white actor to play Gerber in blackface and even shot his own ending without the studio's permission.[57]

Van Peebles's next effort, the notorious indie *Sweet Sweetback's Baadasssss Song* (1971), grossed over $10 million on a budget of less than $500,000.[58] At the same time, two studio-sponsored hits by African American directors, Ossie Davis's *Cotton Comes to Harlem* (United Artists, 1970) and Gordon Parks's *Shaft* (MGM, 1971), also entered the marketplace. These three black-directed films catalyzed the Blaxploitation cycle. All three emphasized violence and sex as they followed the adventures of black characters in the ghetto.[59] The Blaxploitation boom had a clear commercial incentive, designed to appeal to young African American audiences that were attending movies in disproportionately greater numbers than expected. *Sweetback*'s independent production and distribution, radical formalism, and overt revolutionary message, however, set it apart from most of the low-budget exploitation films that the major studios and independent exploitation companies would continue to produce.

Although *Sweetback*, *Cotton Comes to Harlem*, and *Shaft* were substantial hits directed by young and promising black filmmakers, the success of these pictures did not open the door to the same range of genres and budgets for their directors that white auteurs were privy to. Critic Christopher Sieving best sums up the 1970s history of black directors: "The pattern across the decade seldom varied; up-and-coming white filmmakers in the New Hollywood were provided with budgets and studio support that allowed them to make critically acclaimed, award-winning, and sometimes hit pictures, while black filmmakers were relegated to the B-level, low-cost and medium-return, critically disparaged Blaxploitation cycle with its focus on action and sensationalism."[60] In the rare cases where black directors did find themselves helming an unusual project for a major studio, the releases were often egregiously mishandled. Gordon Parks found himself in this frustrating position for his last film, *Leadbelly* (MGM, 1976), a biopic about the folk and blues musician Huddie Ledbetter. Paramount marketed the project as a Blaxploitation film and halfheartedly opened it in an adult film theater in New York City.[61]

Despite its limitations, the Blaxploitation cycle functioned as a legitimate creative outlet for a few black moviemakers during the 1970s.[62] But even for those directors willing to work within the formulaic constraints of Blaxploitation, significant disappointments and boundaries arose. Some of the 1970s most treasured black-directed films were made as Blaxploitation projects, but broke genre conventions in ways that prompted studios to alter or suppress them. Bill Gunn's

1973 black indie vampire tale *Ganja & Hess*, for example, effaces conventional genre expectations and clear narrative causality in favor of montage and shifting points of view. The film was significantly recut by an independent exploitation company for its initial release, but has since been restored to its original cut and declared a masterpiece.[63]

Ivan Dixon's 1973 release *The Spook Who Sat by the Door* offers another unique example of how innovative directors might use a Blaxploitation cover to their advantage. The story centers around the first black CIA agent who leaves the organization to lead a black revolution by means of guerilla warfare in Chicago. As the film concludes, young gang members in Chicago have taken on a political consciousness and a violent revolution has begun. Many critics of the time saw *Spook* as nothing more than a disturbing, violent fantasy, but the movie stands as a potent critique of race in America, black middle-class hypocrisy, and the disingenuous racial tokenism of affirmative action programs.[64] Though Dixon mixed various aspects of commercial Blaxploitation with black independent filmmaking, *Spook*'s distributor, United Artists, promoted it by emphasizing its action sequences. After its release, UA became aware of the film's subversive content and pulled it from theaters amid substantial rumors of interference by the FBI's Counter Intelligence Program.

When the Blaxploitation cycle ended, most African American directors left Hollywood either out of creative frustration or because they were deemed unworthy for rehire after their track record at the box office momentarily dipped.[65] Black directors like Michael Schultz, who made studio-backed comedies like *Cooley High* (AIP, 1974) and *Car Wash* (Universal, 1975), which had crossover potential, were the exceptions. As the 1970s wore on, however, a few of the most widely known and respected African American directors of the day were also able to break out of the Blaxploitation ghetto. Both Ossie Davis and Sidney Poitier had established themselves as actors before they became directors. After *Cotton Comes to Harlem*, Davis found further work in the Blaxploitation mode with his 1973 release *Gordon's War* (distributed by Twentieth Century–Fox), but his previous film *Black Girl*, independently financed and released by Cinerama in 1972, showed an entirely different vision of black life, one which held little interest for the major studios.[66] *Black Girl* considers the circumstances of a teenager named Billie Jean who has dropped out of high school but hopes to become a dancer. The film offers a vision of hope about upward mobility while examining the decimating effects that internalized racism and poverty have had on the multiple generations of women that make up Billie's home.

Sidney Poitier, who had won a Best Actor Oscar in 1964, was a bankable name in Hollywood by the 1970s and had ready access to studio support. His first directorial effort, *Buck and the Preacher* (Columbia, 1972), reworked the western formula with confident black lead characters. Poitier found further success with a trilogy of crime comedies featuring black casts beginning with *Uptown Saturday*

Night in 1974; all three films were made at Warner Bros.[67] Poitier's single flop was *A Warm December* (1973), which explored the romance between a doctor (Poitier) and a female ambassador with sickle-cell anemia from a small fictional African country. It did not garner studio distribution.

A more iconoclastic group of black directors directly opposed Hollywood and its investment in Blaxploitation and managed to create films with fewer creative restraints during the latter part of the 1970s and afterward, but these works rarely found any commercial distribution. Most importantly, the L.A. Rebellion, a group of African American filmmakers who were enrolled in UCLA's Theatre Arts Department during these years, made movies that stood in opposition to Blaxploitation. Led by UCLA's first black film faculty member, Elyseo Taylor, the department actively sought out students of color, and these new talents, including Charles Burnett, Julie Dash, Billy Woodbury, Haile Gerima, and Jamaa Fanaka, began making films that drew on Third Cinema and other less commercial models of filmmaking from abroad.[68] They were united in their mission to rebel against Hollywood's dehumanizing representations of black people and determined to create works that instead offered a fully developed image of blackness based in social reality. In most cases their films had little hope of domestic distribution, but these directors found critical validation at prestigious international film festivals. Gerima's 1976 production *Harvest: 3000 Years*, for example, took the Jury Prize at the Locarno festival that year; while Burnett's 1978 *Killer of Sheep* won the critics award when it was screened at the Berlinale in 1981.[69]

One notable exception to the L.A. Rebellion's rejection of commercial success is Jamaa Fanaka, who simultaneously undermined and used the commercial model.[70] In 1980 Fanaka released the L.A. Rebellion's biggest financial hit, *Penitentiary*, a shrewdly conceived and politically resonant prison boxing film made for less than $500,000, which Fanaka raised in the form of grants and personal loans. *Penitentiary* grossed over $10 million and became the biggest independent hit of the year. In its general outlines, Fanaka's career followed the movie brat pattern identified with white auteurs of the era: he graduated from a film school and channeled his personal vision into critical revisions of commercial genre films.[71] However, unlike the white movie brats who were given progressively higher budgets after creating exploitation films, Fanaka remained an independent who often self-financed his work.[72]

Although black directors enjoyed unprecedented access to Hollywood during the 1970s, other disadvantaged groups were granted more limited access and support during a decade known for its supposed openness to new talent. Women directors, for instance, made measurable progress.[73] After the silent era and up to the end of the 1960s, Dorothy Arzner and Ida Lupino were the only two women directing commercial narrative films in Hollywood. By the late 1960s this record began to shift until fifteen new women directors had made at least one feature film within the commercial film industry during the 1970s. These women included

USC film school graduate Stephanie Rothman; performers such as Elaine May, Anne Bancroft, and Barbara Loden; and others such as Joan Tewkesbury and Claudia Weill who entered the industry through parallel professions or managed to start in independent production.[74] Ultimately, however, the industry sidelined these female filmmakers just as it had done with African American directors.

Underserved directorial cohorts such as blacks and women may have suffered most in Hollywood during the 1970s and after, but all directors ultimately lost out in their quest for free expression and control over their work. In the end, Hollywood's brief golden age of creative control played out over a series of short-lived production models and studio arrangements. As the 1970s drew to a close, the hopes for a new type of American cinema based in strong directorial vision turned to pessimism. The conventional narrative of the period contrasts over-budget auteurist debacles such as *Apocalypse Now* (Francis Ford Coppola, 1979) and *Heaven's Gate* (Michael Cimino, 1980) with the hits turned out by a new generation of commercially savvy directorial talents like Steven Spielberg and George Lucas, who took Hollywood into the conservative 1980s with blockbusters like Spielberg's *Jaws* (Universal, 1975) and Lucas's *Star Wars* (Twentieth Century-Fox, 1977).

For all the larger-than-life personalities featured in the standard accounts of the auteur renaissance, the late 1960s and 1970s can be most accurately described as a partial creative shift thanks to a wave of innovative films made by breakout directors bankrolled by the major studios. At the same time, authorship and the introduction of new talent has always been an economic strategy in Hollywood. The auteur renaissance is best articulated as a studio policy that first invited, then rejected innovation, excluding a much larger number of auteurs than it canonized. From the start, opportunities for film authorship were only offered to the socially privileged, and the risk-averse policies of the studios continued to limit the types of projects in which personal expression could exist.

5

THE NEW HOLLYWOOD, 1981–1999

Three Case Studies Thomas Schatz

This chapter examines the making of three key New Hollywood films, *Batman*, *Do the Right Thing*, and *sex, lies, and videotape*, focusing on the work of their respective directors: Tim Burton, Spike Lee, and Steven Soderbergh. Released within weeks of one another in the summer of 1989, each was an industry milestone and a breakthrough film for its director. *Batman* was Warner Bros.' first high-profile, big-budget release after the epochal Time-Warner merger (announced in March 1989), and it recast the modern blockbuster, creating a template for the studio-produced, conglomerate-controlled entertainment franchises that now rule the global movie industry. Tim Burton's direction was crucial to *Batman*'s success, of course, and it secured his stature among Hollywood's leading directors. But as a calculated blockbuster and consummate "tentpole" picture, *Batman* was a corporate creation on which Burton was essentially a hired gun, sharing hard-won authority and creative control at every stage of the filmmaking process with an array of producers, executives, key collaborators, and studio functionaries.

Burton's experience directing *Batman* differed considerably from Lee's on *Do the Right Thing* and Soderbergh's on *sex, lies, and videotape*. Those two films were

harbingers of the so-called indie film movement in the New Hollywood, a crucial counter-trend to the intensifying blockbuster mentality. In some ways a revival of the director-driven Hollywood Renaissance of the 1970s, the indie movement was cultivated by mainstream Hollywood as well as the independent sector, and these two films were indicative of that dual impetus. *Do the Right Thing* was financed and distributed by a major studio, Universal Pictures, but it was created and closely controlled by Spike Lee, a self-styled auteur with two films to his credit and a background as a New York–based independent filmmaker. *sex, lies, and videotape*, meanwhile, was a bona fide independent film: a low-budget production by first-time multi-hyphenate (writer-director-editor) Steven Soderbergh, financed with "video money" and picked up for theatrical release by a rising independent distributor, Miramax, only after its successful debut at the U.S. Film Festival. Both *Do the Right Thing* and *sex, lies, and videotape* were "personal" films shot on the filmmaker's home turf—and on his own terms—with very little interference; but the fact that Lee's film was a studio picture rendered it a very different filmmaking enterprise from Soderbergh's.

These three films typified the increasingly stratified American film industry during the New Hollywood era; indeed, all three films directly contributed to that stratification. During the 1990s mainstream Hollywood grew increasingly bifurcated between big-budget, wide-release blockbusters like *Batman* and relatively low-budget quasi-independent films for more specialized markets like *Do the Right Thing*. Meanwhile, well over half of the theatrical features released in the United States were, like *sex, lies, and videotape*, produced and distributed outside the Hollywood system on much smaller budgets and with far more limited resources. The mode of production varied at each of these levels, affecting all phases and aspects of the filmmaking process, as well as the work roles of the director and other filmmaking personnel. The director's fundamental responsibility, as always, was to supervise "principal photography"—that is, the actual shooting of the film. But the director invariably had a hand in other phases of the process as well, from story and script development through postproduction and even marketing. In that sense these three case studies underscore a governing paradox and overriding tension in contemporary American filmmaking. During the postwar era, the director's authority and creative control expanded with the demise of the studio system, the rise of independent production, and the enormous influence of international art cinema and auteurism. This culminated in the Hollywood Renaissance of the late 1960s and the 1970s—the closest that mainstream Hollywood has ever come to being a "directors' cinema." The economic recovery of the film industry in the 1980s impelled the major studios to reassert control and rein in the director's authority. In the meantime, however, large portions of the public had learned to identify movies with their directors; thus, directorial names had become potent marketing tools. As a result, a director-driven ethos often persisted even in mainstream studio films like *Batman*,

putting the directors of such productions in a central and a highly conflicted role in the filmmaking process.

Tim Burton and *Batman*

Although *Batman* was a watershed film, it was one of several franchise blockbusters released in 1989, including new installments of the *Indiana Jones, Ghostbusters, Back to the Future, Star Trek,* and *Lethal Weapon* series. Like those films, *Batman* was rooted in the new blockbuster tradition that emerged in the late 1970s with *Jaws* (Steven Spielberg, 1975), *Star Wars* (George Lucas, 1977), *Superman* (Richard Donner, 1978), et al.—megahits that overwhelmed the Hollywood Renaissance and sparked the New Hollywood of the 1980s and 1990s. *Batman* was by far the biggest of the 1989 blockbusters, marking a significant advance in Hollywood's franchise mentality on several fronts. The Warner Bros. release was the number-one film in the U.S. box office that year by a substantial margin, grossing $250 million;[1] it also did record business in the booming home-video market, where it returned a phenomenal $180 million.[2] Meanwhile, the studio's newly merged parent company, TimeWarner, parlayed *Batman* into a global licensing and merchandising bonanza valued at an estimated half-billion dollars within a year of its release.[3] And unlike the other top franchises of the era, most notably the Star Wars and Indiana Jones series, both of which were owned by George Lucas, the movie rights to the Batman franchise were owned and closely controlled by Warner Bros.

Another of *Batman*'s distinctive qualities was of course Tim Burton's dark and stylized direction. While *Batman* is perhaps less "Burtonesque" than the films he directed immediately before and after it—*Beetlejuice* (1988) and *Edward Scissorhands* (1990)—the film is rife with signature Burton elements and with his dark, offbeat sensibilities, which were essential to its success. Moreover, Burton was the key figure in Warner Bros.' reauthorization of the Batman myth, a role that began at the script stage. He did not, however, initiate the project. *Batman* had languished for nearly a decade in the "development hell" undergone by so many presold story properties with franchise potential in the New Hollywood. It was Burton's initiative and compelling conception of the project that brought it to fruition.

The genesis of the Burton-directed *Batman* came in 1978, spurred by the enormous success of the movie version of *Superman*. In the wake of that hit, two independent producers, Michael Uslan and Ben Melniker, secured the screen rights to Batman from DC Comics. Like Superman, the Batman franchise was launched by DC in the late 1930s, and its popularity had waxed and waned through countless media incarnations since then. The campy 1960s TV series marked its most significant onscreen revival in recent years, but Uslan and

Melniker were now thinking of an epic big-screen version of Batman, in the style and tenor of *Superman*. They successfully pitched the idea to Peter Guber, then head of a small production company, PolyGram. Guber financed a screenplay by Tom Mankiewicz, the writer behind the 1970s James Bond cycle who also did extensive rewrites (credited as "creative consultant") on *Superman* and *Superman II* (1980). Mankiewicz generated a workable script draft but the project stalled. Then in 1982, some deft maneuvering and contractual chicanery by Guber and his colleague Jon Peters enabled them to wrest control of the Batman property from Uslan and Melniker; they took it with them to Warner Bros., where their newly launched Guber-Peters Company set up a long-term production deal. The studio had produced the Superman films, and Warner heads Bob Daly and Terry Semel were interested in developing Batman. But still the project languished— until 1986, when the Mankiewicz script caught the attention of Tim Burton.[4]

Then in his late twenties, Burton was a gifted and utterly singular filmmaker who had gone to film school at Cal Arts and, during an unhappy stint at Disney Animation in the early 1980s, made the live-action, horror-comedy short *Frankenweenie* (1984), which caught the attention of an executive at Warner Bros. The studio hired Burton to direct *Pee-wee's Big Adventure*, a low-budget comedy starring Paul Reubens (aka Pee-wee Herman). That surprise 1985 hit led to a multi-picture deal with the studio and the chance to wade through scores of its story properties, including Batman. Burton was less interested in Mankiewicz's script, which he saw as an obvious reworking of *Superman*, than in the idea behind the Batman myth itself, and particularly the darker turn it had taken in a recent spate of comics and graphic novels like Frank Miller's *The Dark Knight Returns* (1986). Working from his own detailed treatment with screenwriter (and comic-book fanatic) Sam Hamm, Burton executed a "page-one rewrite"—that is, a complete overhaul—of the Mankiewicz screenplay, focusing on Batman's early career and his battle with his first arch-enemy (in Bob Kane's DC Comics saga), the Joker.[5]

The Warner executives were impressed with the Burton-Hamm script, as were Guber and Peters, and the project went into active development. But as it evolved and took on blockbuster-scale proportions, with a budget climbing past $30 million and a lengthy development schedule, the studio encouraged Burton to look for an interim project. He found one in *Beetlejuice*, which came to him via music mogul and would-be movie producer David Geffen, who also suggested Michael Keaton for the title role.[6] The horror-comedy ghost story was ideally suited to Burton's dark and quirky sensibilities, and it was one that could be done quickly and on a relatively modest budget of about $13 million. The script needed work, however, so the studio brought in a seasoned script doctor, Warren Skaaren, for a rewrite. Although Burton considered Skaaren "a sort of straight arrow," the writer proved to be an ideal complement to the dour director, reworking the script to the studio's satisfaction (and earning cowriting credit

with Michael MacDowell, who wrote the original screenplay).[7] Burton and Keaton took the script through further impromptu revisions during rehearsals and principal photography, conceiving much of the film's best material in late-night writing sessions and on-set improvisations.

Released in late March 1988, *Beetlejuice* was another surprise hit—Warner Bros.' biggest box-office success of the year, in fact—and immediately after it opened, *Batman* became a go project.[8] Burton and Hamm had just finished a third draft (credited solely to Hamm), which Burton deemed ready to shoot. But he soon learned that, despite the greenlight, Semel, Guber, and Peters all considered Hamm's script too dark and downbeat for what was shaping up as a high-stakes summer blockbuster. Burton had always seen the Batman-Joker clash as a "battle of the freaks," and in the Hamm screenplay both Batman and his alter-ego, Bruce Wayne, were deeply troubled figures, while the Joker was frighteningly unhinged. In this version the Joker kills Vicki Vale, the hero's love interest, which provokes the climactic battle between Batman and the Joker atop the Gotham Cathedral. The Joker has the upper hand and is about to kill Batman, who turns the tables by summoning a huge swarm of bats from beneath the cathedral, which attack the Joker as he flees by helicopter, causing him to fall to his death. Batman then shoots down the helicopter, causing a fiery explosion that leaves him unconscious on the street below. As the smoke clears and a crowd gathers, Batman is turned over and unmasked, revealing the obnoxious newspaperman Alexander Knox—as we glimpse a grinning Bruce Wayne stealing away into the darkness, draped in Knox's trench coat.[9]

What Semel, Guber, and Peters wanted, in essence, was a more heroic protagonist, a more engaging antagonist, a more upbeat romance, and a stronger

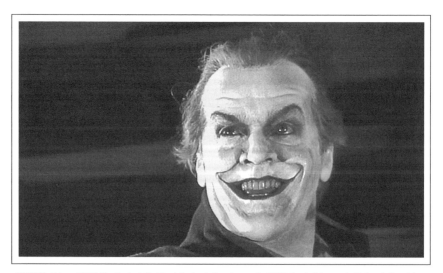

FIGURE 23: *Batman* (1989), Tim Burton's "battle of the freaks," centers on Jack Nicholson's Joker, a role that made it cool for top stars to play arch-villains in franchise blockbusters.

payoff. They decided to replace Hamm with Warren Skaaren, who was hired in August and remained on *Batman* through the entire shoot.[10] His revisions were extensive enough, in fact, to warrant cowriting credit with Hamm on the finished film (after arbitration from the Writers Guild of America). With a start date in early October and a June 1989 release already announced, Skaaren was under the gun and thus in his element as a script doctor. After several meetings at the studio with Burton, Semel, and Peters to decide on the nature and scope of the revisions, Skaaren holed up in the Sunset Marquis Hotel in West Hollywood and, in a two-week span, wrote the first of five drafts he would deliver between September 15 and October 6. His key contributions were to strengthen both Batman and alter-ego Bruce Wayne, to give the Joker more jokes and a more compelling personality, to give the love story more weight, and to give Batman a more decisive role in the climactic battle. Skaaren politely ignored input from Bob Kane, who had been hired as a "project consultant" to mollify the comic-book crowd. In fact he considered Kane's rendition of the Joker as the "Evil Clown" to be a central shortcoming of the original story, along with what he termed "Hamm's literal translation of the Joker as a nut case." In reworking the Joker, Skaaren also conferred with Jack Nicholson, who liked the idea of a more "Nietzschean" take on the character he would portray.[11]

Skaaren sought Burton's approval for the script changes, but as *Batman* went into serious preproduction the director's control steadily diminished. The ultimate authorities were Warner Bros. and Guber-Peters Productions—and particularly Semel and Peters, who had final say on every key aspect of the production. It was Semel who decided (with Bob Daly's approval) to shoot the film at Pinewood Studios outside London, and who approved the initial $32 million production budget—which was expected to escalate. Semel also decided on the June release, which put *Batman* in the summer tentpole arena. It also put the production on a fast track, dictating a remarkably tight shooting and editing schedule, which only intensified the studio's efforts to control the project. Warner Bros. also assembled most of the sizable and predominantly British crew, granting Burton little input even in the hiring of department heads. This resulted in heavy tensions throughout the shoot, pitting Burton against a crew that had little respect for his authority and failed to connect with his offbeat, improvisational methods. One notable exception here was production designer Anton Furst, who had recently worked on Stanley Kubrick's *Full Metal Jacket*, a 1987 Warner Bros. release also shot at Pinewood, and who got along famously with Burton. The two collaborated closely on the transformation of Pinewood's nine sound stages and ninety-five-acre grounds into Gotham City, Wayne Manor, the Batcave, and other locales. And thus the look and feel of the film, with its uncanny melding of comic-book noir and postmodern pop, was very much a product of their collaborative chemistry.[12]

As the company settled in at Pinewood, the dominant force both on and off the set was not Burton but Peters, a talented but outrageous figure even by

Hollywood standards. While Guber, his producer partner, was an industry veteran with a law degree from NYU and solid experience as both an independent producer and studio executive, Peters was a grade-school dropout and successful hairdresser—as legend has it, the inspiration for Warren Beatty's character in *Shampoo* (1975)—who had parlayed his relationship with Barbra Streisand into a career as a music and movie producer. Guber and Peters had a knack for getting projects greenlighted and for attaching themselves as executive producers, including films they scarcely touched. But neither had the talent or temperament for actual filmmaking, and in fact Guber and Peters actively produced less than a half-dozen films in the 1980s. Among the notable exceptions was *Batman*, which Peters took on as a pet project once Warner Bros. gave it the greenlight. In many ways he was a valuable asset—he endorsed Burton's controversial decision to cast Michael Keaton as Batman, for instance, and he personally recruited Jack Nicholson to play the Joker.[13] But once production opened on October 10, Peters's role as a hands-on producer proved to be a decidedly mixed blessing. The set was closed to the press, but the word quickly spread that the hyperactive, high-decibel Peters was running roughshod over Burton and the crew, hiring and firing key personnel, and badgering the director about story and script problems. He pressed Burton to present a more heroic Batman and to intensify the action scenes, which the director managed to deliver. Peters also demanded rewrites from Skaaren throughout the shoot, often without Burton's input or even his knowledge, in some instances, which meant that he was given new script pages just days— sometimes only hours—before he shot them.

Not surprisingly, directing *Batman* was a very different experience for Tim Burton than his previous two films. The pressure from the studio and ongoing interference from Peters, along with the sheer size and financial stakes of the production, turned the shoot itself into "torture," as Burton described it years later, "the worst period of my life."[14] He was working with a far larger crew than he had on *Pee-wee* and *Beetlejuice*, including a cinematographer and other department heads who were simply not receptive to Burton's soft-spoken style and intuitive approach to the material. There were other troublesome factors as well. The tight schedule allowed for only a week of rehearsals and effectively precluded the prospect of improvisation. On the first day of shooting, female lead Sean Young fell from a horse and broke her arm (in a scene later cut from the script), and Kim Basinger was immediately hired to play Vicki Vale. Basinger was a quick study, fortunately, but she also developed a relationship with Jon Peters during the shoot that further complicated matters. The closed set reduced distractions, although it scarcely eliminated them altogether. One serious distraction for Burton was the merchandising and licensing campaign. Warner Bros. was pushing the film's "toyetic" qualities, and consequently a steady parade of prospective licensees was continually assessing the sets, props, costumes, and so forth. "Cereal manufacturers and fast food companies who wanted to make

bat-shaped toys and hamburgers were looking over my shoulder the whole time," complained Burton.[15]

The ongoing rewrites were unnerving as well, upsetting Burton's production plans and increasing the pressures in terms of schedule and budget. By far the most significant of these changes involved the climax, which was a sore point with both Peters and Semel. In mid-December, Skaaren finally came up with a satisfactory rewrite of the grand finale—a new and expanded ("36-beat") sequence that ratcheted up the spectacle and the drama, intensifying both the Batman-Joker confrontation and the Batman-Vicki payoff (as he rescues her from the Joker's clutches).[16] The revisions were costly in terms of both time and money, requiring the construction of a new scale model of the Gotham Cathedral and extensive changes to the bell tower sets—a huge undertaking that was done over the Christmas holidays, pushing the shoot four weeks behind schedule as the production budget climbed beyond $50 million.

While Burton revamped his schedule and production plans to accommodate the new finale, Peters and Anton Furst turned their attention to the film's marketing campaign. Publicity for *Batman* had taken a hit in late November, when a page-one story in the *Wall Street Journal* rehashed the casting controversy and raised concerns about the inexperienced director, the closed set, and rumored budget overruns. The obvious implication was that *Batman* was a seriously troubled picture. Warner Bros. responded with an aggressive ad campaign that defused the negative publicity and underscored both Burton's and Anton Furst's distinctive work. Working with Peters, Furst came up with the idea of an understated poster featuring the iconic "Bat-logo" and the film's release date ("6-23-89"), and nothing else. Meanwhile Peters conceived and edited a movie trailer which, like the poster, was boldly understated: no voiceover or blaring musical score, no graphics or titles, just scenes from the film highlighting the visual style, the stars, and the action. Warner Bros. rushed the artwork and trailer into the marketplace in January to sensational effect. Soon the poster, the Bat logo, and the trailer were everywhere in the United States and overseas, and the now-legendary "Batmania" craze was under way. Warners also opened Pinewood to select journalists and movie critics, all of whom were charmed by Peters, intrigued by Burton, and enthralled by the production itself—both the climactic scenes Burton was directing and the footage he screened for them in the editing room. Suddenly Burton and *Batman* were big news. Jack Kroll wrote in *Newsweek*, for instance, that "this Batman is strictly new wave" and that Burton "may be the first breakaway talent since the Spielberg-Lucas-Coppola-Scorsese movie brats."[17] And a *New York Times* feature by Hilary de Vries gushed about Burton's handling of the bell-tower scene on the second-to-last day of production and suggested that the studio's "blockbuster gamble" might indeed pay off.[18]

After the frenzied and chaotic shoot, postproduction on *Batman* went relatively smoothly, with Burton playing only a minor role. The film was cut by Ray

Lovejoy, a top British editor whose credits included Stanley Kubrick's *The Shining* (1980) and James Cameron's *Aliens* (1986). Lovejoy kept the film moving and, as Stephen Prince aptly noted, "finessed the film's gaping narrative problems by simply rushing past them."[19] For the music, Burton wanted Danny Elfman, who had scored both *Pee-wee's Big Adventure* and *Beetlejuice*. Warner Bros. agreed, but insisted that Burton also use several pop songs by Prince, a Warner Music artist, whose inclusion spawned a second sound track album. The Prince songs were used to enliven a few of the Joker's key scenes, but they were very much at odds with Elfman's lush, brooding score as well as Burton's noirish vision. "I couldn't get the [Prince] songs to work," Burton later admitted, "and I think I did a disservice to the movie and to him."[20]

Batman opened on 2,200 screens on June 23, coming in the wake of two other huge hits, *Indiana Jones and the Last Crusade* and *Ghostbusters II*. Those two blockbuster sequels both set opening weekend records (in the $30 million range), which were promptly shattered by *Batman*, which grossed $40.5 million in its opening weekend and $100 million in just ten days (also a record). The critics were decidedly mixed, consistently lauding Burton's direction while bemoaning the thin, comic-book plotting. Roger Ebert in the *Chicago Sun-Times* called *Batman* "a triumph of design over story, style over substance."[21] Pauline Kael complained in the *New Yorker* that *Batman* was "underwritten," but she was won over by "master flake" Tim Burton, who created "a comic opera that's mean and anarchic and blissful."[22] Vincent Canby in the *New York Times* praised Burton's "nightmare version of megalopolis" but felt that "nothing in the movie sustains this vision. The wit is all pictorial." Canby concluded with a telling insight, that *Batman* "has the personality not of a particular movie but of a product, of something arrived at by corporate decision."[23]

Batman was indeed a corporate creation and a calculated commercial enterprise. After spending $52 million to produce the film, TimeWarner spent $31.3 million on its marketing campaign, which paid off handsomely.[24] Within a year of its release, *Batman*'s worldwide box office, television, home video, and merchandising revenues were well over one billion dollars. But in the larger scheme of things, *Batman* was far more than another breakthrough commercial hit. It marked a radical advance in Hollywood's escalating blockbuster syndrome and a new paradigm for the studio-produced franchise film—and also for the blockbuster director. With *Batman*, Warner Bros. reauthored a venerable American legend and recast the role of the auteur in the process. Much has been made over the years of Jack Nicholson's contribution to the film and to Hollywood's blockbuster franchise mentality, but Tim Burton's contribution was equally significant. While Nicholson made it cool (and lucrative) for top stars to play arch-villains in summer blockbusters, Burton made it cool for up-and-coming directors with film school credentials and art cinema inclinations to helm studio franchise fare.

Others had anticipated this trend, most notably Lucas with *Star Wars*, but none displayed the singular, eccentric style that Burton brought to *Batman*. The press embraced the notion of Burton as auteur, and he certainly fit the role—a pallid, black-clad cineaste with deep-set eyes, a wild nest of black hair, and a perpetually agitated demeanor. Sam Hamm described him in a *New York Times* story as "the first director out there [in Hollywood] to be filtering junk culture through an art-school sensibility," and Burton himself told *Newsweek* magazine as he finished shooting the film, "I feel it's gonna be this big movie and still have some feel to it. Some style."[25] They both proved to be right, although that scarcely made *Batman* a director's film. Burton's distinctive filmmaking talents were reined in throughout the production, with Peters and Skaaren and others acting on behalf of the studio to lighten up *Batman* and to optimize its commercial prospects. The result was a monstrous hit but also, as Vincent Canby suggested, a consummate corporate product.

Spike Lee and *Do the Right Thing*

Whereas the work of Tim Burton was constrained and controlled during every phase of *Batman*'s production, both Spike Lee and Steven Soderbergh enjoyed veritable free rein in the making of their respective films, *Do the Right Thing* and *sex, lies, and videotape*. They were not alone in this regard, as 1989 saw a number of innovative, off-beat productions from a growing cadre of hyphenate writer-directors, including genuine independents like Gus Van Sant's *Drugstore Cowboy* (released by Avenue Films) and Jim Sheridan's *My Left Foot* (Miramax), as well as studio releases like Michael Moore's debut documentary, *Roger & Me* (Warner Bros.). *Do the Right Thing* and *sex, lies, and videotape* were by far the most successful and celebrated of the lot, and they represented something of a matched set on several counts. Both were deeply personal films shot on location where the writer-director came of age, employing a pared-down realism with a darkly comedic, art-cinema edge. The two went head-to-head at the 1989 Cannes Film Festival in May, where they dominated the proceedings, before being released in that overheated blockbuster summer and doing excellent (and almost identical) box office. Their clash at Cannes and ensuing success linked the two films and their directors, not only in that watershed year but in the larger historical scheme of things. As veteran film critic Richard Corliss wrote two decades later in *Time* magazine's fifty-year retrospective of the Cannes Film Festival, *sex, lies, and videotape* and *Do the Right Thing* were "the two top contenders" at the fest in 1989 and "prime examples of the burgeoning American independent-film phenomenon." The two films "announced the arrival of two hard-working, hard-to-pigeonhole auteurs," wrote Corliss, and they "sparked mini-genres—the angry black drama and the subtly winning indie slice of middle-class mores."[26]

Although *Do the Right Thing* and *sex, lies, and videotape* did signal a "burgeoning" film phenomenon—what Peter Biskind in *Down and Dirty Pictures* aptly terms the "modern indie film movement"—it's important to note that they were renewing and redirecting a longstanding tradition of American independent film.[27] Indeed, Hollywood's reliance on independent films and filmmakers dates back to the founding of the studio system itself a century ago by renegade independents like Carl Laemmle and William Fox, and the concurrent creation of United Artists by Charlie Chaplin, D. W. Griffith, Mary Pickford, and Douglas Fairbanks. Throughout the classical era, the studios enhanced their release schedules with prestige productions from independent producers like Samuel Goldwyn and David O. Selznick, who invariably cultivated long-term relationships with top directors—Goldwyn's with William Wyler, for instance, and Selznick's with Alfred Hitchcock. In the third chapter of this book Sarah Kozloff describes the way in which independent production surged dramatically in the postwar era, as the studio system collapsed and scores of producers, directors, and stars launched their own production companies. The ranks of postwar independents also included a new breed of low-budget specialists like American International Pictures (AIP) that cranked out exploitation films and teenpics for the burgeoning drive-in and youth markets. Yet another key development during this period was the influx of imports and art films into the United States, many of them directed by international auteurs like Ingmar Bergman, Federico Fellini, Akira Kurosawa, and François Truffaut.

As Daniel Langford details in the previous chapter, these postwar conditions fueled the so-called Hollywood Renaissance, a veritable American new wave that sprang up in the late 1960s with films like *Bonnie and Clyde* (Arthur Penn, 1967), *The Graduate* (Mike Nichols, 1967), and *2001: A Space Odyssey* (Stanley Kubrick, 1968). The trend flourished in the 1970s as filmmakers like Hal Ashby, Robert Altman, Francis Ford Coppola, and Martin Scorsese came to the fore. This director-driven Renaissance flamed out at decade's end with films like *Apocalypse Now* (Coppola, 1979), *All That Jazz* (Bob Fosse, 1979), *Raging Bull* (Scorsese, 1980), and *Heaven's Gate* (Michael Cimino, 1980), which signaled both its artistic peak and its commercial demise—a passage that was hastened by the blockbuster-driven New Hollywood of Lucas and Spielberg, and the studios' aggressive reassertion of control.

The director-driven, art-cinema impulse was not stifled altogether in the 1980s, but rather it migrated "off-Hollywood," sustained by New York–based distributors like New Line, New Yorker Films, Island, and UA Classics. The off-Hollywood trend hit its stride in 1984 with an impressive run of independent films from a new breed of maverick writer-directors—notably Jim Jarmusch's *Stranger Than Paradise*, Joel and Ethan Coen's *Blood Simple*, Alan Rudolph's *Choose Me*, and John Sayles's *Brother from Another Planet*. All were launched on the "festival circuit," by then a crucial stage in the marketing of independent

films, and all were feted at the newly created Independent Spirit Awards. The independent sector enjoyed even greater success in 1985 with *Kiss of the Spider Woman* (Hector Babenco) and *The Trip to Bountiful* (Peter Masterson), which did solid business and stunned the industry with multiple Academy Award nominations and one major Oscar win apiece (Best Actor for William Hurt in *Kiss of the Spider Woman*, and Best Actress for Geraldine Page in *The Trip to Bountiful*). At that point Hollywood took notice. By 1988 the dominant player in the independent sector was Orion Pictures, a Hollywood mini-major, which financed and released John Sayles's *Eight Men Out* and Jonathan Demme's *Married to the Mob* that year. Orion also had a run of art-house imports that included Wim Wenders's *Wings of Desire* and Pedro Almodóvar's *Women on the Verge of a Nervous Breakdown*.

Spike Lee began his career in the New York–based off-Hollywood scene, and he was a key figure in the migration of American independent filmmaking *back* from the margins to the mainstream in the late 1980s. After earning a graduate degree in the early 1980s from NYU's film school, which produced Jarmusch, Oliver Stone, Joel Coen, Susan Seidelman, and several other off-Hollywood stalwarts, Lee quickly established himself as a distinctive new voice in American independent film. He wrote, directed, edited, and costarred in *She's Gotta Have It* (1986), a heady blend of art-cinema and exploitation film that was shot in just fourteen days for $20,000 (plus another $120,000 in salary deferments).[28] Narrated by the free-spirited, libidinous Nola (Tracy Camilla Johns) as she manages three very different suitors—one of whom is Mars Blackmon, played by Lee— *She's Gotta Have It* was sexy, funny, raw, and inventive; it was also very "urban" and very black, bringing a new sensibility to the American independent scene and the opportunity to tap a sizable and underserved market segment. After a successful screening at the San Francisco Film Festival, Lee's "sales rep" John Pierson was able to generate a bidding war in which Island prevailed, offering $400,000 for the worldwide rights.[29] *She's Gotta Have It* then made a splash at Cannes in May 1986, along with Jarmusch's second film, *Down by Law* (also picked up by Island). *She's Gotta Have It* went on to gross over $7 million that year in the United States. That put Lee on the independent filmmaking map, and it also secured him a deal to write and direct and to costar (as Mars Blackmon) in a series of Nike TV commercials with basketball star Michael Jordan, which vaulted Lee's sudden stardom to a considerably higher level.

After the success of *She's Gotta Have It*, Island opted to finance as well as distribute Lee's next film, *School Daze*, an ambitious musical-drama about racial strife in an all-black southern college. But Island's move into production proved ill advised, and after stumbling badly on its first few ventures, the company withdrew funding from *School Daze*. Lee quickly moved the project to a major studio, Columbia, which well indicated both his rising stature and Hollywood's growing interest in independent film. Produced for $6 million and released in early 1988,

School Daze drew a tepid critical response and was scarcely the crossover hit that both Lee and Columbia Pictures hoped for. Still, it confirmed that a "Spike Lee Joint" (as the director labeled all his films on the front credit roll) would attract a core urban audience; the film grossed over $13 million, doing most of its business in inner-city theaters that catered heavily to young African American moviegoers.[30]

When *School Daze* went into release, Lee was already well under way on *Do the Right Thing*. His original screenplay was provoked by an actual incident in 1986 in which three young blacks happened into a pizzeria in Howard Beach, an Italian American neighborhood in Queens, and were attacked by locals wielding baseball bats. One of the blacks was killed fleeing the attack, which sparked race riots, public outrage, and extensive legal and political turmoil. Lee reconceived the event for his film, setting it in the racially mixed but predominantly black Bedford-Stuyvesant neighborhood in Brooklyn where he had spent most of his youth. The film's multi-stranded plot follows the exploits of various residents on the hottest day of the summer. Racial tensions rise with the temperature, culminating in a confrontation between blacks and Italian Americans in a pizzeria in which a young black is killed by a blatantly racist white cop, leading to a violent race riot and the torching of the pizzeria.

Unhappy with Columbia's marketing campaign for *School Daze* but buoyed by the film's box office success and the notoriety of his Nike ads, Lee decided to shop his new project elsewhere. He quickly set it up at Paramount, where studio boss Ned Tanen approved the $6 million budget as well as Lee's casting and production plans.[31] By March 1988 the film was fully cast, with Lee himself in a principal role, and he was busy prepping a summer shoot in Brooklyn. But prior to production, Tanen began to voice serious issues about the script. He was especially concerned about the explosive payoff sparked by Lee's character, Mookie, an engaging and previously sympathetic pizza delivery boy, who reacts to the cop's killing of the young black by throwing a garbage can through the pizzeria's plate-glass window, inciting the race riot. Tanen insisted that Mookie's actions be more clearly motivated and that the climactic riot be toned down. Lee flatly refused, and when a series of contentious meetings failed to resolve matters, he again shopped the project around. The prospective buyers included Universal, where president Tom Pollock had recently signed deals with Martin Scorsese and Oliver Stone. Pollock loved the idea of adding Spike Lee to his roster, and in April Universal signed a "negative pick-up" deal to underwrite the $6.5 million production and to spend a minimum of $2.5 million on the film's marketing campaign. Lee's compensation as producer-director-writer and costar was $450,000, and he was granted final cut as long as he stayed within 10 percent of the budget and delivered the finished film by May 1, 1989.[32]

At that point *Do the Right Thing* went into serious preproduction in "Bed-Stuy." A block-long section of Stuyvesant Avenue (between Lexington and

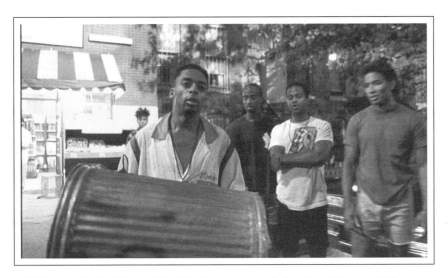

FIGURE 24: *Do the Right Thing* (Spike Lee, 1989): Mookie (Lee), about to spark the climactic race riot in a scene that the director refused to tone down for Paramount Pictures, which led to him moving the project to Universal.

Quincy) was "dressed" for the production, which was to be shot entirely on location. Sets were constructed in vacant lots for Sal's Famous Pizzeria, where much of the action takes place, and for a Korean grocery directly across the street. Vacant buildings were rehabbed for various locations—the local radio station, for instance, where deejay Mister Señor Love Daddy (Samuel L. Jackson) surveys the street scene and provides intermittent snippets of voiceover narration. Production opened in mid-July, and Lee executed the thirty-nine-day shoot without a hitch—a truly remarkable achievement considering not only the scope of the picture but also the fact that it was shot in one of New York's toughest, poorest, and most crime-infested neighborhoods. As the production notes in the press kit accompanying the film's release described it, "The street itself is an urban fatality, a line of poverty, unemployment and drugs that has come to symbolize the inner city."[33] The shoot required an active, ongoing, and highly visible public relations campaign, which Lee himself orchestrated while directing and acting in the film. Lee also publicly castigated New York mayor Ed Koch throughout the production for failing to deal with the racial and economic inequities in areas like Bed-Stuy—a canny strategy that served both to publicize the film and to influence the upcoming mayoral elections (in which Koch was ousted in a primary by David Dinkins, who went on to become New York's first African American mayor).[34]

While the outspoken Lee courted controversy, it was the last thing Tom Pollock wanted at the time. Universal in the summer of 1988 was embroiled in a nationwide firestorm over the pending release of Scorsese's *The Last Temptation of Christ*, which had become an early flashpoint in the "culture wars" that

engulfed the United States. In mid-August, with the nationwide protests against Scorsese's film at a fever pitch, Pollock conveyed to Lee (through production head Sean Daniel) his growing concerns about his film's race-riot finale. But just as Pollock and Universal did the right thing by Scorsese, opening *The Last Temptation of Christ* in the face of death threats and picket lines, they stood by their agreement with Spike Lee as well. At no point in the course of the production did Universal force the issue of the race-riot finale or rescind the filmmaker's creative control.[35]

Lee wrapped production on *Do the Right Thing* in mid-September; just ten weeks later, incredibly enough, he had completed a rough cut and Universal was test-screening the film.[36] The initial audiences were young blacks in urban markets, and among the elements tested (quite successfully) was Public Enemy's hip-hop anthem "Fight the Power," which Lee himself commissioned for *Do the Right Thing*. The song became Public Enemy's biggest hit ever, thanks largely to two popular music videos that Lee also produced and directed—and which effectively promoted the film as well as the song. Lee also built the opening title sequence around "Fight the Power," a stunning performance piece featuring a breakdancing, shadow-boxing Rosie Perez, who choreographed the number and costars in the film. Cut in sync with the pounding beat, the title sequence asserts Lee's political and artistic attitude in the boldest of terms. (And features lyrics such as: "Elvis was a hero to most, but he never meant shit to me, you see. Straight up racist that sucka was, simple and plain, motherfuck him and John Wayne.") The opening title sequence also plants "Fight the Power" as a relentless, pulsating musical theme that recurs throughout the film, blaring from a boom box carried by a large, brooding, black teen, Radio Raheem (Bill Nunn). That boom

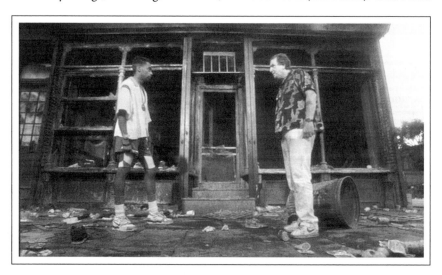

FIGURE 25: The aftermath of *Do the Right Thing:* Mookie (Lee) and Sal (Danny Aiello) say goodbye and make amends outside Sal's burned-out pizzeria, one of the two sets built in the Queens neighborhood that Lee commandeered for an entire summer to prep and shoot the film.

box eventually is smashed with a baseball bat by the enraged pizzeria owner, Sal (Danny Aiello), setting off the series of increasingly violent events that climax the film. While Universal remained concerned about the inflammatory finale, test screenings indicated that its impact was softened somewhat by a morning-after coda in which Sal and Mookie say their goodbyes and tentatively make amends outside the burned-out pizzeria.

Universal anticipated (quite correctly) that *Do the Right Thing* would be a controversial film, but the studio recognized the film's commercial potential as well. Universal took delivery of *Do the Right Thing* in April 1989 and mounted an aggressive release campaign—a premiere at Cannes in May, limited openings in France and England in June, and a four-week, $5 million advertising blitz in the United States for its 350-screen release on June 30. Universal also held a private screening in April for top film journalists—Stephen Schiff from *Vanity Fair*, Bruce Williamson from *Playboy*, Peter Biskind from *Premiere*, and others—all of whom responded favorably. Thus Lee and Tom Pollock were understandably upbeat when they took *Do the Right Thing* to Cannes, and their confidence soared after its premiere.[37] Vincent Canby noted in his rave *New York Times* review that *Do the Right Thing* "has successfully shaken up the 42nd Cannes International Film Festival and is suddenly a contender for the festival's top prize."[38] And Roger Ebert told the *Washington Post* that he wept after the film ended and added, "I'm not coming back next year if 'Do the Right Thing' doesn't win the competition."[39]

Lee exuded quiet confidence at the packed press conference after the Cannes screening, and he displayed quiet defiance as well. He mentioned in his opening remarks that the date (May 19) happened to be Malcolm X's birthday and that Ossie Davis, a costar in the film and a pioneering black filmmaker in his own right (who shared the dais with Lee and three other costars), had delivered the eulogy at Malcolm X's funeral back in May 1965. When asked about the two counterposed quotes that end the film—one by Martin Luther King extolling nonviolence and the other by Malcolm X advocating violent self-defense in the face of white oppression—Lee said that he decided to add them during postproduction "to complete the threads that had been woven throughout the whole film." Pressed further on his own view, Lee said, "In this day and age, in the year of our Lord 1989, I'm leaning more toward the philosophy of Malcolm X."[40]

Do the Right Thing marked the coming-of-age of a true auteur, a writer-director with a distinctive style and a point of view that was both deeply humanistic and politically radical. It was Spike Lee's trashcan hurled through the plate-glass window of 1980s American cinema, an act of rebellion against not only a chronically racist society but also a movie industry that, in Lee's view, was far too complacent and risk averse. But *Do the Right Thing* did not sway the Cannes jury. In a surprising upset, Steven Soderbergh was named Best Director and *sex, lies, and videotape* won both the international critics award and the festival's top

prize, the Palme d'Or. Lee was outraged, although the "Cannes snub" and the competition with *sex, lies, and videotape* did spur interest in the film, as did the growing controversy over its political content. Universal developed a bifurcated marketing campaign, targeting two very different specialty markets while hoping for the film's crossover appeal to the mainstream—along the lines of the Nike ad campaign featuring Lee with Michael Jordan. The primary marketing thrust of Universal's $5 million campaign focused on "urban black teens and young adults," while a "sub-campaign" went after what Universal termed "the 'Club Crowd' (white 18–34 adults who consider themselves to be on the cutting edge of music, fashion, art, and film)."[41] Universal opened *Do the Right Thing* in the United States in late June on 353 screens—a relatively wide release for a specialty film. It did enjoy a degree of crossover success, grossing an impressive $24.3 million, but its box office performance followed a basic pattern that sales rep John Pierson traced back to *She's Gotta Have It*. The bulk of its revenues came from just twenty major urban markets, mainly in the Northeast.[42]

Steven Soderbergh and *sex, lies, and videotape*

As he handed Soderbergh the Palme d'Or at Cannes, jury president Wim Wenders proclaimed the twenty-six-year-old filmmaker (the youngest ever to win the festival's top prize) "the future of cinema." In his acceptance speech, the self-effacing Soderbergh famously quipped, "I guess it's all downhill from here."[43] In fact it would be a number of years—and a string of critical and commercial flops—before Soderbergh regained his footing, which is scarcely surprising given the magnitude of the success and the impact of *sex, lies, and videotape*, arguably the most impressive feature film debut since *Citizen Kane* (1941), by another twenty-six-year-old wunderkind, Orson Welles. But whereas Welles already had made his mark in radio and the theater before his foray into Hollywood filmmaking, Soderbergh came out of nowhere with *sex, lies, and videotape* to become not just an overnight auteur but the veritable poster boy for the ensuing indie-film explosion.

Soderbergh's breakout success with his first feature is even more remarkable in light of his training and production background. Unlike Burton and Lee, as well as the majority of the "movie brats" of the Hollywood Renaissance and the off-Hollywood independents of the 1980s, Soderbergh lacked the advantages of film school training—or even a college education, for that matter. He left his hometown of Baton Rouge immediately after high school, heading west for Hollywood in 1980 with the reluctant consent of his father, a professor at LSU, where as a youngster Soderbergh audited film courses and learned the basics of filmmaking with borrowed equipment. He bounced back and forth between L.A. and Baton Rouge for the next several years, taking the occasional production job on industrial films, music videos, and documentaries while writing scripts and

finding the resources to do a few shorts. He eventually secured an agent, Anne Dollard, who got him a number of writing assignments, including major projects with Disney and Columbia-TriStar, but none of that work was produced.[44]

During a particularly rough patch back home in late 1987, Soderbergh decided to give Hollywood another go. He had been hired to write a modest spy thriller, which was giving him trouble, and he decided that a return to the West Coast might help move it along. Meanwhile, as he readied for the drive west in his ancient Buick Electra, Soderbergh started "making notes on something else"—the first inklings of what would become *sex, lies, and videotape*. As he later recalled: "I sat down a couple of days before the trip and started this other thing, and wrote it during the trip, and finished it a few days after I got to L.A."[45] Like many of Soderbergh's unpaid spec scripts, it was written quickly and was vaguely autobiographical, although he was learning to integrate "commercial elements," as he put it, into stories "that came from the gut." In a later conversation with Aljean Harmetz of the *New York Times* about the film's autobiographical dimension, Soderbergh said, "Nothing in the film ever happened. I never taped women. But it's all true."[46]

Soderbergh's script centered on Graham, a grim but charming loner and veteran slacker who stops by Baton Rouge to visit John, a college friend he hasn't seen in years who has become a smug, philandering yuppie wed to the lovely but sexually repressed Ann. An opening montage reveals that John is having a torrid affair with Ann's liberated, sexually ravenous sister, Cynthia, who is fiercely competitive with her polar-opposite sibling—as different from Ann as Graham is from John. Soderbergh has said that he based the four characters on different aspects of his own personality and different phases of his own personal (and sexual) development, and one of the script's strengths is how finely drawn the principal characters are on the one hand and how they provide a canny composite of the Gen-X contingent on the other. Graham and Ann inevitably connect, and she learns that he is a recovering pathological liar whose travails with women have left him sexually impotent—except when he is alone, getting himself off while watching one of the scores of videotaped interviews he has conducted with women talking about their sex lives. Ann also learns the truth about John and Cynthia and responds by asking Graham to interview her, which leads to a sexual reawakening for Ann and Graham. Major conflicts and crises ensue, and the script ends—in the initial draft, anyway—with all four characters very much alone, left to reassess their lives.

Soderbergh gave the untitled first draft (dated January 2, 1988) to his agent after arriving in L.A. Dollard loved the script although she urged Soderbergh to incorporate a more upbeat resolution, a view that was seconded by the producing team that she assembled. Dollard and Soderbergh went after financing, which came rather quickly thanks to the project's melding of bankable elements—as Soderbergh put it: "a film about sexuality, with four young, attractive

characters which could be made for about one million dollars."⁴⁷ The production budget was actually $1.2 million, most of it coming from RCA/Columbia Home Video in exchange for the domestic video rights.⁴⁸ That home-video deal was a decidedly mixed blessing, since it meant that a U.S. theatrical distributor would receive none of the revenues from home video, where films tended to generate most of their profits. Despite the likely straight-to-video release, Soderbergh was undaunted, pleased to be making his feature film debut and quite satisfied with a budget that paid him a director's fee of only $37,000.⁴⁹ Prepping for a summer shoot, Soderbergh put together "a small crew," most of whom were other twenty-somethings with whom he had worked before in Louisiana on commercials and industrial films. A notable exception was his Los Angeles–based cinematographer Walt Lloyd. Lloyd was a key collaborator on the film and something of a mentor to the neophyte filmmaker, who in later years took over the jobs of DP and camera operator on many of the films he directed. The modest budget of *sex, lies, and videotape* ruled out top stars, but Soderbergh was able to assemble an exceptional cast due to the strength of the script, which attracted heavy interest from actors both in New York and L.A. He first cast Andie MacDowell, a fashion model who had been struggling to break into films, as Ann; he then cast Laura San Giacomo, who had done a bit of series television but very little film, as Cynthia. Auditions in L.A. put James Spader, a fringe member of the Hollywood "brat pack" and by far the biggest name in the cast, in the role of Graham. Spader recommended his friend Peter Gallagher, a seasoned stage and TV actor, for the role of John.⁵⁰

Soderbergh put his cast through an intensive week of rehearsals, something of a luxury on a low-budget picture, and he encouraged them to improvise and flesh out their characters as he continued to revise the script. The revisions included a more positive payoff—an epilogue with three brief vignettes in which all four principals get their just deserts and seem to get on with their lives, with Ann and Graham apparently together. By then Soderbergh was feeling better about his own emotional state, and he also recognized the practical reasons for an upbeat resolution. "Many American independent films are depressing at the end in order to prove they are not commercial," he said later, "and I did not want to fall into that trap." He decided to lighten up the end of a film that grew "increasingly darker" as the story progressed, although the fate of all four principals still remains uncertain.⁵¹ Soderbergh also settled on the title, which was inspired by the three words (and themes) he associated with Graham's character. That title generated endless debate, due less to the lowercase lettering than the term "videotape," which his producers felt devalued the film—despite its expected direct-to-video release route.⁵²

Principal photography on *sex, lies, and videotape* spanned thirty days and went smoothly, thanks mainly to Soderbergh's command of the material, his confidence in a talented cast ("You hire the best people and you let them perform"), and his rapport with Walt Lloyd. The director and DP worked quickly

FIGURE 26: It was only during rehearsals of *sex, lies, and videotape* (Steven Soderbergh, 1989) that the director decided to rewrite the epilogue and leave Graham (James Spader) and Ann (Andie MacDowell) together, ending his "increasingly darker" tale on an upbeat note.

and intuitively without storyboards or even daily shot lists—an unusual practice even in the low-budget independent realm. "I'd walk on the set, we'd block a scene, and then I'd decide on the camera angles," said Soderbergh, who rarely did more than three or four takes on the key scenes to keep the emotions and performances fresh. Soderbergh and Lloyd opted to avoid long lenses and tight close-ups, developing an intimacy via camera proximity with standard lenses. Soderbergh also worked with Lloyd to keep the camera moving, especially in the many dialogue-driven scenes, hoping to keep his "very talky film" from appearing "visually static."[53]

Soderbergh edited the film himself, which put him in rather exclusive company among American filmmakers, independent or otherwise; only the Coen brothers routinely write, direct, and edit their own films. Editing *sex, lies, and videotape* was a challenge due to the cross-cutting that Soderbergh introduces in the opening credit sequence and sustains throughout, and which goes into another register once the videotaped interviews come into play about halfway through the film. The narrative becomes particularly complex in the latter portion of the film, once Ann discovers John and Cynthia's affair and asks Graham to interview her. That leads to radical shifts in temporal structure and point of view, with Cliff Martinez's evocative electronic score taking on a more pronounced role in the narrative. The melding of Soderbergh's montage and Martinez's score, in fact, would emerge as prominent stylistic trait not only in *sex, lies, and videotape* but in almost all of Soderbergh's subsequent films.

Like Soderbergh, producers John Hardy and Bobby Newmyer were new to feature filmmaking. *sex, lies, and videotape* was the first producing credit for both, and they literally kept their distance from Baton Rouge during the shoot.

They left Soderbergh alone during postproduction as well, weighing in only when he asked in early fall whether they thought a rough cut of the film was ready for submission to film festivals. Among the venues Soderbergh had in mind was the U.S. Film Festival, a relatively low-profile gathering in Park City, Utah, which was barely on the radar of either mainstream Hollywood or the off-Hollywood independents in late 1988, due mainly to its focus on innovative regional films—an emphasis mandated by Robert Redford, whose nearby Sundance Institute stepped in to underwrite the festival when it was in deep financial distress a few years earlier. It would be renamed the Sundance Film Festival in 1991, thanks in part to the notoriety generated by *sex, lies, and videotape*.

Remarkably enough, considering that outcome, *sex, lies, and videotape* barely made the U.S. Film Festival cut, squeaking into the competition on the basis of its Baton Rouge setting and the ardent support of a single selection committee member.[54] Soderbergh was pleased to have the opportunity to screen the still-unfinished film to a festival audience, and he personally picked up the print from the lab and flew it to Park City for the showing on Sunday, January 22, in one of the festival's smaller outlying venues. In his introduction, Soderbergh explained that the film still needed finishing touches—color correction, a final mix, and so on—and in the Q&A after the screening he asked the audience about the title, which RCA/Columbia was pressuring him to change. The audience was mixed about the title but clearly taken with the film, and the buzz quickly spread throughout the festival and beyond. The mid-week screening was sold out and by the second weekend, at the high point of the festival, tickets for its final screening were being scalped and film buyers were vying for seats. In the closing ceremony on Sunday, Nancy Savoca's *True Love* was awarded the top festival prize, while *sex, lies, and videotape* won the audience award and the lion's share of media attention, along with the first wave of overtures from would-be distributors.

A bidding war steadily escalated, with Larry Estes of RCA/Columbia and producer Bobby Newmyer fielding the offers in Estes's L.A. office, while Soderbergh concentrated on properly finishing the film. Several top independent distributors like Samuel Goldwyn and New Line passed because the video rights were not available, but interest built nonetheless. The sales effort culminated in a meeting with Harvey Weinstein, who flew in from New York to pitch Miramax as the film's domestic theatrical distributor. Miramax at the time was a minor independent distributor that specialized in imports, art films, and documentary features, and had yet to release a substantial hit. Weinstein had a bold, impressive marketing plan, however, which was modeled on his company's handling of *Scandal*, a British film about an infamous 1960s sex scandal that he was about to open in the United States. The release campaign for *Scandal* demonstrated Miramax's capacity to market a sexy, controversial film and also, crucially, to break out of what Weinstein termed the "arthouse ghetto" and into the suburban multiplex market.

Weinstein impressed Estes and Newmyer with his marketing plan and passion for the project, as well as his guarantee to pay $100,000 more than the highest bid for the film. Weinstein ultimately paid $2 million for the theatrical rights to *sex, lies, and videotape*, a huge risk considering the relatively weak independent market at the time—and without question the single most important transaction in the history of Miramax.[55]

After picking up *sex, lies, and videotape*, Weinstein made another move that figured heavily in its marketing campaign and eventual success—and put Soderbergh on a collision course with Spike Lee. The film had been selected to screen at the Cannes Film Festival in its Directors' Fortnight series, a showcase for emerging filmmakers—where Lee's first film, *She's Gotta Have It*, successfully debuted in the 1986 Directors' Fortnight. But when another film unexpectedly was pulled from the festival's far more prestigious main competition, Weinstein convinced the Cannes programmers to replace it with *sex, lies, and videotape*.[56] The field of twenty-two Official Selections for the main competition was relatively modest that year, highlighted by Jim Jarmusch's *Mystery Train*, Jane Campion's debut feature *Sweetie*, and most notably *Do the Right Thing*, which going into the festival was a solid favorite for the coveted Palme d'Or.

But Soderbergh and *sex, lies, and videotape* were the big story at Cannes that year, winning over critics and audiences as well as the festival jury, headed by German auteur Wim Wenders. Lee voiced his outrage when the Palme d'Or went to Soderbergh, and the press had a field day with the competition between the two young American directors. The notoriety and controversy at Cannes ideally positioned *sex, lies, and videotape* and *Do the Right Thing* for summer release, and in fact Lee's film opened in France and the United Kingdom in mid-June, weeks before it debuted in the United States. The strong marketing push Universal gave *Do the Right Thing* supported the studio's strategy of orchestrating a relatively wide release for this "specialty" film, and Lee's production grossed just under $25 million in the United States. Miramax, meanwhile, held off on its release of *sex, lies, and videotape* until early August, when the summer blockbuster fever had abated. Weinstein spent $2.5 million to market the film, roughly twice its production cost, including an aggressive TV ad campaign—exceedingly rare for an independent film. The ads pushed the more sexual and exploitative aspects of the film, which irked Soderbergh. Weinstein placated the young filmmaker by letting him cut his own trailer, which was promptly dismissed as "art-house death."[57] And Soderbergh could hardly complain about Weinstein's release strategy. Miramax gave the film a platform release, opening on just nine screens and steadily widening it as audiences responded. Within four weeks it was in 100 theaters and by late September it was playing in over 500—about the same total as *Do the Right Thing* at its widest release point. *sex, lies, and videotape* matched *Do the Right Thing* at the box office, grossing $24.7 million, although lower production and marketing costs made Soderbergh's film the more profitable of the

two—one of the most profitable American films ever, in fact. It also was heralded as the most successful "art film" to date, thanks largely to Miramax's successful foray into the mainstream multiplex market.

Critical reception was vital to the box office success of *sex, lies, and videotape*, testifying to the film's considerable strengths as well as the efficacy of the Miramax marketing campaign. Caryn James's review in the *New York Times* typified the effusive critical discourse: "Mr. Soderbergh's astonishing first feature is a 'Liaisons Dangereuses' for the video age," she wrote. After Cannes, it "comes loaded with advance praise that seems impossible to meet; amazingly, the film surpasses that."[58] This description nicely encapsulates Weinstein's key selling points: the sexual psychodrama, the breakout auteur, the festival pedigree, and the Gen-X target audience. Independent sales veteran John Pierson seconded that assessment in *Spike, Mike, Slackers & Dykes*, and underscored Soderbergh's impact as a new breed of filmmaker. "Harvey's single smartest move on positioning this film," wrote Pierson, "was his mold-breaking Cannes strategy"—that is, pushing Soderbergh and the film out of the new directors' showcase and into the main competition. The Palme d'Or and attendant exposure enhanced its box office prospects both in the United States and overseas, where the film also did excellent business. In the process, *sex, lies, and videotape* "showed just how far a first feature, released by an independent no less, could go all over the world."[59]

New Directions in the New Hollywood

As I posited at the outset, *Batman, Do the Right Thing*, and *sex, lies, and videotape* were symptomatic—indeed paradigmatic—of the stratified New Hollywood with its three increasingly distinct classes of product: high-end studio spectacles designed and engineered for a rapidly expanding global marketplace; low- to mid-range films for more specialized markets and more discriminating audiences; and low- to no-budget films produced without a distribution contract (or even a marketing budget), relying mainly on the burgeoning film festival circuit for exposure and a shot, however remote, at a distribution deal. As the preceding case studies well indicate, the role and actual work of the director was both essential to and essentially different within each of these market sectors.

Tim Burton's work on *Batman* demonstrates that the "studio system" was alive and well in the rarified realm of big-budget filmmaking in the New Hollywood. Burton played a key role in reviving and reshaping the property, but once Warner Bros. gave it the greenlight, he was quickly relegated to a rather traditional director's role—much the same "job of work" that John Ford described a half-century earlier. After *Batman*, Burton directed *Edward Scissorhands*, a 1990 release that he coproduced with partner Denise Di Novi for Twentieth Century–Fox. Starring

Johnny Depp in the first of many collaborations with Burton, the modestly bud-
geted film was a solid commercial and critical success. Based on the director's
concept and a script he personally commissioned, *Edward Scissorhands* was also
a definitive "Tim Burton film," clearly signaling the degree of authority and cre-
ative control a filmmaker could enjoy on a studio picture when the commercial
stakes were lower, when the director acted as his own producer, and when the
director's name and signature style were key selling points. Burton did return
to Warner Bros. for *Batman Returns* (1992), on which he exercised considerably
more control than on *Batman*, thanks to the leverage generated by that earlier
film's success and the fact that he and Di Novi were producing. In yet another
indication of *Batman*'s impact and the changing New Hollywood landscape,
Peter Guber and Jon Peters were hired in late 1989 to run Columbia Pictures,
which had just been acquired by Sony. Consequently, *Batman Returns* was more
firmly in Burton's control and was decidedly darker and more macabre than its
predecessor, which undercut its box office performance and also, crucially, its
licensing and merchandising prospects. Warner Bros. deemed *Batman Returns*
a disappointment, and replaced Burton with a more compliant and "commer-
cial" director, Joel Schumacher, on the third and fourth series installments. But
the franchise continued to fade, suggesting that Burton's distinctive stylization
and his reputation with cinephiles were significant factors in the success of the
first two films—especially *Batman*, on which the creative and commercial forces
struck a delicate balance.

At the other extreme of the commercial and the control spectrum, so to
speak, was *sex, lies, and videotape*. As with most independent filmmakers, Steven
Soderbergh was of necessity a multi-hyphenate—in this case the writer-direc-
tor-editor—with unassailable command of the filmmaking process. This creative
control affirmed his authorial status, of course, and reinforced the notion that the
writer-director was at the epicenter of the burgeoning indie movement. As Peter
Biskind put it in *Down and Dirty Pictures*, Soderbergh was the model indie auteur,
with his role as writer-director on a personal project "rendering him a genuine
'filmmaker.'"[60] But the same could be said of Spike Lee and *Do the Right Thing*,
a studio film with its roots firmly planted in the same independent traditions.
Indeed, Lee was among a growing contingent of high-profile writer-directors
with independent roots working in the mainstream movie industry—a cadre that
included Oliver Stone, Joel and Ethan Coen, John Sayles, and Jonathan Demme,
among others, and would soon come to include Richard Linklater, Quentin
Tarantino, Kevin Smith, David O. Russell, and Wes Anderson. The majority of
these filmmakers, like Lee and Soderbergh, parlayed their success on an indepen-
dent first feature into access to the resources of a studio or a major indie outfit
like Sony Classics, Gramercy (funded by Universal), or Miramax (acquired by
Disney). And at that point most were hyphenate writer-directors by choice, not
out of necessity, and were content to operate in the low- to mid-budget range if

that enhanced their authority and creative control. Lee remained the most active multi-hyphenate of the lot in the 1990s, a director who also produced, wrote (or cowrote), and acted in an impressive run of films that included *Mo' Better Blues* (1990), *Jungle Fever* (1991), *Malcolm X* (1992), *Crooklyn* (1994), *Clockers* (1995), *He Got Game* (1998), and *Summer of Sam* (1999). All of these were major studio pictures in the mid-budget ($10–30 million) range, and all but *Summer of Sam* were black-themed films starring African Americans—notably Denzel Washington, who starred in three and was Oscar-nominated for *Malcolm X*.

While Lee stayed within his comfort zone in the 1990s, turning out mid-range studio films for his core constituencies of urban moviegoers and Spike Lee fans, Burton and Soderbergh both exemplified directors who moved from one market sector and production mode to another in the increasingly trifurcated industry. Burton was among the high-profile filmmakers who moved from modestly budgeted director-driven studio films like *Edward Scissorhands* and *Ed Wood* (1994) to $100 million studio-controlled projects like *Mars Attacks!* (1996) and *Sleepy Hollow* (1999). And by far his biggest project of the decade, remarkably enough, was "Superman Lives," a franchise reboot developed by Jon Peters for Warner Bros., based on a script by Kevin Smith. Burton spent a year on the project after completing *Mars Attacks!*, but it was abandoned in 1998 due to anticipated cost overruns (in the $200 million range) and "creative differences" between Burton, Peters, and the studio.[61]

Soderbergh, meanwhile, gradually emerged as the most mobile of New Hollywood directors. After *sex, lies, and videotape*, he directed three ambitious indie-sector films, *Kafka* (1991, for Miramax), *King of the Hill* (1993, Miramax), and *The Underneath* (1995, Gramercy), all of which were critical and commercial failures. At that point he reverted to micro-budget independent projects, *Gray's Anatomy* (1996) and *Schizopolis* (1996), neither of which was widely distributed or well received. While other art-cinema types like Sayles, Gus Van Sant, and Jim Jarmusch occasionally chose to work as true independents to ensure creative control and minimize commercial constraints, Soderbergh was simply unable to find any traction in an industry that seemed to be moving on without him. He did continue to write and audition for studio directing jobs, however, which eventually paid off when Universal hired him to direct *Out of Sight* (1998). That sparked one of the most stunning comebacks in industry annals, propelled by three consecutive runaway hits displaying the full range and depth of Soderbergh's filmmaking talents: *Erin Brockovich* (2000), *Traffic* (2000), and *Ocean's Eleven* (2001). Since then, as J. D. Connor chronicles in the following chapter, Soderbergh has been among the most prolific, multidimensional, and eclectic American filmmakers, and has been a singular multi-hyphenate as well. Although he no longer writes the films he directs, Soderbergh usually works as his own producer, cinematographer (under the name Peter Andrews), and editor (under the name Mary Ann Bernard).

While Soderbergh was struggling during the 1990s, the movie industry was booming and the legacy of *sex, lies, and videotape* became ever more pronounced. Hollywood's domestic, foreign, and home-video markets all underwent record growth in the 1990s, and the indie movement surged as well, spurred by an influx of independent distributors and the launch (or acquisition) of indie subsidiaries by the studios' parent conglomerates. And given these market conditions, even the major studios were risking the occasional director-driven, indie-style film. By decade's end the so-called Indiewood phenomenon was in full swing, as the industry returned to the director-driven ethos of a quarter-century earlier. Consider this inventory of 1999 releases that attest to that ethos—films from a remarkable array of directors, ranging from veterans of the Hollywood Renaissance to the growing cadre of emergent indie auteurs:

- *Election* (dir. Alexander Payne; Paramount/MTV Films)

- *The Virgin Suicides* (Sofia Coppola; Paramount Classics)

- *South Park: Bigger, Longer & Uncut* (Trey Parker; Paramount/Comedy Central Films)

- *Eyes Wide Shut* (Stanley Kubrick; Warner Bros.)

- *The Blair Witch Project* (Eduardo Sanchez and Daniel Myrick; Artisan)

- *The Sixth Sense* (M. Night Shyamalan; Disney/Spyglass)

- *Boys Don't Cry* (Kimberly Pierce; Fox Searchlight)

- *Sweet and Lowdown* (Woody Allen; Sony Pictures Classics)

- *American Beauty* (Sam Mendes; DreamWorks)

- *Three Kings* (David O. Russell; Warner Bros./Village Roadshow)

- *Fight Club* (David Fincher; Fox/Regency)

- *Being John Malkovich* (Spike Jonze; USA Films)

- *Bringing Out the Dead* (Martin Scorsese; Paramount/Touchstone)

- *The Insider* (Michael Mann; Disney/Touchstone)

- *The Cider House Rules* (Lasse Hallström; Miramax)

- *Man on the Moon* (Milos Forman; Universal)

- *The Talented Mr. Ripley* (Anthony Minghella; Paramount/Miramax)

- *Magnolia* (Paul Thomas Anderson; New Line)

Among the other 1999 releases were *The Matrix* and *Star Wars: Episode I—The Phantom Menace* (marking George Lucas's return to directing after twenty-two years). Both were huge hits, of course, and also the first installments in trilogies that rekindled and intensified the franchise mentality that had fueled *Batman* a decade earlier. And among the projects in development in 1999 were the first of the *Lord of the Rings*, *Harry Potter*, and *Shrek* series (all released in 2001), which solidified mainstream Hollywood's increasingly single-minded franchise mentality and steadily diminished the indie movement—and, along with it, the notion of the American cinema as a directors' medium.

6

THE MODERN ENTERTAINMENT MARKETPLACE, 2000–PRESENT

Revolutions at Every Scale J. D. Connor

From the smallest scale—shaping a particular take—to the largest—managing a career across projects—directing in the new millennium has been transformed by changes in technology, the marketplace, and their interactions. While the director remains the figure centrally responsible for the management of the creative labor on a particular motion picture, the evolution of the media ecosystem has radically dispersed and extended the director's role. What is more, those extensions, which are all fed back into the process of marketing, have further raised the stakes of what it takes to be "a director" and reconfigured the very nature of film authorship.

Since 2000, the industry has seen the substantial completion of the process of digitization that began with sound and visual effects and eventually encompassed nearly every aspect of Hollywood production. "We are really in the midst of some sort of revolution that threatens the status quo. This is potentially either a very scary thing or a very liberating thing," director Steven Soderbergh observed.[1] Movies today are overwhelmingly shot, edited, and color-corrected digitally, and moviemakers have had to adjust. Film as an exhibition medium is all but a relic.

Distribution remains a hybrid; studios still send out thousands of hard drives to theaters for major releases, but increasing bandwidths augur a future where theatrical distribution will take place over fiber-optic cables and via satellites. Movie marketing, too, has largely shifted to digital sources as domestic media consumption moves online and away from printed sources and live television.[2] In order to remain viable in today's Hollywood, directors must be cognizant of all these rapidly changing tools of the trade.

In addition, directors must be ready to adapt themselves to the increasingly complex revenue streams today's studio motion pictures are expected to generate. Today the video and streaming markets are mature but ever-changing, and producers have recalibrated their products to capitalize on those formats. Directorial labor is necessary not only to produce "the text" but to generate value-added elements for aftermarkets. Similarly, revenues from licensed characters, theme park rides, and other ancillary markets are vital, and studios devote their largest budgets and the greatest share of their executive labor to the cultivation of franchises that are poised to reap the biggest rewards.[3] Directors need to have a sense of the place of individual movies in such "long tail" marketplaces and transmedia empires, and they need to make their contributions essential to a movie's success in those adjacent arenas. Directing in the twenty-first century is best viewed as a collection of practices and strategies formulated in relation to an ever-shifting constellation of constraints and possibilities—things that are, in Soderbergh's terms, scary or liberating or both. Directors manage individual takes, diverse sites of production, and their own careers and reputations under ever-intensifying pressure.

Takes: Marketing Extended Performance

The smallest unit of direction is the individual take. Historically, Hollywood has offered its most prestigious directors discretion over the number of takes they shoot and print. Some have been famous for economy—W. S. Van Dyke was nicknamed "One Take Woody"—others for shooting and shooting and shooting—George Stevens in the classical era, Stanley Kubrick later. The conventional wisdom has long favored a happy medium. It may take an actor several takes to "find" a particular reading or action, but given the exigencies of production, that process risks wearing out actors and crew. Too many takes are understood to be a symptom of a set out of control and a director in search of a story. Director John Badham calls this approach "playing the lottery."[4]

The sense of Badham's criticism depends on an idea of how performances serve "the story." On his account, the story exists in advance, the director along with the producer and other crucial personnel having broken it down, and the job of the actors on set is to realize that story in the best possible form. Yet technical

changes have opened up the possibility for drastically different approaches to cinematic story generation even within Hollywood moviemaking. Without the need to limit shooting durations to the length of a 35mm film magazine in the camera (about ten minutes), a digital take can keep going, veering off in unexpected directions. Moreover, the simplified lighting requirements needed for digital photography make complex shots and repeated takes far less arduous than before. Instead of the time-consuming process of reloading the camera and relighting a scene, actors and camera operators need simply reset their timers. To be sure, if these longer and more numerous takes buried editors in a thicket of film strips and conscripted them to endless hours at a Steenbeck editing table, directors would likely retain more of their former discipline. Today, though, the ease of digital editing abets the trend toward more improvisation on the set.

A look at the working methods of directors as different as Terrence Malick and Adam McKay gives a sense of the pervasiveness of this change. Malick personifies the visionary independent, creating oblique narratives where lyrical (or simply plotless) visuals are paired with philosophically freighted voiceovers. Perhaps surprisingly, in the early stages of his projects there is usually a substantial, even encyclopedic, script with a great deal of traditional narrative structure. The script, though, serves more or less as a backstory once shooting starts.[5] Beginning with *The New World* in 2005, Malick, working with his cinematographer Emmanuel Lubezki and his Steadicam operator Jörg Widmer, abandoned traditional practices built around precise blocking, repeated takes, classical coverage, and analytical editing. Instead, they have emphasized extended freeform performances that are enabled by the ready deployability of the camera, simplified lighting requirements, and long shooting durations made possible by digital image capture.

In Malick's cinema the openness of individual shots reflects the moviemaking process as a whole. As Michel Chion put it, "Malick's use of camera movements, developed from his second film onwards, is not merely spectacular; it recalls that the space is not delineated, that we are free to cut through it, to come and go here and there."[6] Snatches of narrative appear and disappear. If a troublesome actor struggles to find a performance, Malick attempts to locate what narrative there is during an extended postproduction phase. As Madeline Whittle notes, "Cast members testify to feeling that . . . working with Malick" is a mysterious experience. Sean Penn reports, "We were all gonna be the ink in a pen at the end in the editing room, and that he was gonna write a whole other story with us."[7] Badham saw this approach as playing the lottery, but for Malick it is not a matter of desperately searching for a solution to a particular narrative problem. Rather, it is a process of patching together a narrative that is subjective and elliptical from performances that are captured along the way.

As a director, Malick is obviously an outlier, but the reduction of technological limits on extended and repeated takes enables other, more conventional

directors a relatively inexpensive way of improvising solutions to narrative prob-
lems while on the set. The work of Adam McKay provides an instructive case
study that reveals the way in which many of today's comedy directors make use
of these new options. To be sure, improvisation was an ordinary feature of com-
edy filmmaking earlier, but now the practice may be pursued almost without
limits, creating stories that read as strings of loosely linked performance riffs
rather than causally connected chains of events. In these kinds of comedies,
tightly scripted narratives take a back seat to the laugh-per-minute ratio. Such
an approach indicates how little status certain classical satisfactions (coherence,
balance, accumulation, deferral, and payoff) may have in the new regime.[8] As
with Malick, comedy directors of this stripe come to depend on their editors
to help find the story among the riffs. As editor Melissa Bretherton explained,
"These directors don't want one version of the scene. . . . They want six."[9] In the
case of McKay, Judd Apatow, and Paul Feig, that editor is frequently Brent White,
whose proprietary digital library management system helps him grapple with
the mountain of shot footage he is regularly confronted with. "I cut right behind
the director," White has explained. "The day after they start shooting is the day
I start editing."[10]

An extreme example of what is now possible can be found in the 2004 produc-
tion *Anchorman: The Legend of Ron Burgundy*. The film's opening credits appear
over snippets of Will Ferrell's eponymous anchorman preparing for the evening
broadcast on various days—drinking scotch and smoking on set, chatting with
the crew, warming up his voice. The frenetic editing under the credits disguises
the simplicity of the scenic design: Ferrell sits at a TV news desk set; the lighting
is televisually flat; there is no physical action that requires more than the simple
adjustment of a dolly-mounted TV camera. A DVD extra reveals that the banal
design allows McKay to sit offstage in the role of a live TV director. There, the
director offers ludicrous strings of nonsense as vocal practice—"The arsonist has
oddly shaped feet"; "The human torch was denied a bank loan." Without a reason
to cut away, McKay continues to feed Ferrell lines until the actor breaks character
by cracking up. Judd Apatow, who produced *Anchorman*, discussed this kind of
improvisation with *Cahiers du cinéma* film critic Emmanuel Burdeau, explaining

FIGURE 27: Will Ferrell (left) repeats lines being fed to him off-camera by the film's director, Adam McKay (right), during the making of *Anchorman: The Legend of Ron Burgundy* (2004).

that when one improvises on set, logic dictates that the camera remain fixed, even at the risk of slowing the rhythm of the film.[11]

As unlikely as it may seem, the ways in which Malick and McKay direct day to day are at bottom very similar. For both, the cast (and crew) do not realize a pre-ordained vision except in the broadest sense. Instead, they generate material to be shaped in the editing room. It is in the marketing of that material that the difference between McKay and Malick becomes stark. Malick's insistence on very private sets and his refusal to offer commentary on his work creates a voyeuristic dynamic in which each morsel of information from a Malick production might be pored over and weighed for its occult significance.[12] In contrast, mainstream comedy directors generate vast amounts of surplus material that can be put to use as DVD extras or in other "enfotainment" settings.[13] Extended versions of such films function as an archive of surplus performances and scenes—performance elements that "weren't working," perhaps, but are worth displaying anyway. And in the case of comedies, these gleanings from the computer trash bin are evidence of a qualitative change in the performance paradigm.

In the case of *Anchorman*, the extras far exceeded what might be slotted into an "alternate ending"– or "deleted scene"–style feature. Instead, they were quickly edited into an additional feature-length movie, *Wake Up, Ron Burgundy: The Lost Movie*, also released in 2004. A voiceover from Bill Curtis, the offscreen narrator of *Anchorman*, sets up the movie as a story drawn from subsequent events—a kind of sequel. Yet *Wake Up* does not work as a narratively consistent extension of *Anchorman*, nor is it really supposed to. Instead, it operates as both a grab bag of nearly-as-funny jokes in the same situations and as an ultra-confident assertion that this particular production was talented enough to produce two movies' worth of comedy at once.

Sites of Production: Dispersal in Space and Time

Very early in *The Lost World: Jurassic Park*, Steven Spielberg's 1997 sequel to his 1993 blockbuster, deposed impresario John Hammond (Richard Attenborough) and chaotician Ian Malcolm (Jeff Goldblum) engage in a little expository revisionism. The dinosaurs from the first movie are all gone, but they have to get the sequel off the ground. "Thank God for Site B," Hammond says. "Site B?" queries Malcolm. "Isla Nublar was just a showroom, something for the tourists," Hammond explains. "Site B was the factory floor. That was on Isla Sorna. . . . We bred the animals there and then nurtured them for a few months and then moved them into the park."

The existence of Site B, hence of a new collection of dinosaurs, hence of a sequel, is a bit of harmless post-hoc-kery, but in recognizing a two-site model of entertainment production, *The Lost World* also engaged in a self-reflexive

commentary, insofar as it suggested the increasingly fragmented production of the visual effects–heavy Hollywood films to come. Hammond's remark can thus be read as an allegory of modern Hollywood itself. These days, the split-up production sites referred to in *The Lost World* are no longer reserved for enormous science fiction or action movies. For the contemporary Hollywood director, there is, as likely as not, a Site B—as well as sites C, D, E, F, and more—factory floors operating simultaneously somewhere else as well as both before and after the shoot, churning out more (digital) dinosaurs along with an array of other CGI imagery of every imaginable kind. In contemporary Hollywood production, it is easier to grasp this idea of other sites than to sort out the scattered locales and scrambled temporal divisions of preproduction, production, and post that attend the industry's unending search for novel settings, inexpensive labor, and high-tech enhancements. Directors are no longer safely confined within studios and slotted into a neat sequence of production tasks; they are thrust into a moviemaking environment that typically includes multiple sites, each operating along its own timeline. The existence of such multiple, semi-autonomous sites means that they (and their producers) must manage the process within each site and between them all, keeping each of them on track so that when the moment comes to mesh the work done by all of them, there are no unexpected delays or incompatibilities.

Dispersed location shooting and the high-tech support work that interacts with it present today's directors with exceptional challenges. In a previous era, going on location amounted to playing an enormous *fort/da* game, with development and postproduction located at a studio in Los Angeles and principal photography in some far-flung region. Now, though, the proliferation of production centers, the reduction in rendering costs, the portability of storage media, and the dramatic expansion of bandwidth have made it possible to undertake development and postproduction work either on set or somewhere else entirely.[14] In this new context, a director's attention must jump quickly from one site to another.

The alterations in production protocols in twenty-first century Hollywood involve not just a proliferation of spaces but also a disruption of the orderly timeframe that prevailed in the past. Traditional practices like production design, cinematography, and editing, once slotted neatly into preproduction, production, and postproduction, respectively, now occupy sites that weave themselves in and out of the entire process. While it is still possible to mount a film that slides from development into preproduction, from there into principal photography, and from there into postproduction, that pattern is now liable to be drastically rearranged.

This temporal jumble has transformed traditional below-the-line functions and therefore the director's management of those functions. Production design, once carried out before a shoot began, can now spill into production and postproduction. Supporting details of a set can be revised virtually as the terms of a performance become clearer. Those changes—to the set itself, to the background

actors in a scene, or to the lighting—are nearly equivalent in a digital workspace. Digital tools have transformed cinematography as well. A movie shot in a flat lighting scheme can be digitally graded to punch up its contrast, to saturate or desaturate its colors, and to emphasize or efface its "grain." Such stylistic decisions are increasingly deferred to "postproduction," allowing directors and their cinematographers to revisit earlier, now-provisional choices.[15] Finally, editing, once relegated to the end of the process, can now proceed alongside production, sometimes without even the time lag that dailies formerly required. The on-set "video village" can call up vast libraries of shot material to give directors a rough idea of how two very different angles will cut together, allowing them to shoot another take if necessary.

More radically still, early computer renderings and animations have become essential sites and frequently spill over into the production and postproduction phases. Operating as a "digital storyboard," previsualization utilizes rudimentary 3D animation in order to allow a director to sketch out shots in advance. And in the case of complex choreographies in which live action is combined with computer-generated imagery (CGI), elaborate previsualizations can provide templates for editing even before the actors report to the set. Dan Gregoire of Industrial Light and Magic (ILM), the legendary effects division of LucasFilm, described the previz process on Steven Spielberg's *War of the Worlds* (2005): "It gives [directors] a tremendous amount of flexibility to do wild and crazy things without running into an enormous cost."[16] But that flexibility is not boundless. Since a previsualization serves as the reference document for both live action and effects work to proceed in parallel, once it is locked, changes become very difficult to institute. As a result, the workflow now conforms to the particular possibilities the previz allows.

Even while touting the advantages of previz, Spielberg captured its limits: "I prefer, frankly, making things up as I go along right there on the day," he has said. "The way I think I've done my best work is to really conceive stuff without any preconception." And yet in order to make previz maximally useful, the sets, camera movements, and most of the action were designed to conform to the early animations. As a result, Spielberg notes, "There will be no surprises on the day." On the one hand, as producer Colin Wilson attested, previz "allowed Steven to express himself in a way that we could all understand and then figure out departmentally how and who was going to do what." On the other hand, that need to figure things out "departmentally" forced Spielberg to change his approach: "That's a whole other way of working," the director commented while explaining the virtues of preplanning, "and I never really worked this way before."

A further example makes clear the multiplicity of sites that digital workflows have made possible. In James Cameron's 2009 *Avatar*, Site B was at visual effects production house WETA Digital in New Zealand. Production designers Rick Carter and Bob Stromberg commuted 6,700 miles each way for more than a year

while Cameron directed actors and grappled with a new performance-capture system in L.A. The Los Angeles site amounted to a digital "any-space-whatever," where actors, fitted with headgear, would perform for the director. As Cameron explained, "We have greatly enhanced the size of the performance-capture stage, which we call The Volume, to six times the size previously used. And we have incorporated a real-time virtual camera, which allows me to direct [computer-generated] scenes as I would live-action scenes. I can see my actors performing as their characters, in real-time, and I can move my camera to adjust to their performances."[17] While the digital performance-capture work done in L.A. was becoming more intimate, halfway around the world the *Avatar* production relied on the established infrastructure at WETA to realize and then render the world into that which those captured performances would be dropped.

Yet as dispersed and temporally fraught as the production of *Avatar* was, three factors bolstered its overall continuity. First, Cameron's perfectionism assured that there would be sufficient oversight, either direct or through trusted surrogates. Second, the performance capture technology being used in L.A. was developed with WETA's participation, enlisting the company in making sure the system worked as intended. Third, the massive project had such an extended production schedule that the looped temporalities involved in the shoot were never so tightly coiled that they could not be sorted out.

Careers: Opportunities and Pitfalls

In the current Hollywood environment of digitization and dispersal, directors confront both new possibilities and new limitations in relation to their efforts to

FIGURE 28: Director James Cameron oversees Joel David Moore (Norm) in the performance-capture volume during the making of *Avatar* (2009).

exert control over their professional lives. In the studio era, it was not uncommon for novice directors to be groomed for larger productions or for veterans to direct a steady stream of generically similar films. This kind of career management all but vanished with the solidification of the package-unit system. Today, responsibility for directors' careers falls to the directors themselves along with their agents and managers. Directors are called upon to devise sophisticated strategies to build professional credibility and snare prize assignments. They must exercise imagination and far-sightedness in order to guide their careers effectively across projects. Moreover, the terms of success and failure have altered with the rise of slate-driven franchises and auteur-driven prestige television. Steven Soderbergh has shown himself to be unusually adept at devising creative methods of navigating this world.

The studio superhero slate pairs munificent directorial paydays with the artistic constraints of franchise filmmaking. Marvel (a subsidiary of Disney) plans nine films over five years; Warners' DC Comics slate is ten movies over the same period.[18] Such announcements are followed by a flurry of interest in the out-year titles, particularly in the directing assignments, since the stars are usually set. By committing so far in advance, whether to superheroes or to a multi-novel adaptation, studios are able to staff franchise films much as they staff television series, and in a way that recalls practices more common to low-budget series of the 1930s and 1940s such as the Andy Hardy cycle or the "Road" movies with Bob Hope and Bing Crosby. The property is presold, the story bible is being managed by a supervising producer (Kevin Feige at Marvel), and the leads are cast. The choice of director remains, and she or he is being hired onto an antecedent series. This strategy can limit a director's creative input and lead to friction, but the long lead times allow for personnel changes. The strategy of managing such lucrative assignments reveals itself in a study of contrasts. When the management is successful, as in the case of Christopher Nolan, one project seems to lead logically to the next. But in a system as complex as Hollywood, failures are as revelatory as successes, as the case of Nicolas Winding Refn and the concept of "director jail" make clear.

Nolan successfully managed the move from independent filmmaking to studio blockbusters. His career is, in that sense, paradigmatic, but it also demonstrates a rare degree of studio continuity. He began by directing the low-budget indie features *Following* (1998) and *Memento* (2000). Steven Soderbergh, in his role as producer, helped convince Warner Bros. to back Nolan to direct *Insomnia* in 2002, a remake of a 1997 Swedish film, promising to oversee this step up the ladder via his production company Section 8. Now part of the arthouse arm of Warners, Nolan would make his next film, a reboot of the Batman franchise, for the mothership. "I'd made my last film at Warner Bros. so I was able to go to them and explain to them the way I saw the Batman franchise being interestingly reinvented," the director explained. And while the scale of that production

FIGURE 29: Production designer Nathan Crowley (left), director Christopher Nolan (right), and screenwriter David Goyer (not pictured) worked together in Nolan's garage during the preproduction of *Batman Begins* (2005). The off-lot space allowed the franchise production to take on a more auteurist, independent feel.

was enormous in comparison to his previous work experience, the work process was still described as firmly within the indie model that Nolan had previously been part of. Writer David Goyer considers it "ironic" that this "massive, massive movie" was created in "humble settings"—Nolan's home office in a garage, in the summer heat, with the clothes dryer in the background. But irony is not the right term if the Warners strategy was, from the beginning, to transmute indie cred into franchise gold. Nolan's garage stands as the extra-studio yet studio-sanctioned space. There, he, Goyer, and designer Nathan Crowley worked on the "key elements" of the film. "It was a really interesting way to work because we would feed each other information," Goyer contended.[19]

Nolan's trajectory was a studio-managed tryout on his way to blockbuster auteur status. Nicolas Winding Refn self-consciously modeled his own path on Nolan's, but with different results. In 2010, while at work on *Drive*, Refn confided his ambition for the future to MovieLine. "*Wonder Woman*, I really want to make," he said. "That, I'm hoping, will be my $200 million extravaganza—if I even get close to it. That's why I say, 'Well, let me go make *Drive*. Let me start the ball rolling within the system.'"[20] The next year, he had further elaborated his plans after being attached to direct Warner Bros.' long-simmering remake of *Logan's Run*. "I would love to make *Wonder Woman*," he repeated to another journalist. "And I also think that Christina Hendricks would be the perfect Wonder Woman, but Warner Bros. haven't called yet. But I'm getting closer with *Logan's Run*. I think someone said to me in a meeting that if I get *Logan's Run* right, then I'll get *Wonder Woman*."[21] Refn's plans, however, did not match Warners'. In 2013, the *Logan's Run* remake officially fell apart. In 2014, the studio announced a multi-year slate for its DC Comics characters and signed Gal Gadot to a three-picture deal to play Wonder Woman. Late that year, word leaked that the studio intended to hire a woman to direct the film, and trial-balloon shortlists were floated by industry reporters even as it became clear that Warners had been in negotiations since the summer. Eventually, the studio announced that veteran television director Michelle MacLaren (*Breaking Bad*) would take the reins. While Refn's multiyear campaign was unsuccessful and he returned to

stylish genre filmmaking, the studio's measured information release did what it was supposed to do: built fan excitement around the mechanics of motion picture assembly years before the picture would hit the screen.[22]

If climbing the ladder to studio franchise success is challenging, managing a directorial career through a flop is even more daunting. At every point it inverts the pyramid of success model that Nolan, Refn, and others have tried to follow. When a particular project goes badly, directors end up in "director jail"—unemployable by something like tacit, industry-wide consent. Unlike producers, who might be able to get back in the game if they can assemble sufficient capital, directors must work their way out of jail, rebuilding their cachet by scrambling for the sort of assignments that do not come with such penalties. Writer-directors go back to writing. Non-hyphenated directors turn to television projects, working for-hire on individual episodes, or time-and-budget constrained movies of the week. In these contexts, the possibility of a "ten-ton turkey" is small, and after sufficient time the director is paroled.[23]

Director jail is an idea particular to the package-unit era, but more particular to the precarious director in the contemporary marketplace.[24] The canonical example of a jailed director may be John Lee Hancock.[25] After writing two Clint Eastwood films, *A Perfect World* (1993) and *Midnight in the Garden of Good and Evil* (1997), as well as a number of TV episodes, Hancock directed the hit *The Rookie* for Disney (2002), a film that returned more than $80 million at the box office on a modest budget of $22 million. From there, he moved on to the mega-flop *The Alamo* (Disney, 2004), which made only $26 million against a budget of $107 million. Director jail followed until Hancock was given the chance to write and direct *The Blind Side* (Alcon/WB, 2009).

The rules of director jail are very similar to those of what Rick Altman calls the producer's game.[26] In Altman's account, generic cycles result when producers copy hits, ideally retaining those elements that are successful while varying others in order to be able to claim a certain degree of novelty. In the case of a director's career gone astray, producers will attempt to determine which elements were responsible for the flop and then build a project that avoids them. In Hancock's case, the elements of the hit *The Rookie* might be contemporary southernness, sports, and narrative triumph. The *Alamo* project varied too many of those: the southernness was historical; war took the place of sports; and the narrative resolution was far murkier. All of those innovations represented by *The Alamo* had been part of screenwriter Hancock's repertoire, exemplified on *Midnight* and *A Perfect World*, and so it had made sense for those in charge of the new film to seek to expand director Hancock's "core competency," even if the result proved disappointing. In terms of the modified producer's game, the powers behind *The Blind Side* took a step back, playing it safe by hiring Hancock based on his earlier success in the director's chair; it was a one-to-one mapping of all the crucial elements of *The Rookie*.[27]

In the current media ecosystem, television serves not simply as a training ground but also as a place where reputations can be made and remade. The passage from TV to film is no longer one-way but a more open exchange. That open exchange has been enabled by changes in the nature of television directing. Historically, television production practices have relegated directors to a low rung in the creative hierarchy, with writers at the top serving as executive producers, overseeing the series' bibles, and bringing in directors-for-hire on an episode-by-episode basis. The breakthrough series of the "TV III" era made executive producers such as David Chase (*The Sopranos*) and Vince Gilligan (*Breaking Bad*) into a new generation of writer-auteurs, "showrunners" with unique visions and creative cachet.[28] In short order, the notion of the "showrunner" became unmoored from its origins in the writing room, allowing a director to step into the role.

Technological changes have been key to the elevation of television into a medium capable of luring big-name movie directors. In the DVR-cable/Over-the-Top streaming era, commercial interruptions are no longer inevitable; budgets are bigger; and season commitments are not as long. Moreover, as home screens have become larger, television directors more readily make "cinematic" choices, such as featuring large-scale panoramas or playing conversations in long shots. And as more and more viewing is done via streaming, viewers can watch and rewatch shows as they choose, inserting subtitles or replaying the scene when rapid-fire dialogue or fast-moving action becomes incomprehensible (as on *Game of Thrones*). Sophisticated visuals may be pored over, made into GIFs, and shared online to further heighten a project's prestige and intensify its audience's commitment. In response, many motion picture directors have seized newly viable openings to claim authorship of TV shows.

By 2014, the idea of a credentialed Hollywood auteur directing for television was hardly the anomaly it had been when David Lynch directed several episodes of *Twin Peaks* in the early 1990s.[29] Miniseries were the first to change, as when Mike Nichols directed *Angels in America* in 2003 and Todd Haynes took the reins of *Mildred Pierce* in 2011. For longer-form projects, auteur directors were likely to share duties, as Jane Campion did with Garth Davis for *Top of the Lake* in 2013. Even in more traditional, open-ended series arrangements, director auteurs sometimes stepped in to helm a series premiere and set the overall tone for a series. Thus, Martin Scorsese directed the premiere of *Boardwalk Empire* for HBO in 2010, and David Fincher directed the premiere of *House of Cards* for Netflix in 2013. In the rebalanced mediascape, television was less a safe haven for a career in retreat than the logical home for long-form, indie storytelling.

Steven Soderbergh's exceptionally canny multi-project management strategies reveal a career that has run the gamut from micro-budgeted indies to star-studded studio franchise pictures to prestige television. In some ways, he was the prototypical turn-of-the-century director. As Thomas Schatz describes

in the previous chapter, Soderbergh got his major break via indie networks, winning the Palme d'Or at Cannes for *sex, lies, and videotape* in 1989. Following this triumph, he continued to pursue projects both in and out of the mainstream. The 1990s were a period of misfires (*Kafka* [1991] and *King of the Hill* [1993]) and recovery (*Out of Sight* [1998]), but by the end of the decade Soderbergh was regarded as a director who could work in recognizable genres quickly and efficiently while cultivating a deep rapport with his stars.

In this context, Soderbergh's two Oscar nominations in 2000, for *Erin Brockovich* and *Traffic*, the first such double since Michael Curtiz's in 1938, look like a relic of a long-past studio era when directors would routinely work on several films over the course of a year. But unlike Curtiz, Soderbergh had no secure home in a single studio; instead, his skill set might be put to use either inside or outside the studios, as the contrasting examples of *Brockovich* and *Traffic* make clear. In the case of *Brockovich*, the project had originated with Jersey Films—a production shingle with a first-look deal with Universal. Jersey acquired the life rights to Brockovich's story directly and hired Susannah Grant to write the script. Jersey then approached Soderbergh because he had directed the stylish noir *Out of Sight* for them. Meanwhile, the script had attracted Julia Roberts, and only after she was attached did Soderbergh sign on. *Erin Brockovich* was co-distributed by Universal and Columbia. *Traffic* represented a very different process. Soderbergh was attached to the project before the script was written and well before casting. He and producer Laura Bickford (and later Ed Zwick) sought to adapt the original British miniseries without sacrificing the underlying multi-stranded narrative. Uncertainties about the budget and disagreements about the plot resulted in several abortive distribution deals before the project wound up at mini-major USA Films.

In the wake of his double-barreled success with *Brockovich* and *Traffic*, Soderbergh moved into producing by forming Section 8 with partner George Clooney, a shingle based at Warner Bros. and one that would encourage the studio to form its own specialty releasing arm, Warner Independent Pictures. From his base at Section 8, Soderbergh directed major, mainstream entertainments (beginning with *Ocean's 11* in 2001), more challenging independent films (*Full Frontal* in 2002), and even a complex docu-fictional television series for HBO (*K Street* in 2003). In the course of his career, he has had more than his share of flops, part of a highly adventurous one-for-me/one-for-them strategy. His "ones-for-them" were certainly profitable enough, and his value to Warner Bros. as a producer helped insulate him from the consequences of poor financial performance on some of his riskier ventures. Moreover, he successfully cultivated a reputation for a willingness to undertake an astonishing array of projects knowing that some would be destined to fail monetarily, critically, or both.

One of Soderbergh's most public failures occurred when he was attached to direct the film adaptation of Michael Lewis's 2003 best-selling baseball saga

Moneyball. As the *Moneyball* project developed, Soderbergh imagined the film as the baseball version of Warren Beatty's 1981 *Reds*, complete with interviews with the actual players and management involved. At Warner Bros., where he had a longer track record, and where he had made the successful *Ocean's* series, he might have been allowed to proceed. But at Sony, production head Amy Pascal, already nervous about the film due to baseball's inherent market limitations, became increasingly dubious about the movie's financial prospects and cancelled production.[30]

Soderbergh responded to his firing from *Moneyball* with a flurry of activity and a pledge that he would soon stop directing movies altogether. Then, in rapid fire, he directed *Contagion* (2011), *Haywire* (2011), *Magic Mike* (2012), *Side Effects* (2013), and *Behind the Candelabra* (2013). The last was made as an HBO movie because, Soderbergh said, "We needed $5 million. Nobody would do it."[31] He may have been able to work so consistently by being too busy to jail, by launching a new, modestly budgeted movie before any previous failure could hurt him, and by cycling through projects so different that they offered no ready comparison to what came before or after.

In 2014 Soderbergh turned to television directing for the series *The Knick*, a move that encapsulates nearly all the changes that have revolutionized directing since 2000. At the level of his career, what might have been cast as a setback was transmuted into an adventurous choice. Speaking to the Television Critics Association, Soderbergh was simultaneously promoting himself and his project, as all directors now do. There, he explained that although he had partnered with HBO for *Candelabra* and *K-Street*, he had wanted to make *The Knick* for HBO's smaller cable sibling, Cinemax: "I kind of wanted to be the big kid at a small

FIGURE 30: Digital hyperauteur Steven Soderbergh shoots and directs a three-and-a-half minute shot in *The Knick* (2014–15), a television series cross-boarded like a motion picture.

school."[32] To further amp up the sense of challenge and experimentation around the project, publicity materials stressed that Soderbergh was going one better than his fellow auteurs-turned-showrunners by directing all ten episodes of the first season in a seventy-three–day shoot. What is more, he "cross-boarded" the production—directing the entire season out of continuity rather than proceeding episode-by-episode. Once on a given location, he, star Clive Owen, and rest of the cast and crew consulted elaborate charts in order to maintain continuity and guide their performances from scene to scene across moments that might be nine hours distant in screen time. As Owen would explain, "At the end of the day, Steven Soderbergh is a movie animal. . . . It didn't feel like television."[33] Instead, Soderbergh had audaciously reconfigured prestige television as a sort of mega-cinema in much the same way that slate-driven cinema has been remade as a sort of mega-television.

The Shifting Grounds of Film Authorship

In the twenty-first century, directors have had to contend with altered conditions affecting their image as film authors. On one hand, franchise filmmaking has slotted them into preset formulas, while on the other, prestige TV has presented them with new vehicles that can be imprinted with authorial signatures. Other trends involve further redefinitions of directorial authorship. The industry marketing machine has converted every phase of a director's profession into a further opportunity for publicity, and precarious directors have played along. Moreover, digital technologies have made it possible for directors to shape and reshape their films and enhance their presence as auteurs; they can record a DVD commentary track or prepare a director's cut.

Directors today participate in publicity and marketing to an unprecedented extent at sites both real and virtual, making their role more visible to the public at large.[34] Pre-preproduction ballyhoo surrounding a director's involvement with a project might begin as early as a studio's potential interest in commissioning a script. During production itself directors are typically obliged to participate in a host of para-production marketing tasks. On-set production diaries are posted on social media and keep the project workflow in the public eye as never before. By the same token, a director working on a franchise picture might be expected to interrupt production at any point to tease some aspect of it at Comic-Con or an exhibitor showcase. Finally, in what we might call post-postproduction, a director might participate in press junkets and launch next-project trial balloons that will help create a must-see aura around both the project to come and the one just completed.

Directors may also publicize their contributions to a given film when it is released on DVD.[35] A few hours might be necessary to record a commentary track,

but, as John Thornton Caldwell has argued, such tracks offer a director a chance to explain and justify certain choices, laud coworkers, and, if necessary, relitigate previous production conflicts. Similarly, deleted scenes, particularly those with brief commentaries, show, in mediated form, directors groping their way toward solutions to particular story or performance problems. Finally, "director's cuts" bolster directors' prestige and enable informed fan debates—whether those cuts are actually the contractually secured version of the film that the director handed in before acceding to studio edits or a follow-on edit such as Ridley Scott's enormous cut of *Kingdom of Heaven* (2005).[36] These activities, too, shine a spotlight on the work done by directors and, by extension, on their claim to be considered authors of the films they helm.

But these new opportunities are countered by other trends that imperil directorial authority. Technology and public relations combine to invite spectators to imagine themselves as co-creators. To be sure, Hollywood has always enlisted its audiences in the creative process; out-of-town previews were designed with just this purpose in mind. But today, the whole panoply of digital add-ons—alternate endings, extended versions, "unrated" cuts—creates the impression of viewer-driven choice. At the extreme, directors can become what Janet Murray calls "procedural authors" when director-sanctioned DVD add-ons explicitly offer spectators alternative endings (Danny Boyle's *28 Days Later* [(2002)] or a chance to focus on one or another of the characters in a multi-stranded story (Mike Figgis's *Time Code* [2000]).[37]

One response to these new challenges to the ideal of the director as film author is simply to swallow up key below-the-line roles as a digitally enabled hyperauteur.[38] This has been Steven Soderbergh's strategy. Since 2000 he has served as director of photography and editor on most of his pictures. Editing as he goes along has helped him quickly spot gaps in shooting and quickly accommodate shifts in the project's tone while remaining on a tight schedule. Yet despite the unprecedented level of control he exerts over his projects, Soderbergh's oeuvre exhibits little of the obvious stylistic consistency that might define him as an auteur in the traditional sense. Early in his career, his storytelling was distinguished by temporal loops and stutters (*Out of Sight* [1998], *The Limey* [1999]); later he experimented with florid zoom work (*Ocean's 12* [2004]) or maddening soundscapes (*The Informant!* [2009]); more recently his staging and camerawork have been marked by an almost old-fashioned insistence on the reality of his actors' most spectacular moves (*Haywire* [2011], *Magic Mike* [2012]). The only element common to all is a masked audacity, in which the palpable enjoyment of the act of moviemaking makes outré formal or narrative choices more palatable.

Soderbergh's inclination to absorb the functions of other artisans while working as a director has also characterized his approach to producing. During postproduction for Lodge Kerrigan's *Keane* (2004), on which he served as

executive producer, Soderbergh took time while on location for *Ocean's 12* in Italy to cut together an almost unrecognizably different version of Kerrigan's film. Such a glimpse at a radical alternative would never have been possible in earlier, less fluid eras of linear editing. Kerrigan and producer Andrew Fierberg preferred their version and Soderbergh willingly agreed—the whole edit was simply an experiment. At the same time, though, the Soderbergh cut was not discarded. Rather, it became a monumental DVD extra that could be promoted alongside the film's digital release, allowing critics such as the *Washington Post*'s Michael O'Sullivan to call the DVD version "especially intriguing" to "filmmakers . . . film critics . . . and film students."[39]

Keane 2.0 was a producer's edit, but as a product of Soderbergh's hyperauteurism it read as a directorial effort as well. His liner notes explain: "I loved the film and told [Lodge] so, but I also sent him this version to look at, in case it jogged anything (it didn't). In any case, we agreed it was an interesting (to us) example of how editing affects intent. Or something." The last disavowal is crucial: for Soderbergh as producer to avoid becoming a Dore Schary–like figure chopping Kerrigan's film to bits, the whole effort must be both experimental and contingent. In less accommodating hands, Soderbergh's edit would have been the theatrical release.

Soderbergh's career illustrates some of the strategies that have enabled directors to build careers and make revisionist claims to authorship in a rapidly changing media ecosphere. Like his peers, he has had to cope with the thoroughgoing digitization of the industry as well as with the new modes of reception, newly connected globalized audiences, and new revenue streams from ancillary sources such as merchandise tie-ins and theme park rides that have transformed Hollywood. As a result of these seismic changes, directors now confront new flexibilities and new pressures at every level. At the micro-level, extended individual takes have opened up new aesthetic possibilities even as they demand new skills on the part of directors. The production process, once linear and studio-bound, has been smeared in every dimension, encompassing a multitude of sites that further complicate the job of coordinating the work of actors and crew members. Career management, too, has evolved as directors devise long-range strategies in order to build professional credibility and snare prize assignments. At another level, they are exploring innovative modes of securing their legacy as film authors. Such realities form the contours of a director's working life in the new millennium.

ACADEMY AWARDS FOR DIRECTING

1927/28 COMEDY MOVIE: Lewis Milestone, *Two Arabian Knights*
DRAMATIC MOVIE: Frank Borzage, *7th Heaven*
SPECIAL AWARD: Charles Chaplin, for acting, writing, directing, and producing *The Circus*

1928/29 Frank Lloyd, *The Divine Lady*

1929/30 Lewis Milestone, *All Quiet on the Western Front*

1930/31 Norman Taurog, *Skippy*

1931/32 Frank Borzage, *Bad Girl*

1932/33 Frank Lloyd, *Cavalcade*

1934 Frank Capra, *It Happened One Night*
.

1935 John Ford, *The Informer*

1936 Frank Capra, *Mr. Deeds Goes to Town*

1937 Leo McCarey, *The Awful Truth*

1938 Frank Capra, *You Can't Take It with You*

1939 Victor Fleming, *Gone with the Wind*

1940 John Ford, *The Grapes of Wrath*

1941 John Ford, *How Green Was My Valley*

1942 William Wyler, *Mrs. Miniver*

1943 Michael Curtiz, *Casablanca*

1944 Leo McCarey, *Going My Way*

1945 Billy Wilder, *The Lost Weekend*

1946 William Wyler, *The Best Years of Our Lives*

1947 Elia Kazan, *Gentleman's Agreement*

1948 John Huston, *The Treasure of the Sierra Madre*

1949 Joseph L. Mankiewicz, *A Letter to Three Wives*

1950 Joseph L. Mankiewicz, *All about Eve*

1951 George Stevens, *A Place in the Sun*

1952 John Ford, *The Quiet Man*

1953 Fred Zinnemann, *From Here to Eternity*

1954 Elia Kazan, *On the Waterfront*

1955 Delbert Mann, *Marty*

1956 George Stevens, *Giant*

1957 David Lean, *The Bridge on the River Kwai*

1958 Vincente Minnelli, *Gigi*

1959 William Wyler, *Ben-Hur*

1960 Billy Wilder, *The Apartment*

1961 Robert Wise, Jerome Robbins, *West Side Story*

1962 David Lean, *Lawrence of Arabia*

1963 Tony Richardson, *Tom Jones*

1964 George Cukor, *My Fair Lady*

1965 Robert Wise, *The Sound of Music*

1966 Fred Zinnemann, *A Man for All Seasons*

1967 Mike Nichols, *The Graduate*

1968 Carol Reed, *Oliver!*

1969 John Schlesinger, *Midnight Cowboy*

1970 Franklin J. Schaffner, *Patton*

1971 William Friedkin, *The French Connection*

1972 Bob Fosse, *Cabaret*

1973 George Roy Hill, *The Sting*

1974 Francis Ford Coppola, *The Godfather, Part II*

1975 Milos Forman, *One Flew over the Cuckoo's Nest*

1976 John G. Avildsen, *Rocky*

1977 Woody Allen, *Annie Hall*

1978 Michael Cimino, *The Deer Hunter*

1979 Robert Benton, *Kramer vs. Kramer*

1980 Robert Redford, *Ordinary People*

1981 Warren Beatty, *Reds*

1982 Richard Attenborough, *Gandhi*

1983 James L. Brooks, *Terms of Endearment*

1984 Milos Forman, *Amadeus*

1985 Sydney Pollack, *Out of Africa*

1986 Oliver Stone, *Platoon*

1987 Bernardo Bertolucci, *The Last Emperor*

1988 Barry Levinson, *Rain Man*

1989 Oliver Stone, *Born on the Fourth of July*

1990 Kevin Costner, *Dances with Wolves*

1991 Jonathan Demme, *The Silence of the Lambs*

1992 Clint Eastwood, *Unforgiven*

1993 Steven Spielberg, *Schindler's List*

1994 Robert Zemeckis, *Forrest Gump*

1995 Mel Gibson, *Braveheart*

1996 Anthony Minghella, *The English Patient*

1997 James Cameron, *Titanic*

1998 Steven Spielberg, *Saving Private Ryan*

1999 Sam Mendes, *American Beauty*

2000 Steven Soderbergh, *Traffic*

2001 Ron Howard, *A Beautiful Mind*

2002 Roman Polanski, *The Pianist*

2003 Peter Jackson, *The Lord of the Rings: The Return of the King*

2004 Clint Eastwood, *Million Dollar Baby*

2005 Ang Lee, *Brokeback Mountain*

2006 Martin Scorsese, *The Departed*

2007 Joel Coen and Ethan Coen, *No Country for Old Men*

2008 Danny Boyle, *Slumdog Millionaire*

2009 Kathryn Bigelow, *The Hurt Locker*

2010 Tom Hooper, *The King's Speech*

2011 Michel Hazanavicius, *The Artist*

2012 Ang Lee, *Life of Pi*

2013 Alfonzo Cuarón, *Gravity*

2014 Alejandro G. Iñárrito, *Birdman or (The Unexpected Virtue of Ignorance)*

2015 Alejandro G. Iñárrito, *The Revenant*

2016 Damien Chazelle, *La La Land*

NOTES

Introduction

1 Billy Bitzer, *His Story: The Autobiography of D. W. Griffith's Master Cameraman* (New York: Farrar Straus and Giroux, 1973), 69.

2 Tom Gunning, *D. W. Griffith and the Origins of Narrative Film: The Early Years at Biograph* (Champaign: University of Illinois Press, 1991), 47.

3 Quoted in Janet Staiger, "The Division and Order of Production: The Subdivision of the Work from the First Years through the 1920s," in David Bordwell, Janet Staiger, and Kristin Thompson, *The Classical Hollywood Style: Film Style and Mode of Production to 1960* (New York: Columbia University Press, 1985), 146.

4 Ibid., 147.

5 Quoted in Dan Ford, *Pappy: The Life of John Ford* (Englewood Cliffs, NJ: Prentice-Hall, 979), 97.

6 Preston Sturges, *Preston Sturges*, adapt. and ed. Sandy Sturges (New York: Simon and Schuster, 1990), 270.

7 Quoted in Richard B. Jewell, *RKO Radio Pictures: A Titan Is Born* (Berkeley: University of California Press, 2012), 136–137.

8 John Huston, *An Open Book* (New York: Da Capo, 1972), 83.

9 Quoted in Kenneth Geist, *Pictures Will Talk: The Life and Films of Joseph L. Mankiewicz* (New York: Da Capo, 1978).

10 Quoted in Michael Barson, "Auteur of Duty: Sarris' Theory 30 Years On," *DGA News*, April-May 1993, 10.

11 Quoted in Ford, *Pappy*, 98.

12 Quoted in Howard Mandelbaum and Gary Morris, "Angel in Exile: Alan Dwan," in *Action!*, ed. Gary Morris (New York: Anthem Press, 2009), 8.

13 Among those who have published such books are Edward Dmytryk (*On Screen Directing* [Boston: Focal Press, 1984]); Sidney Lumet (*Making Movies* [New York: Random House, 1995]); and Alexander Mackendrick (*On Film Making*, ed. Paul Cronin [New York: Faber and Faber, 2004]).

14 Alain Silver and Elizabeth Ward, *The Film Director's Team* (Los Angeles: Silman James, 1992).

15 Quoted in George Stevens Jr.'s documentary film *George Stevens: A Filmmaker's Journey* (1984).

16 Hortense Powdermaker, *Hollywood: The Dream Factory* (London: Seeker and Warburg, 1950), 202.

17 For detailed discussions of the ways in which directors can stage a scene, see Alan A. Armer, *Directing Television and Film* (Belmont, CA: Wadsworth Publishing, 1986); Steven D. Katz, *Film Directing: Shot by Shot* (Chelsea, MI: Sheridan Books, 1991); and Steven D. Katz, *Film Directing: Cinematic Motion*, 2nd ed. (Studio City, CA: Michael Weise Productions, 2004).

18 For Bordwell's complete analysis of these scenes, see http://www.davidbordwell.net/blog/2015/12/13/modest-virtuosity-a-plea-to-filmmakers-old-and-young/.

19 For Capra's complete statement, see "Text of the Directors Guild Report on the Film Industry," *New York Times*, August 7, 1938, 4.

20 Lawrence Cohn, "Helmers Who Handed Over the Microphone," *Weekly Variety*, September 3, 1986, 82.

21 Quoted in Damien Love, "Nearer My Corman to Thee," in *Action!*, 155–156.

22 Quoted in John Baxter, *Stunt: The Story of the Great Movie Stunt Men* (New York: Doubleday, 1974), 114.

23 A number of excellent studies document the collaborative process in Hollywood, including John Caldwell, *Production Culture: Industrial Productivity and Critical Practice in Film and Television* (Durham, NC: Duke University Press, 2008); and Thomas Schatz, *The Genius of the System: Hollywood Filmmaking in the Studio Era* (Minneapolis: University of Minnesota Press, 2010). For a good survey of creative collaboration in general, see Grant H. Kester, *The One and the Many: Contemporary Collaborative Art* (Durham, NC: Duke University Press, 2011).

24 François Truffaut, *Hitchcock/Truffaut* (New York: Simon and Schuster, 1972), 91, 93. For an extensive chronicle of Hitchcock's relationship with Selznick, see Leonard J. Leff, *Hitchcock and Selznick: The Rich and Strange Collaboration of Alfred Hitchcock and David O. Selznick in Hollywood* (New York Grove Press, 1987).

25 Quoted in Aljean Harmetz, *Round Up the Usual Suspects: The Making of Casablanca: Bogart, Bergman, and World War II* (New York: Hyperion, 1992), 167.

26 Ibid., 184.

27 Quoted in James Curtis, *Between Flops: A Biography of Preston Sturges* (New York: Limelight, 1984), 183.

28 Quoted in Alex Lewin, "It Happened in *Nashville*," *Premiere* 13, no. 11 (July 1995): 93. For a lengthy description of *Nashville*'s production process, see Virginia Wright Wexman, "*Nashville*: Second City Performance Comes to Hollywood," in *A Companion to Robert Altman*, ed. Adrien Danks (Malden, MA: John Wiley & Sons, 2015), 369–389.

29 Vincente Minnelli with Hector Arce, *I Remember It Well* (Hollywood: Samuel French Trade, 1990), 133.

30 Quoted in Mike Goodridge, *Directing* (New York: Focal Press, 2012), 171.

31 Quoted in ibid., 168.

32 For an account of Sartov's work with Griffith, see Richard Schickel, *D. W. Griffith: An American Life* (New York: Simon and Schuster, 1984), 385.

33 For a further discussion of this collaboration, see Shelley Stamp, *Lois Weber in Early Hollywood* (Berkeley: University of California Press, 2015), 28–29.

34 Quoted in Dan Auiler, *Vertigo: The Making of a Hitchcock Classic* (New York: St. Martin's, 2000), 156.

35 Scott Eyman, "Interview with William Clothier," *Take One* 4, no. 8 (November–December 1973): 32.

36 Quoted in Tag Gallagher, *John Ford: The Man and His Films* (Berkeley: University of California Press, 1986), 462.

37 Alex Simon and Terry Keefe, "The Hollywood Interview: Curtis Hanson," http://thehollywoodinterview.blogspot.com/2008/02/curtis-hanson-hollywood-interview.html?q=curtis+hanson, posted November 9, 2012, accessed March 24, 2016.

38 Quoted in Carolyn Giardina, "LAFF: Production Designers Offer Their Takes on Reimagining LA," *Hollywood Reporter Online*, June 14, 2014, http://www.hollywoodreporter.com/behind-screen/laff-production-designers-offer-takes-711922, accessed December 8, 2015.

39 Quoted in Harmetz, *Round Up the Usual Suspects*, 183.

40 Quoted in https://www.fxguide.com/featured/life-of-pi/.

41 Donald Chan and Joseph Coencas, "Editing Is an Emotional Art," *Action!*, September–October 1978, 42.

42 Murch makes this claim on the commentary track of the DVD version of *The Conversation*.

43 Indie Film Academy, "Steven Spielberg with John Williams Talk about the Soundtracks for *E.T.* and *Jaws*," https://www.youtube.com/watch?v=5_8RTDbDVTU, accessed March 22, 2016.

44 For a report on the figures from 2007–2015, see Stacy L. Smith, Marc Choueiti, and Katherine Pieper, "Inequality in 800 Popular Films: Examining Portrayals of Gender, Race/Ethnicity, LGBT, and Disability from 2007–2015," http://annenberg.usc.edu/pages/~/media/MDSCI/Dr%20Stacy%20L%20Smith%20Inequality%20in%20800%20Films%20FINAL.ashx.

45 Robert R. Faulkner and Andy B. Anderson, "Short-Term Projects and Emergent Careers: Evidence from Hollywood," *American Journal of Sociology* 92, no. 4 (January 1987): 894, 886. For a more recent analysis of this aspect of the film industry, see Arthur De Vary, *Hollywood Economics: How Extreme Uncertainty Shapes the Film Industry* (New York: Routledge, 2003).

46 Faulkner and Anderson, "Short-Term Projects and Emergent Careers," 895.

47 Ibid., 908, 894–895.

48 A discussion of this investigation can be found in Andi Zeisler, "Feminists' Stake in 'Ghostbusters,'" *Los Angeles Times*, May 26, 2016, A17.

49 Quoted in Meg Waite Clayton, "Oscar's Female Deficit," *Los Angeles Times*, January 18, 2016, A13.

1 The Silent Screen, 1895–1927

1 Advertisement, *New York Dramatic Mirror*, December 3, 1913, 36.

2 Ibid.

3 Quoted in Gaylyn Studlar, "Erich von Stroheim and Cecil B. DeMille: Early Hollywood and the Discourse of Directorial 'Genius,'" in *The Wiley-Blackwell History of American Film*, vol. 1, *Origins to 1928*, ed. Cynthia Lucia, Roy Grundman, and Art Simon (Walden, MA: Blackwell Publishing, 2012), 293–312.

4 For an extended description of this process, see Charlie Keil, *Early American Cinema in Transition: Story, Style, and Filmmaking, 1907–1913* (Madison: University of Wisconsin Press, 2001).

5 Janet Staiger, "The Director System: Management in the First Years," in David Bordwell, Janet Staiger, and Kristin Thompson, *The Classical Hollywood Cinema: Film Style and Mode of Production in 1960* (New York: Columbia University Press, 1985), 116; Charles Musser, "Pre-Classical American Cinema: Its Changing Modes of Film Production," *Persistence of Vision*, no. 9 (1991): 47.

6 Musser, "Pre-Classical American Cinema," 48.

7 Janet Staiger, "The Director System: Management in the First Years," and "The Director-Unit System: Management of Multiple-Unit Companies after 1909," in Bordwell, Staiger, and Thompson, *The Classical Hollywood Cinema*, 116–127.

8 Musser, "Pre-Classical American Cinema," 52–53.

9 Staiger, "The Director System: Management in the First Years," 118.

10 Musser, "Pre-Classical American Cinema," 54.

11 I explore this issue in relation to Thanhouser, a transitional-era production company, in "Narration in the Transitional Cinema: The Historiographical Claims of the Unauthored Text," *Cinémas* 21, no. 2–3 (Spring 2011): 107–130.

12 Tom Gunning, *D. W. Griffith and the Origins of American Narrative Film: The Early Years at Biograph* (Urbana: University of Illinois Press, 1991), 47.

13 Hanford C. Judson, "What Goes Over," *Moving Picture World*, April 15, 1911, 816.

14 Allan Dwan, quoted in Peter Bogdanovich, *Allan Dwan: The Last Pioneer* (New York: Praeger Publishing, 1971), 24.

15 Affidavit of Gladys Smith Moore, Fol. 7, Undertaking on Injunction, *Independent Moving Pictures Company of American v. Gladys Smith and Owen Moore (IMP v Smith)*, No. 21423 (N.Y. Sup. Court, New York County, 1911). My thanks to Leslie Midkiffe DeBauche for supplying me with this resource.

16 The biographical information in this paragraph derives from Anne Edwards, *The DeMilles: An American Family* (New York: Harry N. Abrams, 1988).

17 For professional purposes, Cecil adopted a spelling of his name that deviated from the familial norm; the latter retained a lowercase "d" for "de Mille." His brother William preferred to retain the family's spelling of his last name, which meant that he and his brother spelled their last name differently. Occasionally publicity material would produce another variant on the name by inserting a space between "De" and "Mille."

18 Cecil B. DeMille, *The Autobiography of Cecil B. DeMille*, ed. Donald Hayne (1959; reprint, New York: Garland Publishing, 1985), 62.

19 Edwards, *The DeMilles*, 44.

20 Even without the DeMille connection, Famous Players–Lasky would be a revealing case study, given its role in changing the shape of the American film industry in the 1910s. At an early stage of the industry's move to feature film production, Zukor was already putting into place a strategy that would culminate in his company becoming a vertically integrated entity within six years. In order to meet the growing demand for features, Zukor had to expand his production capacity while also devising a reliable system for providing a weekly program of multi-reel films. In 1916, both of these objectives were met, the first through the merger with Lasky and the second through the acquisition of the Paramount Distribution Company. Eschewing the existing distribution system of state-rights and roadshow

arrangements, Zukor delivered features to theaters using the national distribution network Paramount had already established.

21 Letter from Cecil B. DeMille, April 24, 1916, Cecil B. DeMille Papers, L. Tom Perry Special Collections Library, Harold B. Lee Library, Brigham Young University, Utah, Box 238, Folder 12. All subsequent references to these papers are listed as CBD Papers.

22 Telegram from Adolph Zukor, June 26, 1917, CBD Papers, Box 240, Folder 5.

23 Letter from Jesse Lasky, June 27, 1916, CBD Papers, Box 238, Folder 14.

24 Unsigned letter, June 20, 1916, CBD Papers, Box 238, Folder 14.

25 Ibid.

26 Letter from Jesse Lasky, September 15, 1916, CBD Papers, Box 238, Folder 14.

27 Letter from Blanche Lasky, May 30, 1916, CBD Papers, Box 238, Folder 12.

28 Letter from Jesse Lasky, October 12, 1916, CBD Papers, Box 238, Folder 14.

29 Letter from Jesse Lasky, December 7, 1917, CBD Papers, Box 240, Folder 1.

30 Letter from Jesse Lasky, September 14, 1916, CBD Papers, Box 238, Folder 14.

31 Ibid.

32 Letter from Cecil B. DeMille, July 12, 1916, CBD Papers, Box 238, Folder 14.

33 Letter from Cecil B. DeMille, February 8, 1917, CBD Papers, Box 240, Folder 1.

34 Ibid.

35 Letter from Blanche Lasky, May 30, 1916, CBD Papers, Box 238, Folder 12.

36 Letter from Jesse Lasky, January 26, 1917, CBD Papers, Box 240, Folder 1.

37 Note from "H.T." [Hector Turnbull?], February 3, 1917, CBD Papers, Box 240, Folder 1.

38 Letter from Jesse Lasky, January 26, 1917, CBD Papers, Box 240, Folder 1.

39 Letter from Jesse Lasky, October 30, 1916, CBD Papers, Box 238, Folder 14.

40 Ibid.

41 "Statement Showing Heads of Departments and Number of People Employed in Each Department and Salaries as of March 23rd 1918," CBD Papers, Box 240, Folder 5.

42 Letter from Jesse Lasky, October 30, 1916, CBD Papers, Box 238, Folder 14.

43 Letter from Jesse Lasky, December 7, 1917, CBD Papers, Box 240, Folder 1. Conversion of these footage counts to running times can never be exact, because frame rates might vary depending on the speed of both filming and projection. But one can suggest equivalencies of running times, based on speeds of 20 fps and 24 fps respectively: 4,500 feet would translate into either 60 minutes or 50; 5,100 feet would run for 68 minutes or 56; and 6,500 would last 86 minutes or 72.

44 Letter from Jesse Lasky, October 30, 1916, CBD Papers, Box 238, Folder 14.

45 Letter from Jesse Lasky, July 21, 1916, CBD Papers, Box 238, Folder 14.

46 Ibid.

47 Gaylyn Studlar and Sumiko Higashi point to *The Cheat* as a pivotal work in DeMille's career, with Studlar saying that the film "extended [DeMille's fame] worldwide," and Higashi claiming that it helped DeMille achieve "international renown." See Studlar, "Erich von Stroheim and Cecil B. DeMille," 296; Higashi, *Cecil B. DeMille and American Culture: The Silent Era* (Berkeley: University of California Press, 1994), 3.

48 Robert Birchard supplies information about the length of DeMille's shooting schedules in *Cecil B. DeMille's Hollywood* (Lexington: University Press of Kentucky, 2004); David Pierce calculates the budgets and grosses of DeMille's films in "Success with a Dollar Sign: Costs and Grosses for the Early Films of Cecil B. DeMille," in *The DeMille Legacy / L'Eredità DeMille*, ed. Paolo Cherchi Usai and Lorenzo Codelli (Pordenone, Italy: Le Giornate del Cinema Muto / Edizioni Biblioteca dell'Immagine, 1991), 308–317.

49 Scott Eyman, *Empire of Dreams: The Epic Life of Cecil B. DeMille* (New York: Simon and Schuster, 2010), 146.

50 Paolo Cherchi Usai and Lorenzo Codelli, "The DeMille Legacy: An Introduction," in *The DeMille Legacy*, 20. For recent feminist appraisals of Macpherson's career, see Karen Ward Mahar, "Doing a 'Man's Work': The Rise of the Studio System and the Remasculinization of Filmmaking" (2006), rpt. in *The Classical Hollywood Reader*, ed. Steve Neale (New York: Routledge, 2012), 79–93; and Jane Gaines, "Jeanie Macpherson," *Women Film Pioneers Project*, https://wfpp.cdrs.columbia.edu/pioneer/ccp-jeanie-macpherson/.

51 DeMille, *Autobiography*, 62.

52 Ibid., 47; Lea Jacobs makes mention of the announcement of Buckland's hire in an endnote to "Belasco, DeMille, and the Development of Lasky Lighting," *Film History* 5, no. 4 (December 1993): 417.

53 Jacobs, "Belasco," 408.

54 W. Stephen Bush, "Reviews of Current Films: *The Golden Chance*," *Moving Picture World*, January 8, 1916, 255.

55 Higashi, *Cecil B. DeMille and American Culture*, 11.

56 While we should not underestimate Lasky's contribution to the promotion of DeMille as a film artist, Zukor may have played a role as well. The original animating premise of Famous Players entailed the promotion of well-known performers in high-end feature films, beginning with Sarah Bernhardt in *Queen Elizabeth* (1912). Extending the principle of celebrity to a director seems a logical extension of the star system approach Zukor helped to solidify for the film industry.

57 Cherchi Usai and Codelli, *The DeMille Legacy*, 22. The film's French reception is also discussed in Daisuke Miyao, *Sessue Hayakawa: Silent Cinema and Transnational Stardom* (Durham, NC: Duke University Press, 2007), 23–26.

58 Birchard, *DeMille's Hollywood*, xii.

59 Lee Grieveson, "1915: Movies and the State of the Union," in *American Cinema of the 1910s: Themes and Variations*, ed. Charlie Keil and Ben Singer (New Brunswick, NJ: Rutgers University Press, 2009), 152.

60 Scott Higgins, "Editing in the Silent Screen, 1895–1928," in *Editing and Special/Visual Effects*, ed. Charlie Keil and Kristen Whissel (New Brunswick, NJ: Rutgers University Press, 2016), 31–32.

61 Higashi, *DeMille and American Culture*, 111.

62 Sumiko Higashi, "The New Woman and Consumer Culture: Cecil B. DeMille's Sex Comedies," in *A Feminist Reader in Early Cinema*, ed. Jennifer M. Bean and Diane Negra (Durham, NC: Duke University Press, 2002), 300.

63 Higashi, "The New Woman," 301.

64 Ben Singer, "1919: Movies and Righteous Americanism," in *American Cinema of the 1910s*, 235.

65 Birchard, *DeMille's Hollywood*, 147.

66 Wiliiam deMille, *Hollywood Saga* (New York: E. P. Dutton, 1939), 40; cited by Edwards, *The DeMilles*, 231.

67 Lea Jacobs puts forward a convincing case for seeing DeMille as a director often maligned by the press in the 1920s for being a purveyor of hokum, in *The Decline of Sentiment: American Film in the 1920s* (Berkeley: University of California Press, 2008), 85–90; Kaveh Askari demonstrates how directors such as Ingram initiated an early version of Hollywood art cinema in *Making Movies into Art: Picture Craft from the Magic Lantern to Early Hollywood* (London: BFI Publishing, 2014).

68 Quoted in Higashi, *DeMille and American Culture*, 19–20.

69 Letter from Jesse Lasky, November 23, 1917, CBD Papers.

70 Letter from Jesse Lasky, November 27, 1916, CBD Papers.

71 Advertisement, *Moving Picture World*, June 16, 1917, 1700.

72 Advertisement, *Moving Picture World*, February 10, 1917, 778.

73 Advertisement, *Moving Picture World*, January 20, 1917, 310.

74 Advertisement, *Moving Picture World*, July 6, 1918, 16.

75 Edwards, *The DeMilles*, 68.

76 Studlar, "Erich von Stroheim and Cecil B. DeMille," 295; the ad can be found in *Ladies' Home Journal* (June 1921): 30.

77 Advertisement, *Moving Picture World*, March 30, 1918, 1739.

78 Advertisement, *Moving Picture World*, December 14, 1918, 1131.

79 Advertisement, *Moving Picture World*, May 10, 1919, 739.

80 Advertisement, *Moving Picture World*, May 3, 1919, 607.

81 Advertisement, *Moving Picture World*, April 26, 1919, 461.

82 Advertisement, *Moving Picture World*, February 8, 1919, 699.

83 Letter from Neil McCarthy, April 27, 1920, CBD Papers, Box 240, Folder 29.

84 Notation by Cecil B. DeMille on letter from Neil McCarthy, April 27, 1920, CBD Papers, Box 240, Folder 29.

85 Jerome Christensen, *America's Corporate Art: The Studio Authorship of Hollywood Motion Pictures* (Stanford, CA: Stanford University Press, 2012), 7.

2 Classical Hollywood, 1928–1946

I am indebted to Bill Simon of New York University for his generous help and advice about Welles's career, to Cynthia Lucia for research assistance, and to the editor of this volume, Virginia Wright Wexman.

1 See Charles Affron and Mirella Jona Affron, *Best Years: Going to the Movies, 1945–1946* (New Brunswick, NJ: Rutgers University Press, 2009), 3.

2 See Scott Eyman, *The Speed of Sound: Hollywood and the Talkie Revolution, 1926–1930* (Baltimore: Johns Hopkins University Press, 1999), 242.

3 Janet Staiger, "Part Two: The Hollywood Mode of Production to 1930," in David Bordwell, Janet Staiger, and Kristin Thompson, *The Classical Hollywood Cinema: Film Style and Mode of Production to 1960* (New York: Columbia University Press, 1985), 126. This volume provides a detailed, authoritative account of industry shifts during this era and the descriptions to follow draw substantially upon it, particularly the section in pp. 85–153.

4 See Thomas Schatz, *The Genius of the System: Hollywood Filmmaking in the Studio Era* (Minneapolis: University of Minnesota Press, 2010), chap. 15.

5 Bordwell, Staiger, Thompson, *The Classical Hollywood Cinema*, 334–335.

6 Quoted in Emanuel Eisenberg, "John Ford: Fighting Irish," in *John Ford: Interviews*, ed. Gerald Peary (Jackson: University Press of Mississippi, 2001), 12.

7 Quoted in ibid.

8 See Dan Ford, *Pappy: The Life of John Ford* (Englewood Cliffs, NJ: Prentice Hall, 1979), 259.

9 Philip Dunne, *Take Two: A Life in Movies and Politics* (New York: Limelight, 1992), 49. For more on Zanuck, see George F. Custen, *Twentieth Century's Fox: Darryl F. Zanuck and the Culture of Hollywood* (New York: Basic Books, 1997).

10 Quoted in Joseph McBride, *Searching for John Ford: A Life* (New York: St. Martin's Griffin, 2001), 246.

11 Quoted in ibid., 250.

12 Mark Harris, *Five Came Back: A Story of Hollywood and the Second World War* (New York: Penguin, 2014), 73. Ironically, after having left *How Green Was My Valley*, Wyler made *The Letter*, for which he was nominated for Best Direction in 1941. Although he was considered the front runner, he lost to Ford, who had finally made the film Wyler had begun.

13 McBride, *Searching for John Ford*, 323.

14 Quoted in ibid., 247.

15 Quoted in ibid., 253–254.

16 Quoted in ibid., 252.

17 Ford, *Pappy*, 211.

18 Wanger was associated with United Artists and was valuable to them because of his skill at overseeing multiple projects simultaneously. He largely organized the business end of his projects, helped to arrange financing, and set up production schedules for films that would eventually be distributed through United Artists. See Matthew Bernstein, *Walter Wanger: Hollywood Independent* (Berkeley: University of California Press, 1994), 114–117, 146–150.

19 Ford worked for less than his normal salary but, in a pattern later widespread in the industry, participated in the profits.

20 The Motion Picture Directors Association is described in Anthony Slide, *The American Film Industry: An Historical Dictionary* (New York: Limelight, 1990), 220–221.

21 McBride, *Searching for John Ford*, 191.

22 Ibid., 193.

23 Quoted in ibid., 193–194.

24 Quoted in Simon Callow, *Orson Welles: The Road to Xanadu* (New York: Viking Penguin, 1996), 448.

25 Huw Weldon, "The BBC *Monitor* Interview (1960)," in *Orson Welles Interviews*, ed. Mark W. Estrin (Jackson: University Press of Mississippi Press, 2002), 83.

26 Quoted in James Naremore, *The Magic World of Orson Welles*, new and rev. ed. (Dallas: Southern Methodist University Press, 1989), 267.

27 The issue of credit for the film was revived in the 1970s by Pauline Kael who, in a series of articles for the *New Yorker*, which she subsequently published in book form, aggressively championed Mankiewicz's claim for authorship. This touched on the ongoing auteur debate as to whether the screenwriter or director should be considered the author of a film. See Pauline Kael, "Raising Kane," *New Yorker*, February 20, 1971, 43–89, and February 27, 1971, 44–81; and *The Citizen Kane Book: Raising Kane* (Boston: Little, Brown, 1971). The genesis and development of the *Kane* script is fully documented in Robert Carringer, "The Scripts of *Citizen Kane*," *Critical Inquiry* 5, no. 2 (Winter 1978): 369–400.

28 Weldon, "The BBC *Monitor* Interview," 80.

29 Reflective of the resentment directed at Welles by his contemporaries is F. Scott Fitzgerald's short story "Mr. Hobby and Orson Welles," which appeared in the May 1940 *Esquire*. In the story, Pat Hobby, a failed screenwriter from the silent era who now has difficulty even gaining entrance to the studio, bitterly resents the newly arrived Welles's success and money. Through plot contrivances, he puts on a fake beard and dresses up to resemble Welles; the very sight of him causes a studio executive to collapse from a heart attack (reprinted in *The Pat Hobby Stories* [New York: Charles Scribner's Sons, 1962], 41–51). The story's relationship to Welles's image is discussed in Robert Sklar, "Welles before *Kane*: The Discourse on the "Boy Genius," *Persistence of Vision* 7 (1989): 63–72.

30 James R. Wilkerson, "Trade Views," *Hollywood Reporter*, September 26, 1939, 1.

31 Quote in Richard Jewell, *RKO Radio Pictures: A Titan Is Born* (Berkeley: University of California Press, 2012), 207.

32 For a detailed account of the production of *Citizen Kane*, see Robert Carringer, *The Making of Citizen Kane*, rev. and updated ed. (Berkeley: University of California Press, 1996). Production histories of all of Welles's Hollywood projects can be found in Jean-Pierre Berthomé and François Thomas, *Orson Welles at Work* (New York: Phaedon, 2008).

33 Perry Ferguson, "More Realism from Rationed Sets?" *American Cinematographer* 23, no. 9 (September 1942): 430. Quoted in Carringer, *The Making of Citizen Kane*, 65–66.

34 Authoritative accounts of this period of Welles's life appear in Carringer, *The Making of Citizen Kane*; and in Robert Carringer, *The Magnificent Ambersons: A Reconstruction* (Berkeley: University of California Press, 1993), 1–32.

35 Barbara Leaming, *Orson Welles: A Biography* (New York: Limelight, 1995), 231–232.

36 Quoted in V. F. Perkins, *The Magnificent Ambersons* (London: BFI Publishing, 2007), 17.

37 For a full discussion of this lengthy and complicated process, see Simon Callow, *Orson Welles*, vol. 2: *Hello Americans* (New York: Viking, 2006), 107–112.

38 Quoted in Jewell, *RKO Radio Pictures*, 145.

39 For greater detail on and context for Welles's South American activities at this time, see Catherine Benamou, "*It's All True* as Document/Event: Notes Towards an Historiographical and Textual Analysis," *Persistence of Vision*, no. 7 (1989): 113–120, as well as Benamou's book, *It's All True: Orson Welles's Pan-American Odyssey* (Berkeley: University of California Press, 2007).

40 This quote is from page 1 of the unpaginated *Carnaval* treatment (apparently written after Welles arrived in Brazil and had done some shooting, c. May 1942) in the *It's All True* file, Orson Welles Manuscripts, Manuscripts Department, Lilly Library, Indiana University, Bloomington, Indiana. All subsequent citations are from this manuscript.

41 See Douglas Gomery, "Orson Welles and the Hollywood Industry," *Persistence of Vision*, no. 7 (1989): 40–41.

42 Ibid., 39.

43 See Harris, *Five Came Back*.

44 McBride, *Searching for John Ford*, 219.

45 The fascinating story of Argosy Pictures reveals a great deal about the complexities and dangers of independent production during the studio era, even when overseen by industry-savvy figures like Ford and Cooper. It is extensively documented in the L. Tom Perry Special Collections of Brigham Young University under the Register of The Argosy Pictures Corporation Archives, 1938–1958, MSS 1849.

3 Postwar Hollywood, 1947 –1967

1 This phenomenon is described in Tino Balio, *The Foreign Film Renaissance on American Screens, 1946–1973* (Madison: University of Wisconsin Press, 2010).

2 Paul Monaco, *The Sixties: History of American Film* (Berkeley: University of California Press, 2001), 269.

3 Wyler's struggles with the studio are detailed in Sarah Kozloff, "Wyler's Wars," *Film History: An International Journal* 20, no. 4 (2008): 456–73.

4 Film scholar Tino Balio defines an independent company as one that found its own financing and secured distribution for its films without corporate ties to a major. Tino Balio, ed., *The American Film Industry* (Madison: University of Wisconsin Press, 1985), 412.

5 *Motion Picture Herald*, October 5, 1957, 11, cited by Michael Conant, *Antitrust in the Motion Picture Industry: Economic and Legal Analysis* (Berkeley: University of California Press, 1960), 37, 113.

6 *Motion Picture Examiner*, September 29, 1954, n.p., found in Filmakers Releasing Folder, Margaret Herrick Library, Academy of Motion Picture Arts and Sciences, Beverly Hills (henceforth MHL).

7 Janet Staiger, "Individualism vs. Collectivism," *Screen* 24, no. 4/5 (July 1983): 78.

8 The economics of independents are described in "Decree to Stimulate Indie Prod.,—Arnall," *Variety*, January 11, 1950, 13. Edward Arnall was the spokesperson for the Society of Independent Motion Picture Producers.

9 Whitney Williams, "New Life of Indies," *Variety*, November 4, 1954, 24. In *Walter Wanger: Hollywood Independent* (Minneapolis: University of Minneapolis Press, 1994), 237–245, Matthew Bernstein traces the tangled finances of one independent production, *Joan of Arc* (Victor Fleming, 1948).

10 Conant, *Antitrust in the Motion Picture Industry*, 113.

11 The interdependence of such companies is documented in Matthew Bernstein, "Hollywood's Semi-Independent Production," *Cinema Journal* 32, no. 3 (Spring 1993): 41–55.

12 "Truman Offers H'd One Tax Aid; No Frozen Profits; Levy," *Variety*, January 24, 1950, 3. A Treasury official also complained to Congress about the practice. To quote from the *Variety* report on this testimony: "As one example, under the present law producers of motion pictures, and their star players, have attempted to avoid taxes by creating temporary corporations which are dissolved after making one film. By this device, their remuneration from making the film, which ought to be taxed at the individual income tax rates, would be taxed only at the capital gains rate. Thus, they might escape as much as two thirds of the tax they should pay. . . . Lynch [the Treasury official] gave rundown on one case where indie producer and wife held all of the 1,750 shares in picture, which he made. Picture was then sold and corporation dissolved before film was put into distribution. Film cost $1,462,000. Producer's net gain on sale was $615,000. Duo paid 25 percent of amount, or $153,760, in long-term capital gains tax. Had they paid direct tax government would have collected $455,000" ("'T Man Hits Hollywood Tax Dodging," *Variety*, February 8, 1950, 9).

13 Simon N. Whitney, "Antitrust Policies and the Motion Picture Industry," in *The American Movie Industry: The Business of Motion Pictures*, ed. Gorham Kindem (Carbondale: Southern Illinois University Press, 1982), 202.

14 Balio, *The American Film Industry*, 406.

15 Film Classics, through which Ida Lupino's company Emerald Productions distributed *Not Wanted*, merged with Eagle-Lion in 1950.

16 See J. A. Aberdeen, *Hollywood Renegades: The Society of Independent Motion Picture Producers* (Los Angeles: Cobblestone Entertainment, 2000).

17 "Goldwyn Decries Heavy Production: Veteran Film Leader Finds the Industry Burning Itself Out—Sees Competitive Stimulus," *New York Times*, November 19, 1946, 49.

18 Frank Capra, "Breaking Hollywood's 'Pattern of Sameness,'" *New York Times*, May 5, 1946, 18, 57.

19 In an interview with Graham Fuller, Lupino says that she and Collier Young started Emerald Productions because she was under suspension at Warner Bros. at the time ("Ida Lupino," *Interview*, April 1991, 118–121). She is mistaken, however, because by 1947 she had been signed to a loose contract with RKO.

20 Filmakers was spelled with one "m." Later commentators who refer to it as "Filmmakers" are silently correcting the spelling to accord with modern usage.

21 Ida Lupino and Collier Young, "Declaration of Independents," *Variety*, February 20, 1950, 12.

22 Lupino's comment appears in Bob Thomas, "Lupino Trying Low Budget 'Unwed Mother' Drama Film," *San Diego Tribune-Sun*, February 9, 1949, n.p., PCA file for *Not Wanted*, MHL.

23 Although Filmakers' movies were low budget, they were not considered B-pictures when they were released; thus the title of feminist film scholar Annette Kuhn's valuable anthology about Lupino, *Queen of the Bs*, is inaccurate. Annette Kuhn, ed., *Queen of the Bs: Ida Lupino* (Westport, CT: Praeger, 1995).

Discussion of Filmakers' product in the trade press routinely refers to them as A-pictures. See *Not Wanted, Hollywood Reporter*, June 20, 1949, n.p., *Not Wanted* clipping file, MHL; "RKO Distributing 36 'A' Pix in 1951–52," *Variety*, August 15, 1951, 11.

Lea Jacobs's study, "The B Film and the Problem of Cultural Distinction," *Screen* 33, no. 1 (Spring 1992): 1–13, explains that the B-label had something to do with genre, something to do with the film's budget and stars, and a lot to do with national advertising campaigns and release schedules.

24 Ray's career trajectory is summarized in Bernard Eisenschitz, "Biographical Outline," for Nicholas Ray, *I Was Interrupted: Nicholas Ray on Making Movies* (Berkeley: University of California Press, 1993), xlv.

25 *They Live by Night* would not be released until 1949.

26 In 1960 the Screen Directors Guild merged with a group of television directors based in New York City and took the new name the Directors Guild of America.

27 Directors Guild of America, "Basic Agreement of 1960," 15, Directors Guild file, MHL.

28 "Directors Angle for More Say in Editing Films," *Variety*, August 6, 1947, 7.

29 DGA, "Basic Agreement," 14.

30 Lyndon Stambler, "Director's Cut," *DGA Quarterly* (Spring 2011), www.dga.org/Craft/DGAQ/All-Articles/1101-Spring-2011/Feature-Creative-Rights.aspx.

31 As early as 1946 the SDG demanded a closed shop. See "Directors Ask 25% Tilt, All Union Shop," *Variety*, February 26, 1946, 1.

32 Personal communication with Sahar Moridani, DGA Office of Communications, January 2015.

33 Dan Georgakas, "Ida Lupino: Doing It Her Way," *Cineaste* 25, no. 3 (June 2000): 32–36.

34 From the *New York Daily News*, March 1, 1949, n.p., *Not Wanted* clipping file, MHL.

35 Jeanine Basinger, "Giving Credit," *DGA Quarterly* (Winter 2011), www.dga.org/Craft/DGAQ/All-Articles/1004-Winter-2010–11/Features-Giving-Credit.aspx.

36 I have no evidence that the DGA consciously discriminated against Lupino. But I am relying on the "pattern and practice" legal theory, which argues that gross statistical evidence is itself proof of discrimination. Whether the gross statistical disparity of men and women in the DGA during these years arose from the failure of women to put themselves forward or the Guild being unwelcoming (or both), we can never know.

37 Louella and Harriet Parsons, "Ida Lupino: Rarest of the Rare," *New York Journal American*, December 5, 1965. Lupino clipping file, Billy Rose Theatre Division, New York Public Library, New York.

38 Ida Lupino, "Me, Mother Directress," *Action!*, March–April 1967, 14.

39 "You Can Be Free Men Again," *Variety*, June 6, 1951, 5.

40 Greg Mitchell, "Film; Winning a Battle but Losing the War over the Blacklist," *New York Times*, January 25, 1998. See also Larry Ceplair and Steve Englund, *The Inquisition in Hollywood: Politics in the Film Community, 1930–60* (Urbana: University of Illinois Press, 2003). Neither Ray nor Lupino rate mention in either of the two most scholarly analyses of the blacklist era, the aforementioned *Inquisition in Hollywood* or John Cogley's *Report on Blacklisting* (n.p.: Fund for the Republic, 1956).

41 Bernard Eisenschitz, *Nicholas Ray: An American Journey*, trans. Tom Milne (London: Faber and Faber, 1993), 124.

42 Dorothy Jones, "Communism and the Movies: A Study of Film Content," in Cogley, *Report on Blacklisting*, 196–304.

43 From a radio broadcast of the *Anna and Eleanor Roosevelt Program* in which they discuss the topic of illegitimate children and unwed mothers, February 18, 1949, broadcast on KECA. Transcript in Lupino file, MHL.

44 For the relevance of film noir on Lupino's female-centered melodramas, see Carrie Rickey, "Lupino Noir," *Village Voice* (October 29–November 4, 1980): 43.

45 The PCA was not alone in this desire to avoid any backlash about a film's acceptability. Tino Balio notes that banks generally evaluated scripts before agreeing to finance a film, asking questions such as "Is it of an extremely controversial nature from the religious, racial, or ideological points of view?" Balio, *The American Film Industry*, 416.

46 Whitney, *Anti-Trust Policies*, 194. United Artists boldly and shrewdly distributed both *The Moon Is Blue* and *The Man with a Golden Arm* and made a profit on both.

47 Diane Waldman, "*Not Wanted* (1949)," in Kuhn, *Ida Lupino: Queen of the Bs*, 13–39.

48 PCA file on *Not Wanted*, MHL.

49 Letter from Breen to Anson Bond, February 14, 1949, PCA file, MHL.

50 Bob Thomas, "Lupino Trying Low Budget." Lupino also said nice things about the Breen Office to a radio reporter. Transcript of George Fisher Broadcast, February 6, 1949, over station KNX, PCA file, MHL.

51 "The New Pictures," *Time*, August 8, 1949, 68.

52 Leo Penn, who played this role, would soon be blacklisted.

53 Ronnie Scheib, "*Never Fear* (1950)," in Kuhn, *Ida Lupino: Queen of the Bs*, 54.

54 The role of the child murderer is played in the film by Sumner Williams, an amateur actor and Ray's nephew.

55 Eisenshitz, *Nicholas Ray*, 151.

56 *On Dangerous Ground*, "Budget Script of Feb 17, 1950," *On Dangerous Ground* file, MHL.

57 PCA file on *On Dangerous Ground*, March 20, 1950, MHL.

58 Houseman, a long-time friend of Ray's who did not like this project but wanted to provide support, produced the film for RKO.

59 Scheib, "*Never Fear*," 42.

60 Francine Parker, "Discovering Ida Lupino," *Action* 8, no. 4 (July–August, 1973): 21.

61 Eisenshitz, *Nicholas Ray*, 149. Ray and Diskant started the shoot with extras and landscape, and in April the star actors joined the crew. Some of the shots that look most impressive, however, were matted in. A crewmember sent landscape stills back to RKO with the comment, "Baby, it's cold outside." *On Dangerous Ground*, "Budget Script of Feb. 17, 1950," MHL.

62 Both John Houseman and Bernard Herrmann were veterans of Orson Welles's Mercury Theatre, a company that shook up Hollywood with *Citizen Kane* (1941).

63 R. Barton Palmer, "Introduction," in *Larger Than Life: Movie Stars in the 1950s* (New Brunswick, NJ: Rutgers University Press, 2010), 3.

64 Thomas, "Lupino Trying Low Budget."

65 Darr Smith, quoted by Bernard Eisenschitz, *Nicholas Ray*, 157.

66 Waldman, "*Not Wanted*," 33.

67 Eisenshitz, *Nicholas Ray*, 157–158.

68 Frank Capra, *The Name above the Title* (New York: Macmillan, 1971), 372, 400.

69 William Donati, *Ida Lupino: A Biography* (Lexington: University Press of Kentucky, 1996), 166–175.

70 In a similar spirit, Capra entitled his autobiography *The Name above the Title.*

71 Jack Shea, ed., *In Their Own Words: The Battle over the Possessory Credit 1966–1968* (Los Angeles: The Guild, 1970–1972).

72 "Possessory Credit Timeline," DGA.org, *DGA Quarterly* (February 2004), accessed February 2015, www.dga.org/Craft/DGAQ/All-Articles/0402-Feb-2004/Possessory-Credit-Timeline.aspx.

73 Gene Moskowitz, "Producers Not Creators," *Variety*, May 30, 1956, 5. The story's tone is quite snide, referring to the meeting as "high-toned" and full of "Leftists."

74 Jim Hillier, *Cahiers du cinéma: The 1950s, Neo-Realism, Hollywood, New Wave* (Cambridge, MA: Harvard University Press, 1985), 104–124..

4 The Auteur Renaissance, 1968–1980

1 Peter Biskind, *Easy Riders, Raging Bulls: How The Sex-Drugs-and-Rock 'n' Roll Generation Saved Hollywood* (New York: Simon & Schuster, 1998).

2 For a useful periodization of different postwar transitional periods and an explanation of the term "New Hollywood," see Thomas Schatz, "The New Hollywood," in *Film Theory Goes to the Movies*, ed. Jim Collins, Hilary Radner, and Ava Collins (New York: Routledge, 1993), 8–36; and Peter Krämer, *The New Hollywood: From Bonnie and Clyde to Star Wars* (London: Wallflower Press, 2005). For an explanation of classical Hollywood see David Bordwell, Janet Staiger, and Kristin Thompson, *The Classical Hollywood Cinema: Film Style and Mode of Production to 1960* (New York: Columbia University Press, 1985).

3 For a discussion of this historical context, see David Cook, *Lost Illusions: American Cinema in the Shadow of Watergate and Vietnam, 1970–1979* (Berkeley: University of California Press, 2000), 67–72; and Mark Harris, *Pictures at a Revolution* (New York: Penguin, 2008).

4 Thomas Elsaesser, "American Auteur Cinema: The Last—or First—Great Picture Show," in *The Last Great American Picture Show: New Hollywood Cinema in the 1970s*, ed. Thomas Elsaesser, Alexander Horwath, and Noel King (Amsterdam: Amsterdam University Press, 2004), 46.

5 Cook, *Lost Illusions*, 67–157.

6 Ibid., 9–10; Geoff King, *New Hollywood Cinema: An Introduction* (New York: Columbia University Press, 2002), 34–35.

7 For a discussion of these trends, see the third chapter of this volume.

8 For an excellent reconsideration of the roadshow musical's financial history see Brett Farmer, "The Singing Sixties: Rethinking the Julie Andrews Roadshow Musical," in *The Sound of Musicals*, ed. Steven Cohan (London: Palgrave Macmillan, 2010), 114–127.

9 For examples see ibid., 117.

10 *The Graduate* took in every tenth dollar spent on movie tickets in 1968 for a domestic gross of $105 million (Krämer, *The New Hollywood*, 6). For theatrical rentals (the 40–60 percent of a film's gross returned to its distributor) of the top ten films each year from 1967 to 1976, see Krämer, *The New Hollywood*, 106–109.

11 Cook, *Lost Illusions*, 322–336.

12 Movie industry historian Douglas Gomery lists the major studio distributors of the period as Twentieth Century–Fox, United Artists (which also distributed for MGM), Warner Bros., Universal, Columbia, Paramount, and Disney. Gomery, "The American Film Industry of the 1970's: Stasis in the 'New Hollywood,'" *Wide Angle* 5, no. 4 (1983): 53.

13 For discussions of Penn's career, see Michael Chaiken and Paul Cronin, *Arthur Penn: Interviews* (Jackson: University Press of Mississippi, 2008), 35–36; and Nat Segaloff, *Arthur Penn: American Director* (Lexington: University Press of Kentucky, 2011), 120.

14 For an explanation of the art film that opposes classic Hollywood's emphasis on coherency and cause-effect narrative logic, see David Bordwell, "The Art Cinema as a Mode of Film Practice," in *Film Theory and Criticism: Introductory Readings*, 7th ed., ed. Leo Braudy and Marshall Cohen (New York: Oxford University Press, 2009), 649–657.

15 "Columbia Screen Gems Signs with Raybert For TV and Features," *Back Stage*, April 2, 1965, 2.

16 Jack Pitman, "No Biz Like 'Monkees' Biz," *Variety*, January 25, 1967, 27, 45.

17 Hank Werba, "'Rider's' $50,000,000 Gross? Fonda Parlays 325G into Hit," *Variety*, November 5, 1969, 29–30. Figures vary marginally regarding the film's budget, and David Cook notes that from its overall gross the film returned $19.2 million to its distributor solely in domestic rentals (*Lost Illusions*, 25).

18 In several supplemental features on BBS's Criterion Collection home video release, various figures involved with the company enjoy playing up their independence. In one interview Dennis Hopper claims that *Easy Rider* was "the first real independent movie that was ever distributed by a major company" ("Easy Rider: Shaking the Cage," dir. Charles Kisleyak [Columbia TriStar, 1999], in *America Lost and Found*). For further historical contextualization of independents working in Hollywood, see Tino Balio, *United Artists: The Company That Changed the Film Industry*, vol. 2, *1951–1978* (Madison: University of Wisconsin Press, [1987] 2009); and Denise Mann, *Hollywood Independents: The Postwar Talent Takeover* (Minneapolis: University of Minnesota Press, 2008).

19 Ben Kaufman, "Two More Pics from Schneider, Rafelson for Col," *Hollywood Reporter*, September 14, 1970, 1, 4.

20 King, *New Hollywood Cinema*, 98–100. BBS's final film *Hearts and Minds* (1974), a controversial Vietnam War documentary, was denied distribution by Columbia and came at the end of BBS's operation. For more on this situation, see Bob Thomas, "'Hearts and Minds': Vietnam Documentary," *Washington Post*, October 23, 1974, C7.

21 *Five Easy Pieces* press book (1970), production clippings file, Core Collections, Margaret Herrick Library, Academy of Motion Picture Arts and Sciences, Beverly Hills (hereafter MHL).

22 Quoted in Rex Reed, "Turn On the Dandruff Machine," *Chicago Tribune*, December 6, 1970, I24.

23 Wayne Warga, "Tune In as Bob Rafelson Answers Some Questions," *Los Angeles Times*, October 25, 1970, I22.

24 "Bert Schneider at 'Easy Pieces' Bow: 'My Group Bent On Financing Own,'" *Variety*, September 16, 1970, 6. For one example of many from film critics, Charles Champlin opens his review of *A Safe Place* by arguing that "[BBS productions] base their whole being on the belief that the movie-maker is entitled to do his own thing without correction by committees" ("Young Girl's Diary in Code," *Los Angeles Times*, December 16, 1971, G32).

25 Thomas Frank, *The Conquest of Cool: Business Culture, Counterculture, and the Rise of Hip Consumerism* (Chicago: University of Chicago Press, 1997), 20–22. Douglas McGregor's *The Human Side of Enterprise* (New York: McGraw-Hill, 1960) more explicitly contrasted a management "Theory X" of hierarchical supervision with a "Theory Y" structure that empowered the individual worker's ingenuity.

26 For an application of Frank's thesis to a segment of the media culture, see Lynn Spigel's consideration of television commercial directors, "One-Minute Movies: Art Cinema, Youth Culture, and TV Commercials in the 1960s," in *TV by Design: Modern Art and the Rise of Network Television* (Chicago: University of Chicago Press, 2008), 213–250.

27 Andrew Schroeder offers more useful information regarding BBS and Schneider's

involvement with radical politics, but his overall argument reaches too far in claiming that BBS also existed as a radical collective and shifted Hollywood as a whole toward leftist cultural politics. See Schroeder, "The Movement Inside: BBS Films and the Cultural Left in the New Hollywood," in *The World the Sixties Made: Politics and Culture in Recent America*, ed. Van Gosse and Richard Moser (Philadelphia: Temple University Press, 2003), 114–137.

28 For a history of the underground film movement, see David E. James, *Allegories of Cinema: American Film in the Sixties* (Princeton, NJ: Princeton University Press, 1989).

29 For further information about the film, see Lee Hill, *Easy Rider* (London: British Film Institute, [1996] 2004), 26–28.

30 For more information on the film's production, see *"The Last Picture Show: A Look Back,"* dir. Laurent Bouzereau, Columbia TriStar, 1999, in *America Lost and Found*.

31 Cited in Stephen Farber, "The Man Who Brought Us Greetings from the Vietcong," *New York Times*, May 4, 1975, D15.

32 "Steve Blauner: From Screen Gems to BBS," Criterion Collection, in *America Lost and Found*.

33 In *The Foreign Film Renaissance on American Screens, 1946–1973* (Madison: University of Wisconsin Press, 2010), 295, Tino Balio notes that the downfall of the foreign art film came at the success of American equivalents like *Five Easy Pieces* and *The Last Picture Show*.

34 Bert's father, Abraham Schneider, acted as Columbia board chairman until 1973, and his brother Stanley served as the company's president from 1969 to 1974: "A. Schneider Resigns," *Independent Film Journal*, April 16, 1975, 6; Lee Beaupre, "Stanley Schneider Exits Columbia Presidency in 1974 to Produce; Trade Spec As to N.Y. & Europe," *Variety*, June 13, 1973, 3, 14.

35 Various names have been attached to Ned Tanen's arrangements at Universal, some writers referring to it as his "in-house picture division," and others as his "special production unit" or simply "youth unit." For such attributions see, respectively, Kathleen Sharp, *Mr. and Mrs. Hollywood: Edie and Lew Wasserman and Their Entertainment Empire* (New York: Carroll & Graf Publishers, 2003), 259; Alexander Horwath, "A Walking Contradiction (Partly Truth and Partly Fiction)," in Elsaesser, Horwath, and King, *The Last Great American Picture Show*, 93; and Drew Casper, *Hollywood Film 1963–1976: Years of Revolution and Reaction* (Chichester, West Sussex: Wiley-Blackwell, 2011), 43. For financial details on Tanen's production deals see Rick Setlowe, "MCA Backs Pair of Newcomers; 'Cheap Features Gotta See Books,'" *Variety*, December 31, 1969, 3.

36 Aubrey Tarbox, "Universal Act of Faith in 'Youth' Slants: Frank Perry, Mike Cimino Get Remarkably 'Free' Pacts," *Variety*, January 28, 1970, 7, 78; Mel Gussow, "Movies Leaving 'Hollywood' Behind: Studio System Passe [*sic*]—Film Forges Ahead," *New York Times*, May 27, 1970; "Prototype for Hollywood's New Freedom," interview with Ned Tanen, *Show*, March 1971, 24.

37 Gussow, "Movies Leaving 'Hollywood' Behind."

38 "Big Rental Films of 1970," *Variety*, January 6, 1971, 11; Joyce Haber, "Presenting the Exclusive, Reclusive Hal Wallis," *Los Angeles Times*, January 30, 1972, V15.

39 For a lengthy discussion of *The Last Movie*, see David E. James, "Dennis Hopper's *The Last Movie*," *Journal of the University Film and Video Association* 35, no. 2 (Spring 1983): 34–46, reprinted in James, *Allegories of Cinema*, 297–303.

40 *The Hired Hand* press book (1971), production clippings file, Core Collections, MHL.

41 *Two-Lane Blacktop* press book (1971), production clippings file, Core Collections, MHL. The film's theatrical trailer is available in the United States on DVD and Blu-ray from the Criterion Collection, 2013.

42 Connie Bruck, *When Hollywood Had a King: The Reign of Lew Wasserman, Who Leveraged Talent into Power and Influence* (New York: Random House, 2003), 339.

43 For a more detailed account of these events see Jon Lewis, *Whom God Wishes to Destroy .
 . . : Francis Coppola and the New Hollywood* (Durham, NC: Duke University Press, 1995),
 5–20. Corman mentored many of the other up-and-coming 1970s auteurs, including Jack
 Nicholson, Peter Fonda, Monte Hellman, and Martin Scorsese.

44 Ibid., 3.

45 Kent Jones's overview of Hellman's filmography contrasts the Spielberg–De Palma–Cop-
 pola–Lucas New Hollywood with his preference for the Dennis Hopper–Bob Rafelson
 version ("'The Cylinders Were Whispering My Name': The Films of Monte Hellman," in
 Elsaesser, Horwath, and King, *The Last Great American Picture Show*, 165–194).

46 These films, in chronological order of release, were *Murder a la Mod* (1968), *Greetings* (1968),
 The Wedding Party (shot in 1963 and released in 1969; codirected with Wilford Leach and
 Cynthia Munroe), *Dionysus in '69* (1970), and *Hi, Mom!* (1970).

47 For more information on De Palma's relationship with Sigma III, see "Despite Merger,
 Sigma III Sees No Change in Policy of 'Special' Sell," *Variety*, September 13, 1967, 22; "How
 Pic Titles Are Born: 'Son of Greetings' Will Be Released as 'Hi, Mom,'" *Variety*, November
 26, 1969, 6.

48 Dick Adler, "Hi, Mom, Greetings, It's Brian—in Hollywood!," *New York Times*, December
 27, 1970, 64F.

49 David Cook offers a detailed overview of De Palma's industry frustrations across the 1970s
 in *Lost Illusions*, 147–153. For a fascinating consideration of De Palma's career trajectory
 and film texts within the context of the rise and fall narratives of the New Left and the
 auteur renaissance, see Chris Dumas, "Get to Know Your Failure," in *Un-American Psycho:
 Brian De Palma and the Political Invisible* (Chicago: Intellect, 2012), 83–144.

50 Eithne Quinn offers a concise explanation of these debates regarding whether or not
 white-controlled financing or distribution negated black creative control and notes the way
 in which *Super Fly* (1972) offers a textual response to such concerns: "'Tryin' to Get Over':
 Super Fly, Black Politics, and Post–Civil Rights Film Enterprise," *Cinema Journal* 49, no. 2
 (Winter 2010): 86–105.

51 Keith Corson, *Trying to Get Over: African American Directors after Blaxploitation, 1977–
 1986* (Austin: University of Texas Press, 2016), 2, 17.

52 This categorization follows the timeline proposed by Corson, ibid., 1–22.

53 Parks was preceded by black independent filmmakers such as Oscar Micheaux, who were
 significantly removed from the Hollywood film industry.

54 Corson, *Trying to Get Over*, 10.

55 *Stop!* rarely surfaces for viewing opportunities; thus, the film's content must be pieced
 together through a *Variety* review of a screening at the Whitney Museum of American Art
 in 1990 and a remnant press kit from Warner Bros. Lor, "Archive Film Review: Stop," *Vari-
 ety*, July 4, 1990, 26; press kit. The press kit does not describe the film's queer sexual activity,
 although the *Variety* review does include this information. The *Variety* review also labels
 the film "gothic horror" and the press kit confirms this element.

56 Corson, *Trying to Get Over*, 7. *Stop!* failed to secure release even though it fits comfortably
 within the cycle of topical youth-targeted movies marketed during 1969 and 1970. The film's
 hallucinatory drug sequences resemble similar scenes in financially successful films like
 The Trip (Roger Corman, 1967) and *Easy Rider*. An X rating and queer sexuality boosted
 the fortunes of *Midnight Cowboy* (John Schlesinger, 1969), while even releases of this nature
 that proved disastrous, such as Fox's *Myra Breckinridge* (Michael Sarne, 1970) and *Beyond
 the Valley of the Dolls* (Russ Meyer, 1970), were given major studio releases. In fact, in 1970
 Warner Bros. itself begrudgingly released the X-rated *Performance* (Donald Cammell and
 Nicolas Roeg), a film that could easily have elicited all the same critical objections about
 salacious content and artistic pretension as *Stop!*

Tracing some of Gunn's difficulties, Christopher Sieving convincingly laments, "Few match Bill Gunn for unrealized potential" (Christopher Sieving, *Soul Searching: Black-Themed Cinema from the March on Washington to the Rise of Blaxploitation* [Middletown, CT: Wesleyan University Press, 2011], 174–175).

57 Racquel Gates has traced Van Peebles's pre- and postproduction battles on the film in her essay, "Subverting Hollywood from the Inside Out," *Film Quarterly* 68, no. 1 (Fall 2014): 9–21.

58 David Cook notes that the film took in $4.1 million in rentals (*Lost Illusions*, 260). For more information on *Sweetback*, see Jesse Algernon Rhines, *Black Film / White Money* (New Brunswick, NJ: Rutgers University Press, 1996), 43–44.

59 In fact, Blaxploitation films varied considerably in terms of genres and plotlines. For a lengthy analysis of the cycle, see Ed Guerrero, *Framing Blackness: The African American Image in Film* (Philadelphia: Temple University Press, 1993), 69.

60 Sieving, *Soul Searching*, 185.

61 L. Roi Boyd III, "*Leadbelly*, Thirty Years Later: Exploring Gordon Parks as Auteur through the *Leadbelly* Lens," *Black Camera* 21, no. 2 (Fall/Winter 2006), 18–21.

62 By the end of the twentieth century, scholars had begun to reevaluate selected Blaxploitation titles, complicating the protests that many black organizations had launched against the films' glorification of crime and stereotypes of hypersexual black masculinity. For example see Quinn, "'Tryin' to Get Over'"; Amy Abugo Ongiri, "'You Better Watch This Good Shit!' Black Spectatorship, Black Masculinity, and Blaxploitation Film," in *Spectacular Blackness: The Cultural Politics of the Black Power Movement and the Search for a Black Aesthetic* (Charlottesville: University of Virginia Press, 2010), 159–185; and Leerom Medovoi, "Theorizing Historicity, or the Many Meanings of *Blacula*," *Screen* 39, no. 1 (Spring 1998): 1–21.

63 For a reading of the film and its experimental form see Manthia Diawara and Phyllis Klotman, "*Ganja and Hess*: Vampires, Sex, and Addictions," *Jump Cut* 35 (April 1990): 30–36.

64 For discussions of these themes, see Samantha N. Sheppard, "Persistently Displaced: Situated Knowledges and Interrelated Histories in *The Spook Who Sat by the Door*," *Cinema Journal* 52, no. 2 (Winter 2013): 71.

65 Corson, *Trying to Get Over*, 17–20.

66 Jan-Christopher Horak argues that *Gordon's War* might be seen as distinct from Blaxploitation due to its self-reflexive critique of the genre. Nonetheless, *Gordon's War* differs from *Black Girl*, which emphasizes social realism and character interiority rather than action sequences. Horak's analysis of *Gordon's War* appears in his essay "Tough Enough: Blaxploitation and the L.A. Rebellion," in *L.A. Rebellion: Creating a New Black Cinema*, ed. Allyson Nadia Field, Jan-Christopher Horak, and Jacqueline Najuma Stewart (Berkeley: University of California Press, 2015), 121.

67 The other two titles in Poitier's trilogy of comedy crime films were *Let's Do It Again* (1975) and *A Piece of the Action* (1977).

68 For an overview of the movement, see Allyson Nadia Field, Jan-Christopher Horak, and Jacqueline Najuma Stewart, "Introduction," in *L.A. Rebellion: Creating a New Black Cinema* (Berkeley: University of California Press, 2015), 1–53.

69 In 2015 director Ava Duvernay began a project of resurrecting and mounting public screenings for some of these films through her distribution company ARRAY. The first such screening was Gerima's 1983 production *Ashes and Embers*.

70 Jan-Christopher Horak offers an impressive reading of Fanaka's films throughout the 1970s, pointing to his efforts to revise the genre while also using it to reach audiences. See his chapter "Tough Enough," in *L.A. Rebellion*, 121.

71 I would like to thank Allyson Nadia Field for pointing out to me that Fanaka might be seen as the era's "overlooked movie brat."

72 The closest Fanaka came to the major studios was when he mounted a class-action lawsuit against them and the Directors Guild of America (DGA) for racially discriminatory hiring practices. For information about this suit, see Horak, "Tough Enough," 124–125.

73 Maya Smukler's dissertation and forthcoming book consider how the feminist movement impacted the U.S. film industry and women directors. In addition to examining the careers of specific women directors of the era, Smukler also considers how professional guilds in Hollywood pushed for reform in discriminatory hiring practices. Smukler, "Working Girls: The History of Women Directors in 1970s Hollywood" (PhD diss., University of California, Los Angeles, 2014), 12, ProQuest (1549976967); and Smukler, *Liberating Hollywood: Women Directors and the Feminist Reform of 1970s American Cinema* (New Brunswick, NJ: Rutgers University Press, 2017).

74 Smukler's full list of 1970s women directors: Karen Arthur, Anne Bancroft, Joan Darling, Lee Grant, Barbara Loden, Elaine May, Barbara Peeters, Joan Rivers, Stephanie Rothman, Beverly Sebastian, Joan Micklin Silver, Joan Tewkesbury, Jane Wagner, Nancy Walker, and Claudia Weill

5 The New Hollywood, 1981–1999

1 The financial data throughout this essay, unless indicated otherwise, are culled from three principal sources: The Numbers, an online data service provided by Nash Information Services available at www.the-numbers.com; Box Office Mojo, available online at www.boxofficemojo.com; and the Motion Picture Association of America, whose annual reports on all phases of the film (and filmed entertainment) industry can be requested online at www.mpaa.org/researchStatistics.asp. There are many other movie-related data services and sources available, including annual box office and production reports from *Variety* and the *Hollywood Reporter*, which have been consulted as well. But these three have proven to be the most consistent, comprehensive, and reliable.

2 Gerald Putzer, "BO Blasts Off in the Year of the Bat," *Variety*, January 3, 1990, 1.

3 Jennifer Pendleton, "Manic Bat-marketing Underway," *Variety*, April 20, 1992, 3.

4 On the ownership and early development of the *Batman* property, see Nancy Griffin and Kim Masters, *Hit & Run* (New York: Simon & Schuster, 1996), 164–165.

5 Mark Salisbury, ed., *Burton on Burton*, rev. ed. (London: Faber and Faber, 2006), 70.

6 On the development and production of *Beetlejuice*, see ibid., 54–69.

7 Ibid., 55.

8 On the development and production of *Batman*, see ibid., 70–83.

9 Sam Hamm, "Batman" (3rd draft, dated February 29, 1988). Warren Skaaren Collection, Harry Ransom Center (henceforth HRC), University of Texas at Austin, Box 1.

10 For an excellent summary of Skaaren's involvement in *Batman*, see his Guild Arbitration Statement (dated March 1989) in the Skaaren Collection, HRC, Box 1.

11 On Skaaren's revisions, see Warner Bros. and Guber-Peters memo to Tim Burton, August 30, 1988, which summarizes the initial meetings with Skaaren; see also Kane letter to Skaaren dated September 11, 1988, and Skaaren's fax to Burton, September 12, 1988, Skaaren Collection, HRC, Box 1.

12 On Pinewood Studios and the physical production requirements, see Alan Jones, "Batman in Production," *Cinefantastique*, November, 1989, 75–88; see also Joe Morgenstern, "Tim Burton, Batman and the Joker," *New York Times Magazine*, April 9, 1989, 44; see also Griffin and Masters, *Hit & Run*, 164–174. On Burton and Anton Furst, see Salisbury, *Burton on Burton*, 78.

13 Salisbury, *Burton on Burton*, 72.

14 Quoted in Griffin and Masters, *Hit & Run*, 168.

15 Quoted in Tom Shone, *Blockbuster* (New York: Free Press, 2004), 187.

16 Warren Skaaren memo to Jon Peters, Tim Burton, Chris Kenny, "Finale," December 10, 1988, Skaaren Collection, HRC, Box 2.

17 Jack Kroll, "Return to Gotham City," *Newsweek*, January 23, 1989, 68.

18 Hilary de Vries, "'Batman' Battles for Big Money," *New York Times*, February 5, 1989, 11.

19 Stephen Prince, *A New Pot of Gold: Hollywood under the Electronic Rainbow, 1980-1989* (Berkeley: University of California Press, 2002), 196.

20 Salisbury, *Burton on Burton*, 81.

21 Roger Ebert, *Batman*, *Chicago Sun-Times*, June 23, 1989, www.rogerebert.com/reviews/batman-1989.

22 Pauline Kael, "The City Gone Psycho," *The New Yorker*, July 10, 1989, 83.

23 Vincent Canby, "Nicholson and Keaton Do Battle in 'Batman,'" *New York Times*, June 23, 1989. www.nytimes.com/movie/review?res=950DE7D9133BF930A15755C0A96F948260.

24 See the famously leaked internal Warner Bros. financial report, printed under the headline "Holy Bat-Debt," *Entertainment Weekly*, April 26, 1991, 12.

25 Hamm quoted in Morgenstern, "Tim Burton, Batman, and the Joker"; Burton quoted in Kroll, "Return to Gotham City."

26 Richard Corliss, "Top 10 Cannes Film Festival Movies," *Time*, May 13, 2009, entertainment.time.com/2010/05/13/top-10-cannes-film-festival-movies.

27 Peter Biskind, *Down and Dirty Pictures: Miramax, Sundance, and the Rise of Independent Film* (New York: Simon & Schuster, 2004), 26.

28 John Pierson, *Spike, Mike, Slackers & Dykes: A Guided Tour across a Decade of American Independent Film* (New York: Hyperion, 1995), 61-63.

29 Ibid., 65.

30 Ibid., 76-77.

31 Richard Gold, "Spike Lee Plans to Start in August on Next Feature," *Variety*, March 30, 1988, 6.

32 Lee's original July 5, 1988, deal outlined in an internal Universal memo from Jerry Barton to Casey Silver dated March 13, 1990 (Universal Files).

33 "Production Notes," *Do the Right Thing*, Universal Pictures, 5-6.

34 For an excellent summary of the physical production, see *Making 'Do the Right Thing'* (1989), an hour-long documentary by St. Claire Bourne, in the 20th Anniversary Edition DVD of *Do the Right Thing* (Universal Studios Home Entertainment, 2009).

35 For a detailed description of this conflict, see Thomas R. Lindlof, *Hollywood under Siege: Martin Scorsese, the Religious Right, and the Culture Wars* (Lexington: University Press of Kentucky, 2008).

36 Perry Katz, internal Universal Pictures report on the editing and previews of *Do the Right Thing*, October 27, 1988 (Universal Files).

37 Universal's marketing campaign described in "Final Media Plan," an internal Universal Pictures report by Perry Katz, June 8, 1989 (Universal Files).

38 Vincent Canby, "Spike Lee Stirs Things Up at Cannes," *New York Times*, May 20, 1989, www.nytimes.com/movie/review?res=9905E5DF153AF933A15756C0A96F948260?.

39 Rita Kempley, "Spike Lee's Cannes Shake-up," *Washington Post*, May 22, 1989, www.washingtonpost.com/archive/lifestyle/1989/05/22/spike-leescannes-shake-up/92dae46e-a23b-45ba-9231-30927e59cb7c/.

40 The full press conference is included in the 20th Anniversary Edition DVD of *Do the Right Thing* (Universal Studios Home Entertainment, 2009).

41 Perry Katz, "Final Media Plan" (Universal Files).

42 Pierson, *Spike, Mike, Slackers & Dykes*, 75.

43 Wenders and Soderbergh, quoted in Anthony Kaufman, ed., *Steven Soderbergh: Interviews* (Jackson: University Press of Mississippi, 2002), xvii.

44 See Soderbergh career "Chronology" in Kaufman, *Steven Soderbergh: Interviews*, xix–xx.

45 Steve Erickson, "The Further Adventures of Director Steven Soderbergh," *Los Angeles Magazine*, January 2001, 85.

46 Aljean Hermetz, "Sex, Lies, Truth and Consequences," *New York Times*, July 13, 1989, sec. 2, p. 1.

47 Michel Ciment and Hubert Niogret, "Interview with Steven Soderbergh: *sex, lies, and videotape*," in Kaufman, *Steven Soderbergh: Interviews*, 18. Interview originally appeared in *Positif*.

48 Ibid., 23.

49 Terri Minsky, "Hot Phenomenon: Hollywood Makes a Big Deal over Steven Soderbergh's *sex, lies, and videotape*," in Kaufman, *Steven Soderbergh: Interviews*, 10. Interview originally appeared in *Rolling Stone*.

50 On casting, see Ciment and Niogret interview, 19–20.

51 Ibid., 21.

52 Biskind, *Down and Dirty Pictures*, 32.

53 Harlan Jacobson, "Steven Soderbergh, King of Cannes: Truth or Consequences," in Kaufman, *Steven Soderbergh: Interviews*, 31. Interview originally appeared in *Film Comment*.

54 On the festival submission and selection, see Biskind, *Down and Dirty Pictures*, 39–40; see also Pierson, *Spike, Mike, Slackers & Dykes*, 127.

55 Biskind, *Down and Dirty Pictures*, 64–65; Pierson, *Spike, Mike, Slackers & Dykes*, 127–128.

56 Harlan Jacobson, interview in Kaufman, *Steven Soderbergh: Interviews*, 24.

57 On the marketing campaign, see Biskind, *Down and Dirty Pictures*, 80–82.

58 Caryn James, "A Dance of Sex and Love, Through a Lens Darkly," *New York Times*, August 4, 1989, www.nytimes.com/movie/review?res=950DE3DB1630F937A3575BC0A96F948260.

59 Pierson, *Spike, Mike, Slackers & Dykes*, 128, 131.

60 Biskind, *Down and Dirty Pictures*, 40.

61 Drew Taylor, "4 'Superman' Movies That Never Took Flight," *Indiewire*, June 12, 2013, www.indiewire.com/2013/06/4-superman-movies-that-never-took-flight-97060/..

6 The Modern Entertainment Marketplace, 2000–Present

1 Quoted in the documentary *Side by Side* (Chris Kenneally, 2012).

2 For information on Hollywood's new marketing environment, see the several overview essays in Paul McDonald and Janet Wasko, *The Contemporary Hollywood Film Industry* (Malden, MA: Blackwell, 2008); and Stephen Prince, *A New Pot of Gold: Hollywood under the Electronic Rainbow* (Berkeley: University of California Press, 2002).

3 For a lengthy discussion of ancillary markets, see Derek Johnson, *Media Franchising: Creative License and Collaboration in the Culture Industries* (New York: New York University

Press, 2013); and Kristin Thompson, *The Frodo Franchise: The Lord of the Rings and Modern Hollywood* (Berkeley: University of California Press, 2008).

4 Quoted in John Badham and Craig Modderno, *I'll Be in My Trailer: The Creative Wars between Directors and Actors* (Studio City, CA: Michael Weiss Productions, 2006), 181.

5 For more on Malick's working methods, see Carlo Hintermann and Daniele Villa, *Terrence Malick: Rehearsing the Unexpected* (London: Faber & Faber, 2016).

6 Michel Chion, *The Thin Red Line* (London: BFI Press, 2007). My account of Malick's on-set technique depends on work by Madeline Whittle, "Seeing the Glory, Feeling the Lack: Terrence Malick and the Myth of Transcendent Authorship in Contemporary Hollywood" (BA thesis, Yale University, 2014).

7 Whittle, "Seeing the Glory, Feeling the Lack," 61, also 25–26.

8 Ben Stiller seems to be the director in this group most committed to such old-fashioned virtues. For an analysis of Stiller's aesthetics, see Tad Friend, "Funny Is Money," *New Yorker*, June 25, 2012, www.newyorker.com/magazine/2012/06/25/funny-is-money.

9 Quoted in Jonah Weiner, "The Man Who Makes the World's Funniest People Even Funnier," *New York Times Magazine*, April 15, 2015, www.nytimes.com/2015/04/19/magazine/the-man-who-makes-the-worlds-funniest-people-even-funnier.html.

10 Ibid. Weiner's superb article explains that the editors of *22 Jump Street*, "buried beneath reams of improvised footage," were forced to call in White to wrangle a satisfactory rough assembly. If Lord and Miller had had his back-end infrastructure in place on *22 Jump Street*, White suggested, they most likely wouldn't have needed him.

11 See Judd Apatow, *Comédie, Mode d'Emploi, entretien avec Emmanuel Burdeau* (Paris: Capricci, 2010), 115. Since the interview was conducted in English and then translated into French, I have provided a literal translation back into English but have not placed it within quotation marks.

12 See, for example, Evan Minsker, "Terrence Malick's Mysterious Music-Centered Movie Set in Austin: What We Know," *Pitchfork*, November 8, 2012, pitchfork.com/news/48262-terrence-malicks-mysterious-music-centered-movie-set-in-austin-what-we-know/. By the law of the conservation of public relations, journalists turn their attentions to Malick's actors and producers, as in Anne Thompson, "Enabling Terrence Malick: What It's Like to Be His Producers," *IndieWire*, September 11, 2016, www.indiewire.com/2016/09/terrence-malick-voyage-of-time-beauty-toronto-1201725301.

13 For a discussion of enfotainment, see Justin Wyatt and Christine Vlesmas, "The Drama of Recoupment: On the Mass Media Negotiation of *Titanic*," in *Titanic: Anatomy of a Blockbuster*, ed. Kevin S. Sandler and Gaylyn Studlar (New Brunswick, NJ: Rutgers University Press, 1999), 29–45.

With *Voyage of Time* (2016), which exists in both feature and forty-five-minute forms, and which evolved from effects work on *Tree of Life* (2011), Malick may have finally begun to embrace the sorts of digital spinoffs that have become commonplace for others.

14 For more information on this phenomenon, see Greg Elmer and Mike Gasher, eds., *Contracting Out Hollywood: Runaway Productions and Foreign Location Shooting* (Oxford: Rowman & Littlefield, 2005); R. Barton Palmer, *Shot on Location: Postwar American Cinema and the Exploration of Real Place* (New Brunswick, NJ: Rutgers University Press, 2016).

15 For a comprehensive guide to these changes, see Christopher Lucas, "The Modern Entertainment Marketplace," in *Cinematography*, ed. Patrick Keating (New Brunswick, NJ: Rutgers University Press, 2014), 132–57.

16 This and subsequent quotations are taken from "Pre-Visualization," *War of the Worlds*, DVD special feature, Paramount 2005.

17 Quoted in "James Cameron: Performance Capture Re-Invented," www.motioncapturesociety.com/resources/articles/miscellaneous-articles/84-james-cameron-performance-capture-re-invented, n.d.

18 For more on Warner Bros.' investment in superhero slates, see Spencer Perry, "Warner Bros.' DC Comics Movie Slate Fully Revealed!," *SuperHeroHype.com*, October 15, 2014, www. superherohype.com/news/318881-warner-bros-dc-comics-movie-slate-fully-revealed; Dee Locket, "Marvel Announces Eight New Movies, Including Its First for Black and Female Superheroes," *Slate*, October 28, 2014, www.slate.com/blogs/browbeat/2014/10/28/mar-vel_announces_black_panther_captain_marvel_inhumans_and_more_in_film.html.

19 All behind-the-scenes quotes in this paragraph from "Batman: The Journey Begins: Concept, Design, and Development of the Film," *Batman Begins* DVD, Warner Bros., 2008.

20 Quoted in S. T. VanAirsdale, "Exclusive: Nicolas Winding Refn Explains His Wonder Woman Movie," *MovieLine.com*, June 15, 2010, movieline.com/2010/06/15/nicolas-winding-refn-wonder-woman/.

21 Quoted in Oliver Lyttleton, "Empire Big Screen '11: Nicolas Winding Refn Says *Wonder Woman* a Go If He Does *Logan's Run* Right," *The Playlist*, August 16, 2011, www.indiewire.com/2011/08/empire-big-screen-11-nicolas-winding-refn-says-wonder-woman-a-go-if-he-does-logans-run-right-116894.

22 For more information on the production, see Justin Kroll, "Michelle McLaren Set as Director of *Wonder Woman*," *Variety*, November 24, 2014, variety.com/2014/film/news/wonder-woman-director-michelle-maclaren-1201363900/.

23 In *Creative Industries: Contracts between Art and Commerce* (Cambridge, MA: Harvard University Press, 2000), Richard Caves describes the "nurture of ten-ton turkeys" beginning on 136.

24 The first mention of the term "director jail" I was able to find was in the *Washington Times*, which quoted Bill Condon, joking in late 1998 about his stretch between *Sister, Sister* (1987) and *Candyman: Farewell to the Flesh* (1995) (Gary Arnold, "From Monster to Godlike Films? The Low-Budget Movie Adventures of a Director," *Washington Times*, November 22, 1998, D3). Doubtless the phrase existed earlier, but it did not become a commonplace of entertainment industry blogs and trade discussions until the new century. After Condon's remarks to Arnold, the next appearance I found of the term was in a *Vanity Fair* profile of Tony Kaye by Evgenia Peretz ("Stealing Brando," January 2003). (Evgenia's brother Jesse would serve a long stint in director jail after the failure of *The Ex* [2006], emerging with *Our Idiot Brother* in 2011. For more on Jesse Peretz, see Amy Kaufman, "Five-Year Exile Is Over for Jesse Peretz," *Los Angeles Times*, August 21, 2011, D10). In 2004 the *Los Angeles Times* published an article about Disney pulling Mark Waters out of director jail to direct *Freaky Friday* (2003) (Rachel Abramowitz, "Mother Knows Best at Disney; Nina Jacobson's Keen Eye Benefits Parents and Kids—and the Studio's Bottom Line," *Los Angeles Times*, January 25, 2004, E1). The first appearance of the term in *Variety* is in a 2009 article about the sequel to DVD-hit *Boondock Saints* (Peter Debruge, "The Boondock Saints II: All Saints Day," *Variety*, November 2, 2009, 65).

25 Richard Rushfield, "The Rules of Director Jail," *gawker.com*, November 4, 2009, gawker.com/5411923/the-rules-of-director-jail. Short of director jail is the more public shame of having a project pulled away at the last minute. Disney had stopped production on *The Lone Ranger* (2013) in order to compel producer Jerry Bruckheimer, director Gore Verbinski, and star Johnny Depp to reduce the project's cost, but the studio ultimately relented. The picture bombed anyway.

26 Rick Altman, *Film/Genre* (London: BFI, 1999), 44.

27 As with other features of the industry, the rules of director jail apply differently to women and minority directors. Less likely to be incorporated in longstanding, tight-knit talent networks with ready access to capital, such directors are accordingly less likely to be able to parlay a single success into an extended run of gigs and are more likely to be cast aside. When the *Wall Street Journal* asked director Penelope Spheeris about gender issues in 2013, she emphasized that "men can have movies that fail and they keep working, no problem. . . . Women go to director jail immediately if they have one unsuccessful film." Quoted in

Steve Dollar, "Offering Women A Sweeter Deal—Film Company Aims at the Glass Ceiling," *Wall Street Journal*, April 10, 2013, A20. The situation has been no different for African American directors. Writing about the pathway from successful music-video directing to feature films, Tommy Nguyen pointed to Hype Williams's one-and-done career: "One shot, however, may be all you get—after Williams's 1998 film *Belly* flopped, the director has had a difficult time getting another chance. [Video producer Scott] Edelstein calls the situation 'director's jail.'" Tommy Nguyen, "Cut to the Directors: Music Videos Have Black Filmmakers on a Roll—But the Path Remains Uphill," *Washington Post*, August 15, 2004, N01.

28 An overview of discussions of "TV III" appears in Matt Hills and Glen Creeber, "Editorial: TV III," *New Review of Film and Television Studies* 5, no. 1 (April 2007): 1–4.

29 This practice had previously been pioneered by European auteurs like Jean-Luc Godard and Ann-Marie Miéville (*Six fois deux/Sur et sous le communication*, 1976) and Rainer Werner Fassbinder (*Berlin Alexanderplatz*, 1980).

30 *Moneyball* was subsequently resurrected by Columbia and released in 2011 with Bennett Miller at the helm.

31 Quoted in Kevin Jagernauth, "Steven Soderbergh Says *Behind the Candelabra* Was Rejected by Hollywood Studios for Being 'Too Gay,'" *The Playlist*, January 5, 2013, blogs.indiewire.com/theplaylist/steven-soderbergh-says-behind-the-candelbra-was-rejected-by-hollywood-studios-for-being-too-gay-20130105.

32 Quoted in Dade Hayes, "Soderbergh's *Knick* Knack Gives Cinemax Shot in the Arm," *Forbes.com*, August 11, 2014, www.forbes.com/sites/dadehayes/2014/08/11/soderberghs-knick-knack-gives-cinemax-shot-in-the-arm/.

33 See also Alex Suskind, "Clive Owen on the *Knick* Finale, Cocaine, and the Plan for Season 2," *vulture.com*, October 17, 2014, www.vulture.com/2014/10/knick-season-finale-clive-owen-interview.html.

34 There have been notable precursors to this trend, the most famous being Alfred Hitchcock, whose unique position made him a powerful multimedia brand such that his appearance in trailers for his films foreshadowed what was to come.

35 By 2000, the array of DVD extras had largely been set. They included commentaries, out-takes, "bonus" footage, extended scenes, point-and-click interactive games, trailers for other studio movies, script-to-screen comparisons, production diaries, cast bios, and craft profiles. The DVD market plateaued in 2005 before declining. At this writing, the revenue DVDs produced has not been replaced in the move to streaming, and the feature-laden optical disc remains dominant as the omnibus, self-reflexive suprafilm. For an extensive discussion of DVD commentaries, see John Thornton Caldwell, *Production Culture: Industrial Reflexivity and Critical Practice in Film and Television* (Durham, NC: Duke University Press, 2008), Appendix 2, 362–367.

36 I have placed the term "director's cut" in scare quotes to highlight the ambiguity of the term and the artifactual status of many of the releases that carry that label. As Jonathan Rosenbaum has explained, albeit more in the context of art cinema than mainstream Hollywood, the legal and ontological status of the "director's cut" is not fixed. See "Potential Perils of the Director's Cut," in *Goodbye Cinema, Hello Cinephilia: Film Culture in Transition* (Chicago: University of Chicago Press, 2010), 12–24.

37 For more on procedural authorship, see Murray's *Hamlet on the Holodeck: The Future of Narrative in Cyberspace* (Cambridge, MA: MIT Press, 1998).

38 The converse is also possible: to split the directing credit. While there are excellent reasons not to (organizational coherence, labor concord, marketing), there has been a marked tendency toward more multi-director films. Multi-director films require a waiver from the DGA. In a 2004 article written for the Guild's publication *Action*, Ted Elrick noted "a substantial increase in co-directing waiver requests. . . . There were 15 requests (10 granted) between 1979 and 1989; 19 requests (11 granted) from 1990 to 1999" ("Singularity of Vision:

The Origin of the One Director to a Film Policy," *DGA Quarterly*, May 2004). To extend the sample, in the decade between 2000 and 2009, it appears that the DGA granted at least sixty codirecting requests (a sixfold increase), a rate that has remained relatively consistent since then. The DGA was unwilling to divulge recent numbers. My figure is calculated ex-post from publicly available sources. As a result, I lack even cursory figures that might indicate whether the number of waiver *requests* has increased relative to the number of waivers granted.

39 Quoted in Michael O'Sullivan, "Take Two: A *Keane* Remix by Soderbergh," *Washington Post*, March 24, 2006, www.washingtonpost.com/wp-dyn/content/article/2006/03/23/AR2006032300541.html.

SELECTED BIBLIOGRAPHY

Auiler, Dan. *Hitchcock's Notebooks: An Authorized and Illustrated Look inside the Creative Mind of Alfred Hitchcock.* New York: Avon, 1991.

Balio, Tino. *Grand Design: Hollywood as a Modern Business Enterprise.* Rev. ed. Berkeley: University of California Press, 1996.

Beerthomé, Jean-Pierre, and François Thomas. *Orson Welles at Work.* New York: Phaidon Press, 2008.

Bordwell, David, Janet Staiger, and Kristin Thompson. *The Classical Hollywood Cinema: Film Style and Production to 1960.* New York: Columbia University Press, 1985.

Bowser, Eileen. *The Transformation of Cinema: 1907–1915.* Berkeley: University of California Press, 1994.

Buscombe, Edward. "Ideas of Authorship." *Screen* 14, no. 3 (Autumn 1973): 75–85.

Caldwell, John Thornton. *Production Culture.* Durham, NC: Duke University Press, 2008.

Carringer, Robert. "Collaboration and Concepts of Authorship." *PMLA* 116, no. 2 (March 2001): 370–379.

Cole, Janis, and Holly Dale. *Calling the Shots: Profiles of Women Filmmakers.* Kingston, ON: Quarry, 1993.

Coursodon, Jean-Pierre, with Pierre Sauvage. *American Directors: Volume I and II.* New York: McGraw-Hill, 1983.

Crofts, Stephen. "Authorship and Hollywood." In *The Oxford Guide to Film Studies*, edited by John Hill and Pamela Church Gibson, 310–324. New York: Oxford University Press, 1998.

Donalson, Melvin. *Black Directors in Hollywood*. Austin: University of Texas Press, 2003.

Elsaesser, Thomas. *The Persistence of Hollywood*. New York: Routledge, 2012.

Gerstner, David, and Janet Staiger, eds. *Authorship and Film*. New York: Routledge, 2002.

Girgus, Sam B. *Hollywood Renaissance: The Cinema of Democracy in the Era of Ford, Capra, and Kazan*. New York: Cambridge University Press, 1998.

Grant, Barry Keith, ed. *Auteurs and Authorship*. Malden, MA: Blackwell, 2008.

Gunning, Tom. *D. W. Griffith and the Origins of Narrative Film: The Early Years at Biograph*. Champaign: University of Illinois Press, 1991.

Higashi, Sumiko. *Cecil B. DeMille and American Culture: The Silent Era*. Berkeley: University of California Press, 1994.

Kagan, Jeremy, ed. *Directors Close-Up: Interviews with Directors Nominated for Best Film by the Directors Guild of America*. Boston: Focal Press, 2000.

Kapsis, Robert. *Hitchcock: The Making of a Reputation*. Chicago: University of Chicago Press, 1992.

Katz, Steven D. *Film Directing: Shot by Shot*. Chelsea, MI: Sheridan Books, 1991.

Kolker, Robert. *A Cinema of Loneliness: Penn, Stone, Kubrick, Scorsese, Spielberg, Altman*. 3rd ed. New York: Oxford University Press, 2000.

Koszarski, Richard. *An Evening's Entertainment: The Age of the Silent Feature Picture, 1915–1928*. Berkeley: University of California Press, 1994

Lane, Christina. *Feminist Hollywood: From Born in Flames to Point Break*. Detroit: Wayne State University Press, 2000.

Leff, Leonard. *Hitchcock and Selznick: The Rich and Strange Collaboration of Alfred Hitchcock and David O. Selznick in Hollywood*. New York: Weidenfeld & Nicolson, 1987.

Lev, Peter. *The Fifties: Transforming the Screen, 1950–1959*. Berkeley: University of California Press, 2006.

Lewis, Jon. *Whom God Wishes to Destroy . . . : Francis Coppola and the New Hollywood*. Durham, NC: Duke University Press, 1995.

Livingston, Paisley. "Cinematic Authorship." In *Film Theory and Philosophy*, edited by Richard Allen and Murray Smith, 132–148. New York: Oxford University Press, 1997.

Mahar, Karen Ward. *Women Filmmakers in Early Hollywood*. Baltimore: Johns Hopkins University Press, 2006.

Mann, Denise. *Hollywood Independents: The Postwar Talent Takeover*. Minneapolis: University of Minnesota Press, 2008.

Mayne, Judith. *Directed by Dorothy Arzner*. Bloomington: Indiana University Press, 1994.

McBride, Joseph. *Frank Capra: The Catastrophe of Success*. New York: St. Martin's, 2000.

———. *Searching for John Ford*. New York: St. Martin's, 2001.

Monaco, Paul. *The Sixties: 1960–1969*. Berkeley: University of California Press, 2003.

Mottram, James. *The Sundance Kids: How the Mavericks Took Back Hollywood.* New York: Faber and Faber, 2006

Musser, Charles. *The Emergence of Cinema: The American Screen to 1907.* Berkeley: University of California Press, 1994.

Naremore, James. "Authorship, Auteurism, and Cultural Politics." In *An Invention without a Future,* 15–32. Berkeley: University of California Press, 2014.

Polan, Dana. "Auteur Desire." *Screening the Past.com,* 12 (2001). www.latrobe.edu.au/screeningthepast/firstrelease/fr0301/dpfr12a.htm.

Prince, Steven. *A New Pot of Gold: Hollywood under the Electronic Rainbow, 1980–1989.* Berkeley: University of California Press, 2002.

Reid, Mark A. *Black Lenses, Black Voices: African American Film Now.* Lanham, MD: Rowman and Littlefield, 2005.

Sarris, Andrew. *The American Cinema: Directors and Directions, 1929–1968.* Chicago: University of Chicago Press, 1985.

Schatz, Thomas. *Boom and Bust: American Cinema in the 1940s.* Berkeley: University of California Press, 1999.

———. *The Genius of the System: Hollywood Filmmaking in the Studio Era.* Minneapolis: University of Minnesota Press, 2010.

Sellors, C. Paul. *Film Authorship: Auteurs and Other Myths.* London: Wallflower, 2010.

Silver, Alain, and Elizabeth Ward. *The Film Director's Team.* Los Angeles: Silman James, 1992.

Stam, Robert. "The Cult of the Auteur," "The Americanization of the Auteur Theory," and "Interrogating Authorship and Genre." In *Film Theory: An Introduction,* 83–91, 123–129. New York: Blackwell, 2000.

Stamp, Shelley. *Lois Weber in Early Hollywood.* Berkeley: University of California Press, 2015.

Studlar, Gaylyn. "Erich Von Stroheim and Cecil B. DeMille: Early Hollywood Cinema and the Discourses of Directorial Genius." In *The Wiley-Blackwell History of American Film,* edited by Cynthia Lucia, Roy Grundemann, and Art Simon, 293–312. Oxford: Wiley-Blackwell, 2012.

Truffaut, François. "A Certain Tendency of the French Cinema." *Cahiers du cinéma in English* 1 (1966): 30–40.

Usai, Paolo Cherchi, and Lorenzo Codelli, eds. *The DeMille Legacy.* Pordenone, Italy: Edizioni Biblioteca dell'Immagine, 1991.

Wexman, Virginia Wright. "Directors." Oxford Bibliographies Online: Cinema and Media Studies. www.oxfordbibliographies.com/view/document/obo-9780199791286/obo-9780199791286-0092.xml?rskey=7AeDqG&result=70.

———, ed. *Film and Authorship.* New Brunswick, NJ: Rutgers University Press, 2002.

Wollen, Peter. "The Auteur Theory." In *Signs and Meaning in the Cinema,* 74–115. Bloomington: Indiana University Press, 1972.

NOTES ON CONTRIBUTORS

J. D. Connor is an associate professor in the Bryan Singer Division of Cinema and Media Studies of the School of Cinematic Arts at the University of Southern California. He is the author of *The Studios after the Studios: Neoclassical Hollywood (1970–2010)* and is completing *Hollywood Math and Aftermath: The Economic Image and the Digital Recession*. He has written about the digital turn in *Art Direction and Production Design, Under the Skin* in *Jump Cut*, and *Dope* in the *Los Angeles Review of Books*. He is currently at work on a history of tape recording from World War II to Watergate. He is a steering committee member of Post45, a group of scholars of postwar American literature and culture.

Charlie Keil is Principal of Innis College and a professor in the Cinema Studies Institute and the Department of History at the University of Toronto. His many publications on early cinema include a volume in the Rutgers University Press Screen Decades series, *American Cinema of the 1910s*, coedited with Ben Singer. His most recent publication is a volume in the Behind the Silver Screen series, *Editing and Special/Visual Effects*, coedited with Kristen Whissel. His next book, *The Wiley-Blackwell Companion to D. W. Griffith*, is forthcoming.

Sarah Kozloff is a professor of film on the William R. Kenan Jr. Chair at Vassar College. She is the author of *Invisible Storytellers, Overhearing Film Dialogue, The Best Years of our Lives*, and *The Life of the Author*, and the coauthor of *Introduction to Film Genres*.

Daniel Langford holds a master of arts degree in cinema and media studies from UCLA, where he continued to study Hollywood Renaissance filmmaking and the counterculture as a Ph.D. student. He currently works in K-12 education and plans to incorporate critical media literacy into his effort to teach students of all ages to think analytically and develop the academic skills needed to succeed.

William Luhr is a professor of English and film at Saint Peter's University and co-chair of the faculty-level Columbia University Seminar on Cinema and Interdisciplinary Interpretation. He has published and lectured extensively; his most recent book is *Film Noir*.

Thomas Schatz is a professor and the former chair of the Radio-Television-Film Department at the University of Texas. His books include *The Genius of the System: Hollywood Filmmaking in the Studio Era* and *Boom and Bust: American Cinema in the 1940s*. His writing on film has appeared in the *New York Times*, the *Los Angeles Times, Premiere, The Nation, Film Comment, Cineaste*, and elsewhere. His current book project, a history of contemporary conglomerate Hollywood, was awarded a film scholars grant by the Academy of Motion Pictures Arts and Sciences.

Virginia Wright Wexman is professor emerita of English and art history at the University of Illinois at Chicago. Her books include *Creating the Couple: Love, Marriage, and Hollywood Performance, A History of Film* (7th edition), and the anthology *Film and Authorship*. She is currently working on a book entitled *Compromised Positions: The Directors Guild of America and the Cultural Construction of the Artist*.

INDEX